INTO THE VOID

INTO THE VOID

FROM BIRTH TO BLACK SABBATH —AND BEYOND

GEEZER BUTLER

DEYST.

An Imprint of WILLIAM MORROW

HarperCollins books may be purchased for educational, business, or sales promotional use. For information, please email the Special Markets Department at SPsales@harpercollins.com.

FIRST EDITION

Designed by Angie Boutin

Library of Congress Cataloging-in-Publication Data has been applied for.

ISBN 978-0-06-324250-0

23 24 25 26 27 LBC 5 4 3 2 1

Dedicated to the memory of James and Mary Butler.

Thank you to the fans and followers, without whom my life would be very different.

CONTENTS

AUTHOR'S NOTE

One morning in September 1971, two ladies, Mrs. Bagley and Mrs. Heath, were waiting for a bus on Victoria Road in Aston, where I was born and bred. Suddenly, they saw a woman dressed in a "green frilly gown" standing in the middle of the road. Then they saw their bus, heading straight for her. They were frozen with horror. But just as the bus was about to hit the woman, she vanished.

A few months later, this time in the evening, a Mrs. McFarlane was walking past the same spot when a woman in a "yellowish-green dress" suddenly appeared beside her. The woman hurried across the road, before disappearing when she reached the pavement on the other side. It was later revealed that an usherette from the Aston Cross Picture House was killed while crossing Victoria Road, on that very same spot, years earlier. Strange things were always going on in Aston. It makes perfect sense that Black Sabbath were born there.

PROLOGUE

A friend recently sent me a crumpled, dog-eared black-and-white photo of my first-ever gig. The year is 1965, the venue is the parochial hall in Erdington and I'm striking a John Lennon pose while strumming my beautiful red Hofner Colorama guitar.

The kid in the photo is now in his seventies. The hair is now white and the Hofner Colorama is probably in an antique shop somewhere, or rusting away in some old pal's loft. Sixty years gone in the blink of an eye. How the hell did that happen? When I look back at how it played out, it's almost inconceivable.

When you're in a rock and roll band for as long I was, there tends to be a lot of drama. If you were in a rock and roll band back in the seventies and eighties, the drama was turned up to *11*. Being in Black Sabbath felt like being an actor in a soap opera.

It's a minor miracle all four of the original lineup survived beyond the 1970s, let alone that we're all still here. Along the way, we consumed enough booze and drugs to sink a battleship. Music writers spent decades trying to tear us down. There were so many lineup changes I sometimes didn't know what band I was supposed to be in. We made millions, lost it all and had to go back to the well and make it all again. Some records were great and sold by the truckload, others not so much. We brought the house down everywhere from Lichfield, Staffordshire, to Auckland, New Zealand,

but occasionally descended into Spinal Tap levels of farce. Band-mates said and did horrible things to each other—some of it almost criminal—and fought like wounded animals.

But when Sabbath were firing on all cylinders, which was most of the time, there was no better feeling. There was Ozzy looking like a madman while singing and clapping, like only he could do; Tony launching into another monstrous riff; Bill keeping the band swinging; me, making my bass rumble. Four childhood friends from a working-class neighborhood who became as close as broth-ers, doing what most people would cut off their right arms to do (unless you were a musician). Four dreamers who were written off from the start, sticking it to the critics and driving millions of fans crazy.

That's why every time I went onstage, right down to the very last gig, I was still that happy kid from the black-and-white photo. Despite all the aggravation that came with it, there was still no bet-ter way to make a living. I bet you can't think of one. *Rocket engines burning fuel so fast, up into the night sky they blast.* That's Black Sab-bath to a tee—although only a madman would have predicted the fuel would last as long as it did.

1

ALL THE SEVENS

ASTON

When I was six, circa 1955, I had a visit from the future.

There I was, tucked up in bed, when I was awoken by a strange glow. I opened my eyes and saw a spinning sphere, hovering right above my head. Now from darkness, there springs light.

I stared into the sphere and saw a man on a stage. He had long hair, silver boots and was playing a guitar. The only stage I'd ever seen was at school, and that was used for Nativity plays. I had no idea what a guitar looked like, let alone a guitar being played by a man with long hair and silver boots. We didn't have a television in those days, and newspapers in England weren't exactly full of pop stars.

The sphere hovered for maybe a minute, before ducking into the bedroom fireplace and disappearing up the chimney. It sounds like a nightmare, and I suppose it would scare the hell out of some kids, but it didn't seem that strange to me. It didn't take me long to go back to sleep.

You might be thinking, *Blimey, I thought Geezer was meant to be the sensible one in Black Sabbath. How could a working-class kid from Birmingham have a vision that he was destined to be a rock star, when rock stars didn't even exist in the 1950s?* Well, that's exactly what I saw. And not just the once.

When I awoke hours later, the house was silent and still. The heated brick I used instead of a hot water bottle was no longer wrapped in a towel and was like a block of ice against my feet (in case you were wondering, my mom would heat a brick or piece of iron in the oven, wrap it in a rag or towel and place it in my bed to warm it up, since there was no central heating in the house—if the towel came loose just after you popped it under your blanket, you'd scald your feet and wake up screaming). Wallpaper, loosened by damp, was peeling from the wall next to my bed. I had bites from bedbugs, which would appear from nowhere in the middle of the night, like a tiny ambushing army. Whenever I squashed one, my blood would splash against the wall, and we were constantly battling those little bleeders with an insecticide called Flit, which probably did us more harm than them. Pretty grim, really. But judging by that sphere, the future looked quite promising. Whatever the hell it meant.

Hovering spheres and mysterious rock star dreams aside, growing up in postwar Birmingham was gritty. Aston, the inner-city district where we lived, was still recovering from the battering it took in World War II. The Luftwaffe had paid a lot of attention to Birmingham. Our house, 88 Victoria Road, was a few miles from the big Spitfire factory in Castle Bromwich, as well as the ICI and Kynoch factories, where chemicals and ammunition were manufactured. One bomb damaged the roof of our house, but that was a lucky escape. It landed on the corner of Victoria Road, obliterating two houses and a shop.

I was born in the front bedroom of that house, on July 17, 1949. In that same bedroom twenty years later, I'd awake with the lyrics and bass riff for "Behind the Wall of Sleep" rolling around my head. That song ended up on Black Sabbath's first album.

I was the seventh child of a seventh child, born on the seventeenth day of the seventh month, 1949, at seven minutes to midnight. The day after I arrived, my sister Eileen tried to throw me out of the bedroom window. She was five and had been the baby of the family until then, so it was a fit of jealous rage. God knows what she might have done if Mom had had any more.

My father, James, and mother, Mary, were originally from Dublin, Ireland, where my sister Maura and brothers James and Patrick were also born. My eldest sister, Sheila, was born in Aldershot, where Dad had been stationed with the British Army, while Eileen and my brother Peter were born in Aston, like me.

Dad ran away from home when he was fifteen. His father was terribly strict and would administer beatings at the drop of a hat. Dad joined the Royal Scots Regiment at eighteen and saw service in India and Egypt in the 1920s and early 1930s, before settling in Aston. Dad was an intelligent man who had seen an awful lot—the Irish uprising in 1916, the British Army's "invasion" of Ireland, military service and during his stint as an auxiliary firefighter in World War II. He could talk at length about any topic, especially about history and geography. But there weren't a lot of opportunities for working-class veterans like him, however heroic and bright. So Dad ended up working for an engineering company called Tube Investments, packing steel tubes for worldwide export.

Dad worked his fingers to the bone. Every day, he'd come home from work utterly worn out, eat his supper and retreat to bed before eight o'clock. In thirty years, the only time he took time off work was when a duodenal ulcer burst and he was rushed to hospital.

After twenty-five years of service, Tube Investments presented Dad with a gold watch. It wasn't a Rolex, but it was expensive enough. Dad thought it was far too ostentatious and never wore it.

Mom (in Aston it was always "Mom" rather than "Mum") was the seventh of nine children who grew up poor in Dublin, under the tyranny of the British Army and Black and Tans that terrorized Ireland's residents. On leaving school, she became a children's nanny, before marrying Dad in 1929. Mom was an incredible woman who kept the house spotless and was always cooking. She didn't have a choice, what with all those mouths to feed. Before coal became widely available, Mom would take me in a pram to the local gasworks, about two miles away, fill up a sack with coke (no, not the drink or nose powder), remove me from the pram, replace me with the sack and carry me home. There was never much money, but none of us ever missed a meal and Mom always made sure we had new clothes and kept ourselves clean and tidy.

Like Dad, Mom never drank alcohol and was a creature of routine and iron discipline. Every Friday, Mom would clean all the windows in the house, two of which I broke in one week by kicking a football through them. I can still feel the sting of Dad's leather belt, which he would administer when I got too naughty. Mom stood no nonsense either: one day, I came home crying because a bigger kid had beaten me up, and she sent me back out with the instructions to "give him a good hiding." I did exactly that, which gained me respect from the local kids.

Mom only punished me once, with a cane she kept in case any of us got out of hand. But that's just how it was back then—if your mom hit you, you'd understand why. You certainly wouldn't question it. I couldn't have asked for better parents. They gave me an incredibly loving, happy childhood.

Aston was a very working-class area, mainly comprised of Vic-

torian terraced and back-to-back houses. Life was probably more Dickensian than modern times. Milk and bread were delivered by a horse and cart (there were few cars on the streets of Aston, and very few bicycles). The bread would be hot and crusty by the time it arrived at our house—I've never tasted bread as good as that since. Because Britain was still recovering from the war, other food was rationed until 1954, when I was five. But when you've never had treats, like chocolate, sweets, and all the things that kids take for granted today, you can't possibly miss them.

Until my late teens, occasional day trips and holidays in Dublin were almost the only times I left Aston. Aston was almost my entire world, but that was fine by me. Because no-one had much, we all looked out for each other, and there was no looking over the garden fence. Aston was a thriving part of Birmingham, with a great library, a park, sports fields, several churches and schools, plenty of pubs, shops and cinemas. My first film was *Invaders from Mars*, which my mom took me to see at the local flicks and is still one of my favourites. I'd go and watch Flash Gordon serials every week—no wonder I was so fascinated by anything to do with space.

The Aston Hippodrome had played host to lots of big stars, including Laurel and Hardy and Judy Garland. We even had a magnificent seventeenth-century mansion called Aston Hall, which was home of the Holte family and attacked by Parliamentary troops during the English Civil War. Somehow, the Luftwaffe missed it. The great American man of letters Washington Irving stayed at the hall in 1821, which is when he wrote *Bracebridge Hall*.

More important, there was plenty of work in Aston, including in the famous HP Sauce factory and Ansells Brewery. Aston wasn't glamorous, and it was certainly rough at times, but it had everything you could wish for. I feel very lucky to have grown up there.

Our house would have been quite roomy if there hadn't been

eight people living in it, Sheila having married and moved out in 1951. My three brothers slept in the front bedroom, my mom and two sisters in the middle bedroom and me and my dad in the back bedroom. We had no telephone, hot water or bathroom. The only electrical outlets were downstairs. We still had the original Victorian fireplace, which must have been eighty years old. It was a big, black cast-iron thing with ovens on either side, in which we'd roast chestnuts, bake potatoes and puddings. We had a decent-size yard, a place to store coal and a room where the previous Victorian residents would have stored food for their horse. I'd play in there when it was raining, among all the junk. Occasionally, I'd discover a picture of a naked woman, presumably hidden there by one of my brothers. If Mom or Dad had discovered them, they would have dropped down dead with shock.

Bath time was once a week. A tin bath would be dragged in from the yard and water heated on the gas stove and copper boiler. When we were younger, us kids would take our baths in front of the fire in the living room. When we got older, we'd take them in the kitchen, where there was more privacy. At least in theory. One evening, my sister Maura was taking a bath when one of my marbles got stuck under the kitchen door. As I was retrieving it, I saw her getting out of the bath. And when she returned to the living room, dried and clothed, I asked her why she had a brush between her legs. Well, I was only six.

We were lucky enough to have our own outside toilet, but some of our neighbors had to share one. When I learned that some people had an indoor toilet, I was disgusted: *You mean to tell me that people do number twos inside their house?* Not that having our own toilet was much of a luxury, because it was bloody freezing in the winter. And we didn't have toilet paper. Instead, we'd use a newspaper . . . after everyone had read it. On Saturdays, the local

football paper ("soccer" to you Americans) was pink and seemed slightly softer. That made Sunday the best time to empty one's bowels. If there was a picture of a Birmingham City or West Brom player to wipe your arse on, even better.

AVFC

If you were from Aston back then, you supported Aston Villa Football Club. No ifs or buts. No supporting Manchester United, Liverpool or Chelsea, like some kids from Aston do nowadays, just because they've got more money and win stuff. And you certainly didn't support Birmingham City, who were the dreaded "scum" from the wrong side of town. I've got to hand it to their supporters, they stick with their club through thick and thin. And it's mainly been thin. I'd go as far as to say that that team are a disgrace to the city.

For those who don't know much about football, here's a brief lesson: Villa were a powerhouse in the early years of the organized game in England, winning six league titles and six FA Cups between 1886 and 1920. Queen Victoria was said to be a fan, as is Prince William now. By the time I came along, Villa still held the record for the number of FA Cup wins and were one of only two teams to have won the league and cup in the same season. They were like a second religion to me, after Catholicism. Nowadays, they're my only religion.

From our house, I could hear the roar of Villa Park's Holte End, which in those days was an uncovered terrace and held about twenty thousand fans. Hearing that kind of noise on a weekly basis had a profound effect on a small child. I also remember floodlights being installed in the 1950s and how they cast a glow over the entire neighborhood, like a spaceship parked at the bottom of the street. When Villa played at home, I'd kick a ball around with our

border collie Scamp in the backyard. And whenever Villa scored and that great roar came rolling over, like a tidal wave, I'd pretend they were cheering for me.

In 1957, when I was seven, Villa reached the FA Cup final, and Dad went out and bought a tiny black-and-white TV set so we could all watch it. Villa were given absolutely no chance, because our opponents, Manchester United, had just romped to the league title and their star man, Duncan Edwards, was like the David Beckham of the era. That TV set was money well spent, because Villa won 2–1 to claim the trophy for a record seventh time (there's that special number seven again!), courtesy of two goals from my hero Peter McParland.

My sister was in bed with tonsillitis that day, so Mom sent me to the shop to get her some Lucozade and a tube of Smarties (in the UK in those days, people thought Lucozade, a golden-colored fizzy drink, was some magical cure-all). But instead of giving the goodies to my sister, I kept them for myself. Every cup final since, I've watched it with Lucozade and Smarties (well, the vegan variety).

From the age of seven, I was allowed to go to matches on my own, or with a friend or two. It was only one shilling (five pence) to get into the Holte End. And if I didn't have a shilling, I'd sneak in for free at halftime. On the final whistle, I'd jump over the little fence behind the goal, wade through the thick, sticky mud (how they played in that mud I do not know) and slap Peter McParland on the back. I bet poor old Peter couldn't wait to get away from me.

In those early days, there was no crowd segregation, so you could stand with away supporters and exchange a bit of banter with no trouble. But things started getting dangerous in the 1960s. Manchester United supporters were the first to gain a reputation for violence. After we beat them in the '57 cup final, they'd turn up to Villa Park wearing "We Hate Villa" badges. One Saturday after-

noon, I was in my usual spot behind the goal when I noticed hundreds of United supporters making their way to the Holte End. And a few minutes after kickoff, the bloke next to me collapsed, with blood gushing from his head. He'd been hit by a flying beer bottle. Suddenly, bottles started raining down and Villa supporters were dropping like flies. The police quickly moved in, but that night's local newspaper headlines were all about the disgraceful behavior of United's supporters. Football hooliganism had raised its ugly head and has never really gone away. Then there was the time we played Nottingham Forest. Before kickoff, Forest fans ambushed Villa fans on the Trent Bridge and started tossing them into the river. Mercifully, I managed to avoid a dunking and slip into the ground after the match had started.

Two years after winning the FA Cup for the seventh time, Villa were relegated from Division One, as the Premier League was called then. I'd been to the pictures with Dad and when we got home, the news of Villa's relegation was on the radio. I burst into tears and didn't stop sobbing until the morning. But the worst thing to happen to me, Villa-wise, didn't involve a beating or a relegation. I can still remember the date: November 14, 1959. Villa were playing Charlton Athletic and I was to pick up my friend Francis Egan on the way to the ground. As we were about to leave Francis's house, his dad called us inside and said, "Why don't you save your shilling and help me paint the living room?" I couldn't believe my ears. *Miss a Villa game? Miss the chance of seeing Peter McParland and Gerry Hitchens, my heroes, run riot?* No chance. However, Francis's dad insisted it was going to be a dull game anyway, maybe even a 0–0 draw, and told us that he was doing us a favor. I could see where this was going. If we disobeyed him, he'd probably ban me from seeing my best friend and then give Francis a beating. So I very reluctantly agreed.

While painting, we could hear cheer after cheer coming from the ground, even more of a racket than normal. *What the hell was going on over there?* On my way home, I asked a Villa fan what the score was. "Eleven to one," he replied with a big grin on his face and his thumbs up. It was one of Villa's biggest ever wins and I was fuming. Needless to say, my friendship with Francis was never the same again. Even now it makes my heart ache.

ANIMALS

Sadly, I wasn't much good at playing football. I only got picked for the school team a few times, and dear old Scamp was probably better in goal than me. I got Scamp for my seventh birthday. I'd take him for long, rambling walks and we became inseparable. I got to love him more than any human friend.

Back then, people would let their dogs roam the streets unaccompanied. One night, Scamp came home in terrible agony, because someone had thrown acid on him. It was burning a hole in his back, so we rushed him to the local vet, where my parents spent a good deal of their life savings on his treatment. It took months for the wound to heal and he was left with a huge visible scar, because no fur could grow over the affected area. A few days after the attack, there was an article in the local newspaper about a cowardly bloke who had thrown acid on someone. He also admitted that he had tested the acid out on a dog. I hope he had a horrible life.

Our house was full of pets. The rag and bone man, who went around on his horse and cart shouting "any old iron, any old rags," would swap baby chicks for anything you had going spare. We had a rabbit and a goldfish, tiddlers and tadpoles, and even a tortoise, which I found in the entry behind the house. That tortoise was constantly escaping and wandering over to the local pub. He was

always barred from entry, and the White Swan wasn't fussy. But it was mainly because of Scamp that I became a vegetarian, which was a weird thing to be in Aston in the 1950s.

When I was a little kid, I didn't know where meat came from, it was just something that appeared on my plate (Mom rarely ate it, but she cooked it for the rest of us). But one day, I cut a piece of meat open and blood came out. I said to Mom, "Where did this meat come from?" She replied, "From animals." I thought it was the most disgusting thing imaginable. *Who'd want to eat the rotting flesh of a dead creature? And what was the difference between Scamp or a pig or a cow?* I haven't touched meat since.

ALRIGHT, GEEZER?

I got on great with my siblings, but most of them were too old to play with. Jimmy and Paddy were called up for compulsory National Service, so I didn't see much of them in the early fifties. Jimmy is the reason I got the nickname Geezer (my real name's Terence). He was stationed with a lot of Cockneys and when he came home on leave, he was suddenly calling everyone "geezer" (people in London say, "Alright, geezer?," in the same way Americans say, "What's up, dude?"). And because I was only about seven and looked up to Jimmy, I started calling everyone "geezer" as well.

Jimmy loved fighting. One Saturday night, he came home from the pub covered in blood and with two black eyes. I said to him, "Oh no. Did you lose?" And he replied, "No, the other bloke's in hospital." Jimmy also loved the army life and wanted to join the SAS, but he discovered he had vertigo during training, when he was meant to jump off a tower to simulate parachuting.

In 1956, Paddy was sent to Africa to take part in the British, French and Israeli invasion of Egypt (otherwise known as the Suez

Crisis). That was the first time I saw Mom cry. Paddy was a sharp-shooter and had been through special combat training. When he came home from Egypt, he was awarded a medal. He stuck it in a drawer and it was never seen again. One night two muggers jumped on him, and with two flicks he had them both on the floor, whimpering. His special training came in useful after all.

Peter, Mom and Dad's second-youngest son, wasn't eligible for National Service as he was partially deaf in both ears from a child-hood accident. He became a Teddy Boy instead and caused may-hem on the streets of Birmingham. He dressed all in black, with a drape coat, drainpipe trousers, brothel-creeper shoes and a boot-lace tie. His jacket was specially adapted, with razor blades sewn into the lapels. If anyone grabbed him by those lapels, they'd cut their fingers to ribbons. He also had an elongated inside pocket, in which he stashed a rubber cosh, with a three-inch piece of lead attached to the end, and at least three flick knives. Once, when we were visiting family in Dublin, a witty Irishman saw my brother and said, "Look! Death takes a holiday!" Everyone fell about laugh-ing; even Peter raised a smile. But that old fella had actually hit on the truth: Both Peter and I had a morbid fascination with death.

Because we were only a few years removed from the end of World War II, during which my parents and siblings had survived air raids, near-starvation levels of rationing and evacuations to live with strange families in the countryside, there was a tangible air of trepidation in the house. Paddy being sent off to the Suez Crisis and the Cold War–era fear of nuclear annihilation didn't help. The house was filled with air rifles, air pistols, knives, bayonets and even a revolver, which I'd found hidden under the copper boiler in the kitchen. All these weapons were left over from the war, from the fear of invasion.

I'd seen a poster for the film *The Camp on Blood Island*, which

showed a Japanese soldier about to behead someone. That poster probably made some kids queasy, but I found the threat of violence strangely thrilling. I'd pretend I was a Japanese soldier, too, and carry out beheadings with a bayonet, complete with a wooden stump where the imaginary victim would lay his head. One day, one of my brothers sent me to a petrol station to get some paraffin for their bedroom heater. I walked in wearing a gas mask and a German helmet, and the attendant went berserk: "A lot of people from around here died fighting that lot! Take that helmet off!"

Peter was fascinated with Hitler and the Nazis. Some readers might find that odd, especially since he was born during the war. He and his friends played English and German war games, like me and my friends played cowboys and Indians, probably because they only knew wartime for the first six years of their lives. Who knows what being constantly bombed and confined to air raid shelters does to an impressionable young mind. Peter collected Nazi regalia, badges, medals, uniforms and even taught himself a bit of German. He found a record shop in Dublin that sold records of Hitler's speeches and IRA rebel songs, both of which were banned in Britain. He'd smuggle them back in, hidden inside record sleeves of traditional Irish singers, and play them on a windup gramophone in his bedroom, as there were no electrical outlets upstairs.

Dad was inked, so when Peter was sixteen, he took himself off to the tattoo parlor and got himself a swastika with a sword running through it on his forearm. Dad went absolutely nuts when he saw it. The tattoo got infected, which served him right. And when Peter recovered from his fever, Dad made him return to the parlor and get it changed to something less offensive. He ended up with some roses, with "MOM" written underneath. Mercifully, once he discovered girls, Hitler and the Nazis became a thing of the past—and I've never wanted a tattoo because of what happened to him.

Mercifully, once he discovered girls, Hitler and the Nazis became a thing of the past.

Every Saturday morning, me and Peter would have wrestling matches. Then one morning he got carried away and gave me a black eye. No more wrestling after that, he'd got too rough. I spent a lot of time with my youngest sister, Eileen, and we teased each other mercilessly. And when I wasn't with her, I hung out with friends from school or the neighborhood. I didn't have tons of mates, but I wasn't shy. That came later, after years of touring with Sabbath and craving privacy.

Our favourite playground was a bomb site, literally, because those two houses and the shop that got obliterated by the Luftwaffe hadn't been rebuilt. One day, I found a huge fragment of the bomb that had done the damage. An abandoned lorry on the site became our den. We'd thieve bread and milk off neighbors' doorsteps, retreat to the den and fill our faces. And across the road was an air raid shelter, which was half flooded and which we'd dare each other to enter. My parents and siblings used it during the war, when the bombing got too heavy for them to use the Anderson shelter in our backyard.

Having a bomb site as a playground might sound a bit grim. Far from it. It was a child's paradise, a place where a young imagination could run wild. I certainly had a more adventurous childhood than many kids today, sitting in their bedrooms staring at computer screens. I'd stomp around the bomb site firing toy guns—a space gun or a cowboy gun, depending on what character I wanted to be that day—and be transported to another place. And because the local shops sold surplus army gear, on the cheap, us kids could buy army accessories, which made our war games that much more realistic.

I always carried a knife, although that was mainly for show. I only brandished it once, when another kid pulled a knife on me. We jabbed at each other for a while before deciding we didn't really

want to get stabbed. Things could get pretty rough, though. One time, I was sword fighting (they were wooden!) with my neighbor Johnny Smith on the roof of the local school. I got a bit carried away, knocked Johnny off the roof, and he broke his arm. Another time, I was playing with Johnny's brother Robert and cut his head open with the edge of an opened tin can. He had to have stitches and tetanus shots, and his mom came around to our house to complain about me. I couldn't really blame her.

DIVERSITY

With us kids, it was mostly just rough-and-tumble. But I witnessed a lot of proper violence, especially in and around the White Swan. When I was little, our neighborhood was mainly Irish, with a few Scottish families and one from Yorkshire. But as more families from the West Indies, India, Pakistan and Bangladesh moved into the area, attracted by work in the various industries, interracial clashes increased.

One night, I saw a West Indian have his head bashed in by a brick, thrown by an Irish bloke. His crime? He wanted to have a drink in the White Swan. Another time, a young Pakistani man was stabbed outside the pub. Mom cradled him until the ambulance arrived. Then there was the time I came home to find a man slumped against our front wall, being shredded to pieces by a couple of Pakistani men with broken milk bottles. His flesh was hanging off his face, and he was barely breathing by the time an ambulance and a couple of coppers arrived on the scene.

Some of what I witnessed was just weird. For example, a West Indian bloke, who moved into one of the houses across the road, would hang out of his bedroom window and shout, "Go back to Africa, ya Black bastard!," at any Black person who happened to walk past. Who knows what was going through his head, but he

didn't last long in that house—probably taken off to a mental in-
stitution.

A teacher told us to welcome Asian newcomers by saying *as-
salamu alaykum* ("peace be upon you") if we saw them on the street.
But the first time I tried it out, the bloke produced a knife and chased
me. I've no idea why he did that, but he obviously felt offended. On
another occasion, I was walking along Victoria Road with my girl-
friend when we were stopped by an Asian man. I thought he was
lost and wanted directions, but eventually I worked out he wanted
to pay for my girlfriend to go to his house. I told him no and was
again threatened with a knife, but we managed to give him the slip.

However, it wasn't all misunderstandings and hostility. When
an Indian family moved in next door, I became friends with the
son Magenlal and developed a crush on his sister Madhu. The day
they arrived, the mother came knocking on our door in a panic. I
followed her into her house and she pointed at a running tap, which
was causing the kitchen sink to overflow. She didn't realise that she
only had to turn the tap anti-clockwise to turn the water off.

I was always intrigued by their home. Because they couldn't
readily get Indian ingredients, they'd grow herbs and spices in
their backyard and dry chapatis above the roof of the outhouse.
Inside, they had pictures of an elephant god and gurus on their
walls, much like our pictures of Jesus and Mary. As Dad had been
in India with the army, he explained that the elephant god was
the Hindu deity Ganesha and that a guru was a Hindu spiritual
teacher. Dad made friends with the father, and they'd often talk
over the garden wall while smoking cheroots, which Dad hadn't
had since his time in India.

My parents would never admit they were discriminated against,
but being Irish in Britain at the time was often difficult. I struggled
to understand that, because Dad and thousands more Irishmen

had fought for Britain in both world wars. My uncle Tommy was wounded in Burma, where he pretended to be dead so the Japanese wouldn't take him prisoner. He lay in the mud for so long he caught malaria, and he had to recuperate in our house in Aston until he was well enough to go home to Dublin. I suppose the hostility had a lot to do with the IRA's bombing campaign around the start of World War II. One bomb killed five people and injured seventy in nearby Coventry, so a lot of British people assumed the Irish were on Hitler's side. I suppose some were, but the vast majority— including my dad and uncle—were not.

One day, me and a friend from Belfast were playing outside when a binman said, "Get out of the way, you little Irish cunts." I'd never heard that word before. That evening, we were all sitting around the dinner table when I blurted out, "What's a cunt?" Our house had a strict no swearing rule—if as much as a "bloody" or a "bleeder" slipped out, Dad would tell me that only ignorant people swear and beat me with his belt—so it was as if I'd announced I was the devil.

My brothers and sisters almost choked on their food. Mom and Dad blessed themselves and said about ten Hail Marys. Undeterred, I followed up with, "Is it like the Count of Monte Cristo?," because that was on TV at the time. After a long, awkward silence, someone finally told me that it was a bad word and not to be used again. Even now I seldom swear, despite spending thousands of days in the company of Ozzy Osbourne.

We never went on holiday in Britain or ate out in restaurants or cafés. On day trips to seaside towns like Rhyl, Weston-super-Mare and Aberystwyth, we'd take our own food. My sister Maura once booked to stay in a bed-and-breakfast in Blackpool. When she turned up, she saw a sign on the door that said: NO IRISH. NO BLACKS. NO DOGS. She turned around and came straight home.

We'd go to Dublin every other year, by steam train from Birmingham to Holyhead, and then boat to Dún Laoghaire. During one train journey to Holyhead, we were in a compartment with two nuns. One of the nuns was eating sandwiches from a tin, and when she finished them, she launched the tin through a tiny open window. Because she had such an accurate shot, I thought she must have had special powers. The first time I boarded the boat to Dún Laoghaire, I noticed it had big barrel-shaped attachments on each side. I presumed they were depth charges and started panicking, because I thought we might be attacked by submarines.

We'd stay at my granny's house on Upper Leeson Street and visit aunts, uncles and cousins, and sing Irish rebel songs like "Kevin Barry" or "The Rising of the Moon." Granny Butler was the only grandparent I knew, because the others died before I was born. From her house, we'd go for walks along the canal on Mespil Road, or down to St. Stephen's Green. At the green, I'd notice people crossing themselves when they walked past a building across the road. I asked Dad why, and he told me that some time ago, a cross had appeared in the window and people thought of it as a miracle. Other walks weren't so pleasant. One time, I got into a fight with two Irish kids who were offended by my English accent. I couldn't bloody win!

2

JESUS, MARY, AND JOSEPH

BRAINWASHED

I was raised a strict Catholic and enjoyed the rituals of Mass, Communion, confession and Benediction, as well as that intoxicating smell of incense and everyone dressing up in their Sunday best.

All religion is inherited brainwashing, in my opinion. Every religion is portrayed as the "one true faith," even though each religion's doctrine was made up by some bloke who just didn't want to follow the previous one. I was a bit of a fanatic as a kid. I liked the idea of Jesus, Mary and the Holy Ghost. It reminded me of a fairy tale. Even the horrific sight of a man nailed to a cross with a big gash in his side—which was deemed suitable for young children—didn't put me off.

I became fascinated with souls, so that whenever one of my fish died, I'd cut it open with a razor blade to see if its soul was still present. When I was six, our dog Rusty died and he was buried in the backyard. A few months later, I dug him up and cut him open as well. I couldn't see his soul, so I assumed it had escaped.

After my First Holy Communion, when I was seven, I began spending my pocket money on all sorts of religious ephemera. For a while, toy guns and comics were passé. Instead, I'd buy rosaries, crosses, medals, prayer books, pictures of Jesus, anything my pennies would stretch to, and which was stocked in the repository of the Sacred Heart church.

My first ambition was to be an altar boy, but there was a long waiting list. I obviously wasn't the only religious nut in Aston. When I finally got my chance, when I was about eleven, I overslept and missed my audition. God's calling obviously wasn't that great and getting up early has never stopped being one of my weaker points.

The Catholicism preached at church was pretty fire-and-brimstone, designed to put the fear of God into us. One Sunday, a missionary back from the other side of the world visited our church and gave a sermon. It was a horrifying sight. He was dressed in a flowing black cloak, such that when he ranted and raved and waved his arms about in the pulpit, he looked like a giant bat in flight. He seemed to take strange pleasure in telling the congregation that we were all doomed and that our deaths were impending. There was even stuff about fornicators being damned. I'm not sure I knew what a fornicator was. I still have a pamphlet from that particular Mass, warning of mortal sin and hell, a reminder of a terrifying afternoon. Incidentally, the pamphlet is titled *Heaven or Hell*.

Missing Mass on Sunday, or any other holy day, was considered one such mortal sin. Luckily, there were several services on a Sunday morning. I'd go to confession every Saturday and confess the same sins every time—not doing the dishes, fighting with my sister—which would result in three Hail Marys as penance. One time, I went with my sister Sheila's son, Jimmy, who was only two years younger than me. He went into the confessional first, and from outside the booth I heard the priest erupt in laughter. When

Jimmy emerged, I asked him what he'd said. He'd confessed that he'd told his mom she had a big red nose. Jimmy probably only got one Hail Mary for that.

My brothers would pretend to go to eleven o'clock Mass, which conveniently finished just before the pubs opened at noon. Whenever the priest knocked on our door, my brothers would go flying through the living room door, scramble up the stairs and hide in their bedroom until the priest had gone. Usually, the priest would sit and stare at the TV for fifteen minutes, as if it was something beamed down by aliens. If I asked nicely, he'd bless one of my new religious acquisitions, before bidding farewell and continuing with his visits.

I eventually fell out with the rituals of Catholicism when a local nun kept calling me "miss," because I'd grown my hair long. Whenever I went to Mass, she'd make a beeline for me and say, "Oh, can I find you a seat, miss?" She thought it was hilarious, but eventually I snapped, flashed her a V sign (the good old-fashioned British alternative to the middle finger), walked out and never went back. But once a Catholic, always a Catholic at heart. At least I've found.

SCHOOL DAYS

Almost all the pupils at my first school, the Sacred Heart, were Irish or had Irish parents, although there were a few Italians and one Jewish boy. Discipline at the Sacred Heart was strict. If you were late or ate in class, you got a caning from the head teacher. When Mom went into hospital for a thyroid operation, I started crying during class because I was terrified I'd never see her again. Instead of a cuddle, I was pulled out of class and given a whacking. But none could match the nuns for cruelty.

At infant school, when I was five, I was handed a brand-new

box of lead soldiers, which I loved. Unfortunately, they were easy to break, and I accidentally knocked the head off one of them. When the nun saw this, she whacked me across my knuckles with the edge of a wooden ruler, "six of the best," until I was in excruciating pain. I couldn't even bend my fingers, which were swollen and bruised. Nor could I tell my parents about it—back then, parents assumed you got whatever you deserved, and being Irish, we were told never to "inform" on anyone. From that day on, I chose napping over playing with soldiers.

When I was ten, me and the rest of my class were set a mysterious exam, completely out of the blue. I answered the questions and quickly forgot about it. But a few months later, I was told I'd passed the eleven-plus, without knowing I'd taken it. Passing the eleven-plus was a big thing for working-class kids in England, because it meant they could go to grammar school. Grammar schools were a step up from secondary moderns or comprehensives, where children who failed the eleven-plus went. And a grammar school education usually meant getting a solid white-collar job, rather than a job in a factory. That's why my parents were so overjoyed.

I started at Holte Grammar School, which was even closer to our house than the Sacred Heart, in September 1960. That was a strange feeling, because Holte had been the common enemy before then. There were always fights between the Catholics of Sacred Heart and the Protestants (or "Prods") of nearby Prince Albert School, where Ozzy received his education. But they'd combine forces to fight the pupils of Holte, because they were considered posh and snooty. But now I was one of them, a so-called "grammar grub."

The syllabus at grammar schools was challenging, and at the age of eleven, I was suddenly learning all manner of weird and wonderful things, including French, Latin, Greek, physics, music

and English literature. I'd always been into reading and the English language. I read comics, like the *Dandy,* the *Beano* and *Eagle,* which featured Dan Dare, Pilot of the Future. I also read a lot of my brothers' horror comics, which were strictly under-the-counter purchases. Whatever the subject matter, I never went a day without reading *something.* But at Holte, we studied Shakespeare, Homer and poetry. I became good at English composition, because my imagination, which had always been vivid, was working overtime.

There were some pretty strange goings-on at Holte, at least by modern standards. Boys and girls had separate entrances, and if a boy was caught going into the girls' entrance, they'd be caned. When I was thirteen, a "free period" was introduced for Catholic pupils. Later I discovered that while us Catholics were twiddling our thumbs, the other kids were being taught sex education. Punishment at Holte could be quite cruel and unusual, depending on the teacher. The English teacher, Mr. Hinds, would make you bend over in front of the class and punch you in the rump, four or six times, depending on your infraction. If you were unlucky enough to be sent to the deputy headmaster, Mr. Mordecai, he'd make you kneel on the stone floor outside his room for forty minutes before administering a merciless caning.

Everyone was terrified of Mordecai. One time, he kicked me down the stone steps which led to the front gate of the boys' entrance. My crime? Putting my school cap on inside the school, rather than immediately after leaving. Before my last sports day, me and some other kids conspired to spear him with a javelin. The plan was to say it slipped out of my hand. Luckily—or unluckily, whichever way you look at it—Mordecai didn't turn up. Not to be outdone, a bunch of us pissed all over the door of his office on our final day.

Not all of our teachers were as intimidating as Mordecai. Mr.

Thompson was a lot more easy-going, which made him an easy target for pranks. Before one lesson, one of the naughtier kids sawed through all the legs on his chair. When Mr. Thompson sat down, the chair collapsed and he knackered his back. He went absolutely nuts and started calling us "the dregs from Aston's gutters." I think he had a bit of a breakdown after that incident, because he was off work for months.

My worst beating at school wasn't at the hands of a teacher, but at the hands of eleven kids from a rival football team. A fight broke out during the game, and I whacked one of the players with a chain I had in my kitbag (as you've probably already worked out, things were quite rough in Aston back then, so you had to come prepared!). To get home from the playing fields, I'd catch the number 33 bus. But when the bus arrived and my teammates piled on, I discovered there was no room for me. While waiting for the next bus to arrive, the entire rival team turned up and kicked the stuffing out of me. By the time I got home, I was black and blue all over. I had to tell Mom it had been a particularly violent game of football and that, obviously, we'd lost.

But there was some love at Holte as well. Because it was a coed school, we were given lessons to ready us for the end-of-term dance. For American readers, the end-of-term dance was like a budget version of a school prom, without any of the dressing up or over-the-top preparations. We were taught the waltz and the foxtrot, rather than anything too modern or racy. But it was at that dance that I met Georgina, who I'd marry six years later.

When I was thirteen, I was allowed to drop two subjects, and I swapped music and art for German and economics. That might sound strange, given how I'd live most of the rest of my life, but music lessons at Holte weren't exactly riveting: the teacher would stick a piece of classical music on an old windup gramophone, promptly

disappear and return just in time for the end of the lesson, if you could call it that. He'd probably spent the hour in the pub.

ROCK AND ROLL

We weren't a particularly musical family. In fact, until Elvis came along, there were only two LPs in the house, both by Ruby Murray, a singer from Belfast who became better known as rhyming slang for "curry." Popular music in the UK in the 1950s was incredibly dreary. Other than Ruby, Dad listened to Jimmy Shand on the radio. Shand was a Scottish folk accordionist and not really my thing. He also listened to Billy Cotton's big band, the vocal group The Stargazers and a BBC radio program called *Sing Something Simple*, which was usually the Cliff Adams Singers accompanied by another bloody accordion. About the only music on TV was *The Black and White Minstrel Show*, which featured a bunch of white blokes in black face singing songs of the American South, along with a bunch of white women. It depressed me and I hated it.

The music that changed everything for so many kids in the UK was skiffle. Lonnie Donegan was the main pioneer, with his version of the old Lead Belly blues number "Rock Island Line," a big hit in 1956. Skiffle bands were very DIY: the "bass" player used a broom handle and a piece of string tied to a tea chest, and the "rhythm section" would consist of a washboard. Usually, the only person who had a proper instrument was the guitarist. Skiffle was like the punk of its day, in that it was cheap and you didn't have to be very good at your instruments, which was ideal for a working-class kid like me.

One Christmas, 1958 or 1959, I got a carpentry kit as a present and decided to make myself a very, very rough guitar, inspired by a skiffle tea chest bass. It consisted of a piece of plywood for the body,

a piece of an old clothesline prop for the fretboard and some elastic bands wound around some nails I'd hammered in. I didn't make the best of sounds, but it was better than nothing.

In my first year at senior school (or high school, as you Americans would call it), one of my schoolmates brought in an acoustic guitar and asked if anyone wanted to buy it. It only had two strings, and he was demanding the eye-watering sum of ten shillings (about fifty pence in today's money), which was way beyond my means. But at the time, my brother Paddy would give me a shilling a week to buy his cigarettes and pop, and I persuaded him to give me a ten-shilling advance.

It took me about a year to work out that if I put my finger down on the fretboard and pressed down on a string, it changed the note. *A revelation*. I couldn't afford to buy the other four strings needed to play chords, so I learned to play melody lines with only two, which meant I developed a very strange style, but one that would come in handy when I eventually switched to bass guitar.

One day, in 1957, my brother Jimmy came home with a record called "Heartbreak Hotel" by some bloke called Elvis Presley. I couldn't believe what I was hearing! It was like something from another planet, never mind another country. Of course, rock and roll had exploded in America a couple of years earlier, but news took a lot longer to arrive in Aston back then.

I soon discovered Radio Luxembourg, which had cultivated a reputation as a hipper alternative to the BBC. The BBC's radio stations were very middle-class and very conservative, which meant they only played "wholesome" music. Meanwhile, Radio Luxembourg was playing Elvis, Buddy Holly, Bill Haley & His Comets, Eddie Cochran and Gene Vincent.

Inevitably, British singers jumped on the rock and roll bandwagon—people like Marty Wilde, Billy Fury, Adam Faith

and Joe Brown—performing covers and trying to sound more American than the Americans. The most popular British rock and rollers were Cliff Richard & the Drifters (later renamed the Shadows). My sister Eileen absolutely adored Cliff Richard, bought all his singles and pretty much anything with his picture on it. One of Cliff's biggest hits was "Living Doll," which he said he hated in one of his magazine interviews. One of my brothers wrote, "So did I," next to it to wind up my sister.

When I was eleven, I wanted to buy Cliff's latest single for my sister's birthday. Unfortunately, the local record shop had sold out. The nearest record shop to that one specialized in jazz, blues and blue beat, and didn't have Cliff's new single either. But they did have Muddy Waters's live album, *At Newport 1960*, and a record by Dizzy Gillespie, whose photo on the front sleeve showed him puffing out his cheeks like a frog, and whose trumpet was bent almost in half. They were on sale for a little more than a Cliff single, so I decided to buy them both and get my sister a bar of chocolate with the money I had left over. Those two albums were my introduction to jazz and blues.

THE BEATLES

Classic American rock and roll was great, but my love of music suddenly became serious when a sound like no other came on the radio one night. The song was called "Love Me Do" by a group called the Beatles. That song spoke to me in ways no other music had. It's no exaggeration to say that hearing that song for the first time changed my life, as it did for so many kids my age.

Every night for weeks, I sat glued to the radio waiting for "Love Me Do" to be played. When I told my brother Paddy about this incredible new song, he had a listen, gave me some money and

told me to go out and find it. I played that record over and over again, as well as the B side, "P.S. I Love You," until it was practically worn out.

Of course, there was no Google back then, so I had to wait until the Beatles were written about in the newspaper to find out anything about them. And when I discovered they were from Liverpool, it blew my mind. Liverpool was less than one hundred miles from Birmingham! Then that summer, my sister Eileen sent me a postcard from Blackpool, with a picture of the Beatles on it. Not only did they sound different to anything else, but they also looked different, with collarless jackets, Cuban-heel boots and longer hair combed forward into mops, rather than slicked back into a quiff, like rock and rollers and Teddy Boys.

I started to grow my hair like the Beatles, got myself some Beatle boots, and Mom even bought me one of those collarless Beatles jackets for Christmas. I also started playing Beatles songs on my two-string guitar. When my brother Jimmy saw what a hero John Lennon was to me and how keen I was to emulate him, he bought me a proper six-string guitar.

That guitar was a brand-new Rosetti semi-acoustic and cost £8, which was a lot of money back then—probably about two weeks' wages for Jimmy. And that act of kindness changed the course of my life. After that day, all I wanted to do was listen to music and play my guitar. It took me to worlds far beyond my dreary working-class existence, and it made me feel that I could be whatever I wanted to be, wherever I wanted to be. Suddenly, life made sense.

The British pop scene exploded with the arrival of the Beatles, and most of those American rock and rollers now seemed horribly outdated. It seemed like every week a new British group or singer would appear. There were the Rolling Stones, the Animals, the Kinks, the Who, Gerry and the Pacemakers, the Fourmost, the

Searchers, Billy J. Kramer & the Dakotas, all showcased on TV programs like *Thank Your Lucky Stars* and *Ready Steady Go!*

When the Beatles appeared on *Thank Your Lucky Stars* in January 1963, which was broadcast from the ATV studios in Aston, among the hundreds of fans trying to get a glimpse of the Fab Four leaving the building were two people who'd later be part of their own musical revolution—me and a certain John "Ozzy" Osbourne, although we didn't know each other then.

When the Kinks released "You Really Got Me" in 1964, they replaced the Beatles as my favourite band—for that month at least. That September, the Kinks played the Carlton Ballroom in Erdington, and me and my best mate Roger Hope went to get a glimpse of the band arriving. While we were waiting outside, Ray Davies appeared and asked us where the nearest cinema was. We were beyond thrilled that he'd taken the time to talk to us, and I couldn't believe how normal he was. We showed him the way to the nearest cinema and he instantly became our number one hero.

MY FIRST BAND

Like every other aspiring guitarist in Britain at the time, I was learning chords from Bert Weedon's book *Play in a Day*. And I eventually saved up enough money to put down a deposit on an electric guitar, that beautiful red Hofner Colorama, and a Bird Golden Eagle amplifier. There were no credit cards back then, and I couldn't open a bank account, but a company called Pay Bonds would give you a loan for almost anything. At least I think that's how I paid for them.

In 1965, when I was fifteen or sixteen, I formed a band with Roger Hope. We were called the Ruums, after the sci-fi short story by Arthur Porges. I forget the drummer's name, but a kid called

Peter Brant was on bass. Our first gig, as depicted in that crumpled, dog-eared photo, was the pop hop at the parochial hall in Erdington, where we covered songs by the Beatles, Kinks, Stones, and various Merseybeat bands (the Mersey is the river in Liverpool).

I've no idea how we got all the equipment to the venue, but I do remember travelling with my guitar on the 40A bus. I couldn't afford a case, so it was wrapped in a plastic bag. Quite a few people turned up to watch, mostly friends, and it actually went pretty well. The Ruums were short-lived and only played a handful of local gigs. But it reinforced the notion that I wanted to play music for the rest of my life, rather than waste away behind a desk in an office.

On December 9, 1965, I saw the gig of a lifetime: the Beatles at the Birmingham Odeon. Hundreds of kids queued overnight to secure a spot in the audience, and many of them were left disappointed. The police had to put barricades up, to stop them from storming the place. Luckily for me, the daughter of the Odeon's manager, Beverley, fancied me and gave me a complementary ticket. It's one of the rarest tickets in pop music history, because they never toured the UK again.

Of course, it was impossible to hear them, what with all the screaming going on, but to be in their presence was enough for me. They were done and dusted in thirty minutes, but that night will forever be etched on my brain. I mean, look at the songs they played: "I Feel Fine," "She's a Woman," "If I Needed Someone," "Nowhere Man," "Help!," "We Can Work It Out," "Yesterday," "Day Tripper." No wonder everyone, including the blokes, was going hysterical.

In October 1966, I saw the Stones at the same venue. By this stage, they were my second favourite band behind the Beatles, with the Kinks down in third. But Mick and the rest were almost blown off the stage that night—not that anyone could hear them anyway—by Ike and Tina Turner. It was relatively quiet when

Ike and Tina took to the stage, but what followed was one of the most amazing performances I've witnessed. When they did "River Deep, Mountain High," complete with a rudimentary light show and Tina and the Ikettes singing and dancing, I was dazzled and electrified like never before.

SINGIN' THE BLUES

There was a growing blues movement in the UK at the time, with a lot of up-and-coming musicians giving the songs of the great American bluesmen, who were virtually ignored in their home country, a British slant. The Stones did this most successfully, but they were always quite poppy. However, people like John Mayall and Alexis Korner were delving far deeper into the blues of Robert Johnson, Son House and Big Bill Broonzy, and were putting more emphasis on musicianship. John Mayall's Bluesbreakers, featuring Eric Clapton, were the most influential British blues band in Britain. Their *Beano* album, released in 1966, triggered the blues boom that would last until the end of the decade. And when I first heard it, I dreamed of one day owning a Gibson Les Paul, so that I could sound like Clapton. I wasn't the only one.

When Clapton left the Bluesbreakers to form Cream, the first-ever supergroup, it felt like the second coming of Jesus, musically speaking. I remember seeing a poster advertising their first gig in Birmingham—CREAM—FEATURING ERIC CLAPTON, JACK BRUCE AND GINGER BAKER—and when I got to see them at a pub in Yardley, I was spellbound by their musicianship, but appalled when Clapton smashed up his guitar at the end of the show. At the bar afterwards, I got to talk to Clapton and asked him why he'd wrecked his guitar rather than giving it to someone like me. He laughed and said he didn't like that guitar, anyway.

I saw Cream three times before they became huge. The final time, at the Carlton Ballroom (which would become Mothers), was life-changing, because I was mesmerized by Jack Bruce's bass playing. I didn't know a bass player could do what he was doing, filling in where the rhythm guitar would normally be.

In January 1967, an alien landed in my TV. He was a man with a huge Afro, a style I'd never seen before, and playing an upside-down white Fender Stratocaster, left-handed. The show was *Top of the Pops*, and this bloke made every other act on the show look bland. The alien was Jimi Hendrix, who played that Strat like I'd never heard a guitar played before, and the song was "Hey Joe." These were heady times for a kid into his pop music.

By that time, me and Roger Hope had formed a new band called the Rare Breed, with Roger on lead guitar, me on rhythm guitar (I'd traded my Hofner for a black Fender Telecaster), John Butcher on vocals, Mickey Hill on bass and Tony Markham on drums. We were all music mad, so every week we'd come up with something new.

Besides the Bluesbreakers, the Yardbirds and Cream, we also did pop covers (the Kinks's "You Really Got Me"), R & B (Eddie Floyd's "Knock on Wood") and more obscure stuff, such as "Flames" by Elmer Gantry's Velvet Opera, "My White Bicycle" by Tomorrow and "Think I'm Going Weird" by Art. I also loved The Mothers of Invention, because Frank Zappa's lyrics were like nobody else's. "It Can't Happen Here" was one of my favourite Zappa songs, because it took me to a completely different place, which is what music is supposed to do. Zappa's lyrics were tinged with cynicism and sarcasm, perfect for the growing antiestablishment culture of the time.

Tomorrow were one of the first psychedelic bands in Britain, and their shows included mini wordless plays, complete with strobe

lighting and dry ice (their guitarist, Steve Howe, went on to form Yes). It would probably look terrible now, but at the time, we'd never seen anything like it. We even tried to copy them, using flour instead of dry ice, which we couldn't afford, and a couple of huge classroom lights instead of strobes. We also experimented with Halloween-style makeup, similar to Arthur Brown's, which in turn was pre-Kiss and –Alice Cooper. Unfortunately, our amateurish attempts at theatrics got us banned from pretty much every venue we played. At one gig, the lights set fire to the stage.

That gig was at Fort Dunlop in Birmingham, where we supported another local band called Way of Life. Halfway through their set, the drummer jumped off his stool and threw beer on his singer, before smacking him around the head. He was the loudest drummer I'd ever heard and went by the name of John Bonham.

Birmingham was a big soul town and Geno Washington & the Ram Jam Band were huge at the time. Some nights, we'd start off with a couple of soul numbers and everything would be great. But as soon as we started up with the blues and anything remotely psychedelic, the crowd would start throwing bottles at us and chanting, "Geno! Geno!," like in the song by Dexys Midnight Runners. We'd soldier on and try to last the distance, but sometimes that wouldn't be possible.

At another gig, in a placed called the Penthouse, I slashed my arm with a broken beer glass and John Butcher destroyed the DJ box with a ball and chain. Soon after that, we changed our name to the Future, in an attempt to get rebooked in the venues the Rare Breed had been banned from.

In the audience that night were members of a band called Mythology. Roger worked at the same place as their singer Chris Smith, who introduced us to Mythology's guitarist Tony Iommi and drummer Bill Ward, who I'd already seen in various music

shops around Birmingham. Back then, Tony dressed like a 1950s rocker, in white T-shirts and blue jeans, while I dressed in colorful tops and flares. But we shared a love of music and soon met again at a coffee bar called the Crypt, which had coffin-shaped tables.

Most up-and-coming bands played the Penthouse, and Saturday was an all-nighter that began around 9 P.M. and finished at five or six on Sunday morning. That's why the Penthouse was also the place to score dexies and Black Bombers, which were prescription amphetamines. One weekend, I left the Penthouse at 6 A.M., flying on Black Bombers, and went straight to early morning Mass. After Mass, I stumbled home and pretended to sleep, while still out of my head.

Robert Plant and Band of Joy were Penthouse regulars, as were Jim Capaldi and Deep Feeling (Jim, Steve Winwood and Dave Mason would later form Traffic, who'd occasionally play at the Elbow Room on Aston High Street). Other bands who played the Penthouse around that time were John Evan's Smash, who'd later become Jethro Tull, and Chicken Shack, with Christine Perfect (later McVie of Fleetwood Mac fame) on keys. I remember chatting to Christine about our favourite guitarists. She was for former Fleetwood Mac's Peter Green, whereas I was for Eric Clapton. Both brilliant, of course. I was sad to hear of Christine's recent death. She was a lovely woman, and a good laugh, especially when she used to outdo Tony at eating the hottest curry ever at the Canard De Bombay in Los Angeles.

Another all-night club in Birmingham was Midnight City, where they'd play soul music and which was mainly attended by mods, "mohairs" and skinheads. One Sunday morning, I was walking home from the Penthouse and on the other side of the road was a mod/mohair on his way home from Midnight City: cropped hair, button-down gingham shirt, Sta-Prest tapered trousers and boots. I later discovered that mod/mohair was Ozzy.

Another place I'd visit was Middle Earth in London's Covent

Garden. I'd save my money for train fare, leave on Friday night and return on Saturday morning. Walking into that club was like visiting another planet. Radio 1's John Peel often deejayed there, while the early psychedelic bands Pink Floyd and Soft Machine were regularly on the bill. The crowd in that place was completely bonkers—because most of them were on acid. I remember a couple sprayed entirely in gold and covered in sequins dancing to Captain Beefheart. Another time, some bloke tried to hang himself from a beam and had to be rescued.

It was also in 1967 that I started hearing about the hippy movement in San Francisco—anti–Vietnam War, free love, flower power and the rest of it. Radio 1, which was dedicated entirely to pop music, first broadcast that autumn. It played songs like Scott McKenzie's "San Francisco (Be Sure to Wear Flowers in Your Hair)," the Flower Pot Men's "Let's Go to San Francisco," Procul Harum's "A Whiter Shade of Pale" and the Move's "Flowers in the Rain," the first track to be played on the station. I listened to those songs and dreamed of strolling along Haight-Ashbury, smoking a spliff in the glorious California sunshine, with like-minded revolutionaries. It seemed like the only place to be if you were a kid like me, with hair down your back and a longing for peace and freedom.

When Steve Winwood walked into a music shop I used to hang out in, wearing a kaftan and bells around his neck, I thought, *What the heck does he look like?* But a few seconds later, I was thinking, *This bloke's from down the road in Handsworth, has just left the Spencer Davis Group and formed Traffic. Who cares what he looks like! And if he could escape, why can't I?*

THE DAILY GRIND

Unfortunately, it didn't look like I had much hope of joining the revolution. Having got into grammar school, my parents had great

expectations of their youngest son becoming something special. At the age of fifteen, I just managed to pass the five GCE (General Certificate of Education) exams I needed to continue my education. And if I'd chosen to take A-levels and passed a couple, I could have gone to university. But I dreaded the thought of staying on at school and wanted to start paying my way in the family.

I knew I didn't want to work in a factory or on a building site, like my dad and brothers. All I was interested in was pop music, but that wasn't much of a money-spinner at the time. So when the job fair came to school, I asked the guy in charge which profession paid best. He told me accountants didn't do badly. I had the requisite exam passes in maths and English, so accountancy was the profession I chose. It was as simple as that.

Having left school on my sixteenth birthday, I had my first job interview at Ansells Brewery in Aston, where my sister Maura worked. In the waiting room, I sat next to this other candidate with cropped hair and wearing a smart suit and tie. I soon discovered he had no GCEs, which made me think I'd get the job easily. But when the personnel manager came out of his office, he took one look at me and said, "How dare you apply for an office job looking like that!" It didn't matter that I was way more qualified than the other bloke, only that my hair was too long and I wasn't wearing a suit and tie. He refused to even interview me.

My hair had grown so long by the age of fourteen that my English teacher had taken to calling me Tarzan. And because of the length of my hair, I was turned down by six interviewers. But before the seventh interview (that number again!), I greased my hair back, so that it looked vaguely presentable, and got the job as a trainee cost-and-works accountant at Spartan Steel in Aston.

At Spartan Steel, I was given every menial task imaginable— tea making, fetching cigarettes and newspapers—as well as tasks

that were way above my pay grade. One time, I was told to go down to the steelworks and estimate what this huge steel plate was worth. It was precariously balanced and had rough edges, and as I touched it to read the description, it fell towards me. I jumped out of the way, but the edge of the plate sliced through my jacket and shirt and cut my chest. That was the only jacket I owned, and I only had one spare shirt. The nurse was quite sympathetic, but the tight-fisted office manager only agreed to repair my jacket and not shell out for a new shirt. I could have sued them for thousands, if I'd known what I do now.

The longer I was at Spartan Steel, the more depressed I became. Playing music was a relief, but only temporarily. One day, I walked in front of a lorry, not caring if I lived or not. Luckily, the driver slammed on his brakes in time, and I escaped with some verbal abuse. Sometimes, to relieve my anxiety and depression, I'd cut my arm with a razor blade or stick pins in myself. This stopped when I cut myself so deeply my arm poured blood, which frightened me so much I never did it again.

As well as my office job, I was required to go to college every Monday and Friday, to study English economic law, economic geography, economic history, economics and English language, all for the princely wage of £4 and 10 shillings a week. In my third year, I didn't turn up for a single English lesson. I couldn't be bothered catching the bus into Birmingham city center for the 9 A.M. Friday starts.

While doing English homework one night, I drank a whole bottle of cough medicine and started hallucinating. A child appeared beside me, and we struck up a conversation. After about forty-five minutes, Dad stuck his head around the door and asked who I was talking to. I quickly snapped out of it, the child disappeared and I told Dad I was thinking out loud. Miraculously, I passed the

English exam, but failed all the other subjects, despite attending every lesson. Maybe I was destined to be the lyricist in a band.

SUMMER OF LOVE

The closest I got to San Francisco was the Festival of the Flower Children at Woburn Abbey in Bedfordshire, which took place in August 1967. It was one of the first pop/rock festivals in England and rammed with weekend hippies, me being one of them.

Me and the rest of the Rare Breed travelled south from Birmingham in the group's van, stopping off in London's Carnaby Street, where I bought myself a floral-print shirt and a matching tie. Very revolutionary. I'd also thieved a pair of welding glasses from work, on which I'd placed a flower sticker, and an old hat of my dad's, which I'd adorned with paper flowers. I must have looked like a giant bouquet.

When we stopped at Watford Gap services, on the recently opened M1 motorway, I was stung on the lip by a wasp that had crawled into my can of pop. My lip swelled up so much, my fellow Rare Breeders started comparing me to Mick Jagger and calling me "tit lip." It kind of spoiled my look, and I thought it had scuppered any hopes I had of experimenting with free love.

Among the bands on the bill that weekend were the Jeff Beck Group (with Rod Stewart on vocals), the Kinks, the Small Faces, the Bee Gees, Eric Burdon, Tomorrow and a Birmingham band called Breakthru, who were mates of ours. It was a grand few days, other than a gang of skinheads setting fire to the stage canopy on the second night. As it happened, I did get to test the limits of free love with a girl from Norwich (her limits were actually rather unlimited) and smoked my first joint, having embarrassed myself by lighting the cardboard end first.

But having tasted a little bit of San Francisco in the Bedford-shire countryside, it was soon time to go back home to Aston. The following Monday, there was a picture of me in all my hippy gear in the *Daily Mail*. My dad completely lost it—"Mother of God! What the hell are you doing?" He thought I'd brought dishonour to the family. I thought I looked great.

YOU'RE FIRED!

In 1968, my life changed completely. I hated my job so much that I was arriving at work later and later each day. Thankfully, the clocking-in procedure at Spartan Steel was primitive, consisting of a book you signed with a pencil. I started bringing an eraser in and rubbing out everyone who had signed in after 8.59 (the workday started at nine). Then I'd sign myself in as nine, even though I usually showed up a lot later than that.

Of course, the manager knew what was going on and started to complain about my timekeeping. And when I arrived at eleven-thirty one day, the managing director summoned me to his office and gave me a final warning. Not long after that, I went out for lunch and got completely drunk and wired on Black Bombers, before returning at four-thirty. That was the final straw. The following day, I was hauled into the managing director's office again and fired.

My first reaction was relief because it meant I could concentrate on becoming a full-time musician. However, there were two major problems: First, I had no money and was in debt because I still hadn't paid off my guitar and amp; second, my dad would kill me if he found out.

Dad was proud that no member of the family had ever been on benefits and thought I had the job of a lifetime. As far as he was concerned, once I qualified as an accountant, I'd have a lifestyle he

could only dream of. So over the next few weeks, I'd pretend I was setting off for work but would actually go to the dole office to sign on. I was allowed £4 a week, as long as I went for any interviews they set up for me. Of course, with my long hair and lack of enthusiasm, I had no chance of being offered a job. For three or four weeks, I left home at nine o'clock in the morning and returned just before teatime, and my parents were none the wiser. But in the end, I had to tell Mom, who in turn told Dad. He went mental. I remember him screaming, "I cannot believe a Butler is on the dole!," while I was cowering on the living room sofa.

More disaster was to follow. The Rare Breed's singer John Butcher got a job on a cruise ship bound for Australia. That meant I had no job, no band and no immediate prospects. The people at the dole office kept telling me to cut my hair and I kept replying, "What's the length of my hair got to do with my qualifications? I'm not cutting it!"

My lowest point came when I went for a job cleaning cars at a car showroom. The owner told me it was more a job for a retired person, not an eighteen-year-old with qualifications. When you can't get a job cleaning cars, you know you're in trouble. Then my beloved dog Scamp died. He'd never fully recovered from being doused in acid, but he never stopped being my best friend. After my brother Jimmy buried him in the backyard, I lay on his grave and cried for over an hour. I felt like getting the spade out, digging a grave of my own and climbing in next to him.

3

SOMETHING AT THE DOOR

OZZY ZIG NEEDS A GIG

I had to make a success of being a musician; otherwise, I worried I might top myself, because I was falling deeper and deeper into depression. I didn't have much choice but to give the Rare Breed one last try.

In desperation, I started looking around for a replacement singer. And one day, I was in Jones & Crossland, a musical instrument shop in Birmingham, when I saw a notice pinned to the wall:

OZZY ZIG NEEDS A GIG. SINGER WITH OWN
P.A. 14 LODGE ROAD, ASTON.

Lodge Road was no more than half a mile from my house, near Sacred Heart church, so after reading the announcement I headed straight there. "Ozzy Zig" wasn't in, I was told, but I gave one of his sisters my address and hoped he'd turn up at some point.

The following day, I was having tea with the family when there

was a knock on the front door. When Jimmy came back from answering it, he said to me, "There's something at the door looking for you." I asked what he meant by "something," and Jimmy replied, "You'll see . . ." And there he was: a skinhead, dressed in his father's work gown, without any shoes on, a chimney brush over his shoulder and a sneaker on a dog lead. That's right, a sneaker.

I immediately recognised him as the bloke I'd seen on the opposite side of the road when I was making my way home from the Penthouse. My first words to him? "Oh no, a bloody skinhead." To which Ozzy replied, "I'll grow my hair!" When I'd got over my initial shock, I couldn't help laughing. God knows I needed cheering up. And when I explained that the Rare Breed were looking for a singer, and told him about the kinds of music we were into, he said he'd give it a go.

I introduced Ozzy to the rest of the Rare Breed the following weekend. I was a bit worried about what would pan out. It wasn't just that Ozzy was a skinhead, it was also that he was obviously a complete nutter. Not only did he walk around with a sneaker on a lead, but he also walked around with no shoes on, even in winter. He'd also just got out of Winson Green prison for burglary. But desperate times call for desperate measures. We'd take anybody who could get up onstage and sing a few notes, and especially one who owned his own PA.

Around that time, I was spending what little extra money I had on "five-bob deals" (twenty-five pence in today's money), which was enough hash (or "charge," as it was known to us indulgers) for one or two joints. I'd score these five-bob deals from some Jamaican friends in Handsworth or shebeens in Erdington, where I'd also buy cans of Red Stripe lager. None of the rest of the band were into drugs, but Ozzy was. At that first rehearsal, I discovered he was partial to uppers and downers and hash, so we immediately bonded.

The Rare Breed's first gig with Ozzy was in Walsall. After get-

ting booed off with the same rapidity with which we'd set up, the promoter said, "Here's five quid, now piss off." Ozzy told him to stick it up his arse, but I snatched the money from his hand. I was stony broke and had to pay for the petrol.

Ozzy's second Rare Breed gig was at Aston University, where once again we were booed off and the promoter only gave us half our fee. That was the night I learned that Ozzy could defecate at will. As we were loading our gear back into the van, Ozzy pulled down his pants, crouched on the bonnet of the promoter's Jaguar and left one of his trademark calling cards. To be fair, he refined his talent as the years went by. On future American tours, he'd shit in hotel ice machines, so that anyone who fancied a Scotch on the rocks might get it with a twist.

I wanted to be a full-time musician, but the others had too much to give up. While they all had decent day jobs, I only had what the dole office would give me. And because I was still refusing to cut my hair, they were threatening to end my handouts.

In the summer of 1968, the Rare Breed all headed down to Woburn Abbey again. Jimi Hendrix was topping the bill, and although he had trouble tuning his guitar throughout his set, just being in his presence was good enough. The last time I'd seen him was fronting the Jimi Hendrix Experience, when they played the Birmingham Odeon. They were supporting the Walker Brothers and Engelbert Humperdink, and I think I was the only person in the audience who was there to see Hendrix. His three-song set was politely applauded by the girls in the audience, who probably had no idea who he was.

TONY'S DOORSTEP

Eventually, I decided I needed to leave the Rare Breed and find some bandmates who were as desperate as me. I didn't hear from

Ozzy for a few weeks after the Jaguar gig (as it will always be known), but one night I visited him at his friend's house in Handsworth. His friend was a slide guitarist called Jimmy Phillips, who I'd played with a few times as a kid. There was also a Black guy with a bass, whose name I can't recall. Ozzy told me he'd left the Rare Breed and was forming a new band with Jimmy and the other fella. When I told Ozzy I'd also left the Rare Breed, he suggested I join his new band and that we look for a drummer to complete the lineup.

Ozzy had heard that Bill Ward, the drummer I'd met in the Penthouse, and his Mythology bandmate Tony Iommi, who went to the same school as Ozzy, had just returned to Birmingham after being busted for drugs in Carlisle. So me and Ozzy decided to pay them a visit. Tony lived at his mom's shop on Park Lane, a couple of streets away from my house. I'd often pop into that shop for a Mars bar on my way home from Mass, because I couldn't eat before receiving Communion and was always starving. I'd also been dating a girl called Patty who lived almost opposite (me and Georgina were a bit off and on), and Tony had dated Patty's sister. One night, I'd seen Tony's van parked outside the shop and left a flower in the wing mirror, as a good-vibe gesture.

Upon seeing Ozzy, Tony looked disgusted and said, "Oh no, not Osbourne. What do you want?" Tony was the year above Ozzy at school and allegedly bullied him—he always said that Ozzy had the kind of face you wanted to punch. Ozzy never stopped being the kid from the year below Tony, and Tony never stopped being the band leader. As is common with lots of groups of mates, once that hierarchy was established, it never disappeared.

Undeterred, Ozzy told Tony we'd got a band together and were looking for a drummer. Tony replied, "Bill's here now if you want to talk to him." Bill came to the door and Ozzy asked him if he

wanted to join. That was the first time all four of us were together, on the doorstep of Tony's childhood home.

Bill asked us what sort of stuff we'd be playing, and we started going on about Cream, the Bluesbreakers, Spooky Tooth and Art. Bill thought for a moment before replying, "I'm not joining without Tony, we do everything together." And Tony said, "Okay then, I'll give it a go." When Tony went back into the shop, I flashed a lump of hash in Bill's face. Bill panicked and said, "Don't show that to Tony, we've just been busted and he'll go nuts." But sure enough, that sealed the deal with Bill.

POLKA TULK BLUES

The bassist I'd met at Jimmy Phillips's house said he wasn't interested in joining, which is how I came to switch from rhythm guitar. I even bought his Teisco Top Twenty bass off him (I've no idea where I got the cash from, even though it was a mere £10). One problem: It only had two strings and I couldn't afford any more. As a result, at our first rehearsal, which took place in Jimmy's backyard, I was forced to tune down my Fender Telecaster as low as it could go, which must have sounded horrendous. Even worse, we had a saxophone player called Alan Clarke, who came as part of a package deal with Jimmy. Rock and sax don't really mix.

Halfway through the rehearsal, the neighbors started complaining about the noise. So we eventually abandoned Jimmy's backyard and reconvened in a local pub, the Star on Birchfield Road. By the end of the day, we had a list of eighteen songs, almost all of them twelve-bar blues covers. That made things easy for me, because all the bass lines were nearly identical.

After a few rehearsals, we started trying to get bookings. Tony was the only band member with a telephone, because his mom

had one in her shop. So we got the telephone book out and took it in turns to make calls. It was Jimmy who rang an agency called Spotlight Entertainment. When they answered, Jimmy, quite innocently, asked to speak to Mr. Spotlight. The rest of us creased up laughing and "Mr. Spotlight" slammed the phone down.

Tony, Bill and their band, Mythology, had built up quite a decent following in Carlisle and the surrounding area, so Tony got in touch with an agent they'd worked with up there. This agent booked us a couple of trial gigs, on the strength of Mythology's following, and on Friday, August 23, 1968, we all set off for Carlisle in Tony and Bill's clapped-out Commer van.

It was about two hundred miles from Aston to Carlisle, along a half-finished motorway and winding roads, including the notoriously dangerous Shap Fell. Even with a decent vehicle, Shap Fell was a treacherous climb. And Tony and Bill's Commer was *not* a decent vehicle. It only worked when it wanted to and had a gaping, rusty-edged hole in the floor of the passenger side. I'd sit there and watch the white lines beneath my feet as we were bombing up the motorway.

One time, we stopped and picked up a couple of girls who were hitchhiking. They jumped in the passenger side, fell through the hole and cut all their legs up. Unsurprisingly, they went mad and jumped straight out again. Oh, and that van had no seats, except for the driver's and passenger's front seat. Instead, there was an old sofa in the back, and all our equipment was loaded up behind that.

Apart from the van, we had two big problems: I still didn't have a proper bass guitar and we didn't have a name for the band (we were being advertised in Carlisle as Ex-Mythology, which wasn't particularly catchy). The second problem was solved when we were driving through Handsworth and Ozzy spotted an Indian sari

shop called Polka Tulk. Hey presto, we were suddenly the Polka Tulk Blues Band. The first problem was solved when we stopped off at Peter Brant's house and he lent me the Hofner bass he'd played in the Ruums.

Not surprisingly, the van overheated and we had to stop to let the radiator cool down. When Tony unscrewed the cap, he was covered in a geyser of hot, brown water, much to Ozzy's amusement. When Tony saw Ozzy laughing, he gave him a vicious tongue-lashing. Nobody laughed at Tony after that. Tony was the alpha male in the group, no doubt about that, and it took Ozzy quite a while to feel comfortable in his presence. He'd be acting up, Tony would walk into the room and Ozzy would immediately fall silent.

Actually, there was *one* other slight issue: We had no uniformity. If the police had stopped the van for whatever reason, they'd have probably thought we were a circus clown act. Tony and Bill looked like rockers, in T-shirts and jeans. But Alan was dressed for the office, in a white shirt and smart slacks, Ozzy was wearing his dad's work gown again, Jimmy was wearing a kaftan and a big hat with an even bigger feather in it and I was wearing my girlfriend's Chinese-style blouse, a net curtain waistcoat, green trousers with twenty-eight-inch flares and home-dyed green boots. That's how the Polka Tulk Blues Band took to the stage for the first time. We didn't look like a band, but like six different bands rolled into one.

Our first gig was at Carlisle's County Ballroom—and the place was packed. Most of the crowd were there to see Tony and Bill again, and there was a real electricity in the air. It was a typical Saturday night up north, with everyone wanting to listen to some great music, get pissed, have a fight and possibly get laid. At least our back line looked impressive: Tony had a double Marshall stack, I had my Park four-by-twelve speaker (well, three-by-twelve speaker, because one of them had blown) and seventy-watt Laney

amp. The snag was that neither of them was meant for playing bass through, and the Hofner I'd borrowed only had three strings. Then again, I could only play two strings anyway.

And so it began. Badly. We were all doing it trial by numbers, with a bit of solo stuff, when Alan the sax player came on and started doing "Take Five" by Dave Brubeck. We later found out that that was the only thing he knew how to play. Meanwhile, Jimmy's slide guitar didn't go with anything else.

After the show, some blokes decided to tell Ozzy and me how crap we were and begged Tony and Bill to get their old bass player and singer back. Mind you, we'd soon find out that professional critics could be even harsher. As if things couldn't get any worse, as we were loading the gear out to the van, two Irish blokes—one of whom was just about the biggest I'd ever seen—accused us of chatting up their girlfriends. I remember Ozzy saying to them, "You're not even with any girlfriends!," and the giant bloke replying, "Yeah, but you could be talking to them, if they were here." You didn't need much of an excuse to start a fight in those days.

As we were carrying our gear down the stairs of the venue, the smaller bloke whacked Bill on the chin and the giant started chasing me. I kept screaming, "Don't hit me, mate, I'm peaceful!" I managed to get inside the van, and before the giant could wrench the door open, the police arrived and arrested him. It took six coppers and a dog to get the giant into the back of the police van, and later we found out he'd strangled the dog, broken out of jail and was on the run. That was me, Ozzy, Tony and Bill's first gig together. Not exactly auspicious, but at least we had some good stories to tell down the pub.

Our second gig was at Banklands Youth Club in Workington. That didn't go well either. Jimmy wasn't taking things seriously, and his playing was getting in the way of Tony's. Meanwhile, Alan

could still only play "Take Five." That's when I first saw Tony's ruthless side. He decided he didn't want to play with Jimmy and Alan anymore, and after those gigs they'd be out on their ears. From that point on, it was just going to be the four of us.

We spent some time at a caravan park in the village of Nethertown, which was attached to a venue called the Tow Bar Inn. There was nothing to eat except for meat, and I had no money to go shopping. Luckily, the caravan park was next to a pig farm, which was next to a field of turnips, which the farmer fed to his pigs. So when it got dark, I raided the field and dug up some grub. I survived on raw turnips for four days, like some medieval peasant.

Tony had boxed as a kid, and it was while we were in Nethertown that I saw him in action for the first time. We were strolling around the village, minding our own business, when two blokes started taking the piss out of our clothes and hair. Rockers still hadn't reached the darkest reaches of Cumbria, let alone blokes wearing Chinese-style blouses and with hair hanging down past their shoulders. Tony walked straight over to these blokes and said, "You talking to me?," like Robert de Niro in *Taxi Driver*, before grabbing both of them by the hair and whacking their heads together. They dropped to the floor, like two sacks of cement, and that was the last we heard of them.

On our way back home to Birmingham, going down Shap Fell, which was even more dangerous than going up it, Bill's drums tumbled forward, crashed into the sofa and almost knocked us all out. I got home at six in the morning, just as my dad was preparing to go to work. We hadn't spoken much since my sacking from Spartan Steel, so I was dreading what he'd say to me. And I wasn't in much of a talking mood anyway. But that morning, having finally realised how much that band meant to me, he said nothing and made me a cup of tea.

EARTHLING

Having had time to reflect on our jaunt to Cumbria, Tony, Bill and Ozzy met at my house and decided to make the split with Jimmy and Alan permanent. Slide guitar and sax were cramping our style. At that same meeting, I played the guys a record, "Warning" by the Aynsley Dunbar Retaliation, which I'd been learning the bass to (Dunbar had been the drummer in John Mayall & the Bluesbreakers and the Jeff Beck Group). That became a staple in our set list and would feature on our first album. And over the following weeks, we nailed down the rest of our set list, most of which consisted of old American blues and British blues revival songs, such as "Spoonful" and "Crossroads."

It was a borderline miracle that Tony could play anything, given that he'd lost the tops of two of his fretting fingers while working in a sheet metal factory. To this day, I can't understand how he plays with those plastic and leather thimbles on his fingers, especially as his playing has so much feel to it. How does he manage to play individual strings and know how far to bend notes?

That he does manage says a lot about Tony. When others would have given up, Tony persevered and became one hell of a player. It takes a certain individual, with a lot of patience and grim determination, to overcome odds that overwhelming. But I always think things happen for a reason, and Tony's unique style would lay the foundation for a whole new form of music.

We rehearsed in Burlington Hall on Aston High Street, within walking distance of three of our houses. By this time, Bill and his parents had moved to Perry Common, so he had to make a bit of a schlep. A lot of credit has to go to Tony and Bill for sticking with me in those early days. They were accomplished musicians, while I was still learning to play bass. Personally, I'd have kicked myself

out. But it helped that we enjoyed each other's company beyond the music and had become good friends by that point.

With good companionship comes brutal honesty, and we knew we needed to ditch the name Polka Tulk Blues Band. And it was Bill who came up with the name Earth. There were a few blues venues in and around Birmingham at the time, one of them Henry's Blueshouse, where we'd see the likes of Taste and Duster Bennett. The manager of the club, which was above the Crown pub, was a guy called Jim Simpson. He gave Earth a booking and, to our surprise, we went over well. Meanwhile, I traded my trusty Telecaster for a Fender Precision Bass. Its paint had been removed and stripped to the wood, which wasn't aesthetically pleasing, but what a sound it had! To this day, I regret trading it for a new P Bass, and it's why I've never parted with any basses I've played at gigs since.

Tony then got us some bookings back in Carlisle, the problem being I had to attend the dole office every Friday. Instead, I turned up on Thursday, on my way to Carlisle. I was wearing my girlfriend's mother's motheaten fur coat, lime-green flares and matching boots, which I'd dyed myself. When I told the dole officer I had to go to a funeral up north and needed my money a day early, she looked scandalized. Then she said, "You're going to a funeral dressed like that?" She reluctantly gave me my four quid and told me that if I didn't go for my interviews, there'd be no more dole.

I practically lived in those green flares. But one day, I washed and dried them by the gas fire in our front room and one of the legs burst into flames. God knows what they were made of. I had absolutely no money at the time, so I had to sacrifice my old black flares, which I'd had made in London for the astronomical price of £8. My sister Maura cut one of the legs off, sewed them onto my green flares, so I now had a pair of flares with one black leg and

one green leg. I walked around like that for months, until I could afford a new pair.

The rest of my wardrobe consisted of a satin yellow shirt, a T-shirt, my green dyed boots, that tatty old fur coat and my sister's cast-off green corduroy jacket. I'm not sure how you'd describe my style, except to say it was very green and not very stylish.

STOP THE EARTH, I WANT TO GET OFF

We started to build a following, and after our audition at Henry's Blueshouse, Jim Simpson told us he'd be interested in managing us. Simpson managed Locomotive, who had had a hit single with "Rudi's in Love," which made him the main man in Birmingham. Locomotive, along with Simpson's other bands—the Bakerloo Blues Line and Tea and Symphony—would occasionally play under the billing of Big Bear Follies. Simpson said we could be part of the Follies, but also play our own gigs. That sounded ideal, so we accepted his offer.

However, Earth didn't end up doing many follies. The final straw was when Simpson suggested we end a night with all four bands jamming together in the nude. Ozzy, being Ozzy, accepted, but the rest of us declined. We also resisted Simpson's suggestions that we become a jazz rock band, like Chicago and Blood, Sweat & Tears (I think he was looking for a job, because he used to be a trumpeter). We were a blues band, and no one was going to tell us otherwise.

Another way we got gigs around Birmingham was by hanging around blues clubs with our van full of gear, on the off chance that the advertised band didn't show up. That paid off twice at Le Metro, first when Free went AWOL, then when Jethro Tull failed to appear.

What I remember most about the Jethro Tull no-show was their lead singer Ian Anderson arriving halfway through our set, coming onstage and asking if he could make an announcement. He apologized to the crowd for the band's absence but thanked us for saving the night and doing a great job. *Wow. Ian Anderson, a bona fide rock star, heaping praise on us in public. Surely that couldn't do us any harm.*

When we supported Tull in Stafford a few weeks later the place was packed, as Tull had a massive following by then. We were in good form that night, but halfway through our set, I noticed Ian Anderson making his way through the crowd. He was fixated on Tony, seemingly fascinated by his playing. Tony was on fire that night, but I had this growing feeling of unease, which got worse when I watched Tull's set. There seemed to be some tension between Ian and Mick Abrahams, Tull's guitarist, and I feared the worst when Ian asked to speak to Tony in private after the show.

On our way home from the gig, Tony broke the news to us that Mick Abrahams was on his way out of Tull and that Ian had asked him to go to London and try out as his replacement. I was devastated, but respected Tony's decision. Tull were about to embark on their first American tour, which was what every musician dreamed about, and Tony had been offered twenty quid a week, which was a considerable wage back then. I was genuinely pleased for Tony that he was finally making his dream come true. But his achievement meant I was unmoored once again.

I dreaded telling my dad that the band was no more. His worst fears had come true: I was just a working-class kid, not meant to be successful in the entertainment business. Dad thought hard graft for pittance was my destiny—albeit a safe and secure one—and dreams were what you had when you went to sleep. Maybe he was right?

LOST AND FOUND

That band had been my life, not least because I'd had to stop watching my beloved Aston Villa. At some point in the late sixties, our skinhead fans started beating up anyone with long hair, even if you had a claret-and-blue scarf around your neck. I'd be standing in the Holte End and hear someone say, "Hello, dear," before getting a clump around the head. I went about five years without seeing a game in person.

While Tony was on his way to becoming one of rock music's great guitarists, I was thinking, *How the hell can we pick ourselves up and start all over again?* Great guitarists didn't grow on trees in Aston, or anywhere else for that matter. I got another bout of depression, kept saying to myself, "What am I going to do if this doesn't work out?" I didn't make any specific plans, but if things didn't get back on track, music-wise, I couldn't see the point of living.

I asked Tony if he wanted some company on the journey to London, and he happily said yes. I also thought I could see if there were any bands looking for a bass player down there. The roadie for Ten Years After, a thoroughly good bloke called John, put us up in his flat, and the morning after arriving in the capital, we showed up at Tull's rehearsal studio at nine on the dot. Ian Anderson ran a tight ship, and Tony knew that lateness was not tolerated.

All the members of Tull were dressed identically, which I found hilarious. I mean, it was only a rehearsal, why did they need to be in uniform? But Tony didn't see the funny side. Like Ian, he was serious about his music and thought being in uniform kept the band disciplined. While Tony was setting up his gear, Tull's bass player Glenn Cornick let me have a go on his Fender P Bass. While I was dabbling away, Ian said to Glenn, "He sounds good." That

was just to keep Glenn on his toes, because I was nowhere near as good as him.

While they rehearsed, I took a lonely walk around the streets of London. I made my way to Carnaby Street and the King's Road, to see what was happening in the world of fashion (not flares with one green and one black leg, as it turned out), but it's not as if I could afford anything. It was a miserable afternoon, mostly spent contemplating life after Tony. Or not.

However, after a few days rehearsing, Tony didn't seem very happy, mainly because he didn't like being told what to play. I couldn't believe my ears. Earth had been earning about ten quid a gig, and Jim would usually get his hands on the money first. By the time we'd paid for petrol and Jim had taken his share, we were left with about two shillings each. In contrast, Tony was being offered twenty quid a week and an American tour—so why was he bothered about being told what to play? But I was secretly delighted. Maybe Earth weren't dead after all? *Thank you, whoever you are!*

At the end of the week, Tony told Ian that he wouldn't be joining Tull. I told him he was mad, but he was adamant. That was Tony, always his own man. When Tony told his mom, she went nuts: "You what? Join that band, you silly bleeder!" She thought he was throwing away his chance at stardom. Tony did have a change of heart and asked Ian for another chance, but Ian already had someone else in mind. So after one appearance with Tull a week or so later, in The Rolling Stones Rock and Roll Circus, he came back to Earth.

Tony turning Tull down was the turning point for Earth. As a result, me, Ozzy and Bill felt like we owed it to him to pull ourselves together and give it our all. And those Tull rehearsals were like a blueprint, showing us what was required to make it big. You had to graft and take things seriously, not turn up whenever you

wanted and piss about for a few hours, playing the same old blues and hard rock songs we knew backwards. In other words, we had to treat it like a nine-to-five job, albeit a job we enjoyed. And we had to start writing our own songs. Covers would no longer do.

WELCOME TO LONDON!

With Tony back on board, we hit the road again. And gigs could be a rough and tumble affair back in the sixties. In December 1968, we returned to Cumbria. And at Wigton Market Hall, the crowd was full of Christmas spirit. Literally.

Before we'd even hit the stage, there was a massive brawl. It still hadn't stopped by the time we'd nervously crept on. Bottles were thrown our way and we had to call a halt to proceedings, while the promoter asked for calm. But after we went back on, two gangs of pissed-up women started tearing each other apart, and before long, their boyfriends joined in. When the police arrived, the whole place stopped fighting and began singing "All You Need Is Love." It's one of the funniest things I've ever witnessed.

Another night, we played just over the Scottish border in Langholm. Towards the end of our set, some of the locals started chanting, "Play Elvis! Play Elvis!" So we reached into our repertoire and served them up "Blue Suede Shoes." The gig was scheduled to end at ten-thirty, but we finished at 10:29. You wouldn't think ending a minute early was much of a crime, but the place went ballistic. As we were taking down our gear, pennies rained down on us. Some disgruntled punters even tried to rush the stage and give us a kicking. Fortunately, some slightly more sober locals formed a defensive ring around us while the hooligans drifted from the building. Afterwards, we went to the promoter's chip shop for the fish supper he'd promised us (*just chips for me, thank you very much*). The poor

bloke had a roughly bandaged broken arm, two black eyes and was covered in cuts and bruises. All because we'd finished one minute early!

After a gig supporting Ten Years After, who were one of our favourite bands at the time (their bass player Leo Lyons was a big influence on me), their lead singer and guitarist Alvin Lee told us he could get us a gig at the Marquee Club in London. The Marquee was probably the most famous and prestigious club in the UK, having played host to the Stones, the Who, Led Zeppelin, the Jimi Hendrix Experience, Pink Floyd and many more legendary outfits. And Alvin was true to his word, landing us a support gig.

The Marquee's manager was a guy called John Gee, who was a great admirer of Ten Years After and very particular about which bands played in his beloved club. When we turned up, he was disgusted at the state of us, particularly Ozzy, who was wearing an old pajama jacket and a tap (or what you Americans call a faucet) attached to a piece of string around his neck. To make matters worse, there was a big band recording playing at the time. Trying to get on the good side of John, Bill said, "Oh, I love Gene Krupa." John growled back, "It's Woody Herman . . ."

The headline act was Colosseum, a well-established jazz-blues outfit. Their drummer, Jon Hiseman, had replaced Ginger Baker in the Graham Bond Organisation, after Baker had joined Cream, and been in the Bluesbreakers. In other words, he was at the top of his game. Meanwhile, Bill couldn't afford to buy sticks. The few he had were snapped and splintered and left his hands shredded after a gig. His drum stool had also seen better days. During the sound check, the stool finally gave way and the metal stand went right up his arse. After dusting himself down, he asked Colosseum's roadie if he could borrow one of Hiseman's spare stools. "No chance," came the reply. Bill had to play our most important gig yet with

broken sticks and perched on a patched-up stool. Welcome to London! (Incidentally, because bass strings were so expensive, I used to take mine off after three or four months and boil them in water to prolong their life—it worked to an extent.)

In early 1969, Jim Simpson got us some European gigs. First stop . . . Copenhagen. Tony had had enough of driving, and none of the rest of us knew how to (we couldn't afford a car, making lessons pointless). So our part-time roadie Geoff Lucas, who had been with me since my Rare Breed days, was the man behind the wheel, as well as the man who helped hump all our gear about.

When we picked Ozzy up, he was carrying a T-shirt on a wire hanger and nothing else, apart from what he was wearing. None of us were from well-off families, but Ozzy was on a different level. Things were very rough and ready in Ozzy's house. For example, when he was arrested for burglary one time, his parents refused to pay his fine and allowed him to go to prison to "teach him a lesson." My sister would see his brothers down the welfare center, poorly dressed. And the first time Ozzy came to my house, he couldn't believe how clean it was, and how nice my parents were to him.

When we got to Copenhagen, Ozzy mysteriously disappeared for two days before turning up at our hotel ("dump" would be a more accurate description of any of our accommodation in those days) wearing a brand-new set of clothes. He never told us where he got them from, but no doubt he'd been out thieving.

After playing our first gig at the Revolution Club, I went to the promoter's office to get our earnings (I was in charge of anything to do with money, since I'd trained to be an accountant and was probably the only member of the band who could be trusted with it), only to find him kissing another bloke. I was frozen in shock. I'd heard about people like this but didn't really believe they

existed. People think the sixties music scene was all about free love and letting it all hang out, but homosexuality was still a very taboo subject. You've got to remember that it had only been legalized in the UK in 1967, so that was a very awkward situation for a kid from Aston.

THE END OF INNOCENCE

It was in 1969 that we wrote our first song, "Wicked World," at The Railway pub in Nechells, Birmingham. We only had that one chance because the landlord said we were too loud and didn't invite us back. The song had a nice swinging hi-hat intro courtesy of Bill, who loved his jazz, and Ozzy set the tone of the band with his lyrics, which were about the darker side of life: "The world today is such a wicked place /Fighting going on between the human race/ People go to work just to earn their bread/While people just across the sea are counting their dead." Flower power it wasn't.

By 1969, reality had dawned, and all that hippy stuff was far behind me. At first, I'd loved it. It was a massive escape for a kid living in Aston. And it did change my attitude towards violence. I'd been quite rough before then, but now I'd learned to respect people a bit more. However, a lot of our early lyrics were about how the movement had all been a pipe dream. The world seemed to be in an even worse state than before the hippies turned up, preaching peace and love.

The Vietnam War was still raging, and there was a lot of talk in the media about National Service being reintroduced in the UK, because Australia and New Zealand had already been dragged into the conflict. I'd hear bands on the radio, singing about falling in love and breaking up, and there we were, without two pennies to rub together, rehearsing in this horrible little pub in Nechells,

which was about to be demolished. Things were bleak, they really were. Yet nobody was singing about that side of life, which is why we thought we should.

One of the most famous music venues in the world in the 1960s was the Star-Club in Hamburg. It was at the Star-Club that the Beatles honed their craft, and it was the ambition of every up-and-coming band or singer to play there. And to give Jim Simpson his due, he managed to get us a residency.

But before we got to Hamburg, we had to play an indoor "festival" in Belgium, with the Bakerloo Blues Line and the Gods, a band which featured, among others, Ken Hensley and Lee Kerslake (both later of Uriah Heep) and Greg Lake (later of King Crimson and Emerson, Lake & Palmer). On the way to our "hotel," our van got stuck on some train lines. Luckily, Bakerloo were there to help us shove it out of the way of any oncoming trains. When we arrived at our digs—a tiny inn owned by a woman wearing a catsuit, who wasn't too pleased to see us—we discovered there were only two bedrooms. So it was all of Earth in one bedroom and all of Bakerloo in the other. God knows where the Gods were staying.

The gig was held in a massive warehouse and only a few people turned up. It was so cold that Ozzy decided to set fire to some wooden benches he'd found backstage, before everyone else started chucking empty seats on top. Soon, the fire was out of control and we were all standing around pissing on it—every member of Earth, Bakerloo and the Gods, like some weird rock fire brigade. Alas, that only made the smoke toxic. By the time the real fire brigade turned up, we'd made our escapes and left the place blazing. How we managed not to get arrested by the local constabulary, I do not know. The place was so remote, maybe there wasn't one?

The following day, we played at a youth club in the same town, the locals seemingly having forgotten about the warehouse inci-

dent. The place had an open bar, and there were all these thirteen- and fourteen-year-old kids openly boozing. After the gig, we all got stuck into the drink as well. Tony drank over thirty glasses of whisky and became the most drunk I'd ever seen a man. When we were leaving, he thought the streetlamp was the sun and couldn't believe it was daylight. Then he proceeded to stick his willy in the petrol tank of the van. When we finally got him inside, he puked all over my lovely freshly dyed green boots.

Our lodgings in Hamburg were bang in the middle of the red-light district, above a strip club/brothel on the notorious Reeperbahn. They'd recently had a fire, and it still stank of burnt wood and smoke. We were crammed into two rooms, around a big hole in the floor, and every time we went to the lavatory, the landlady would yell at us for disturbing her.

The Star-Club had seen better days as well. We were the resident band on weekdays, playing five forty-five-minute spots to a few sailors and tourists, and seven forty-five-minute spots on weekends. On Friday and Saturday, a "headline" act would be scheduled to play after our set. The 1910 Fruitgum Company were one of the "headline" bands, and they were the epitome of American bubblegum pop (their biggest hit was "Simon Says"). I was fascinated by their appearance: They'd arrive looking like office workers in suits and ties before changing into their glitzy stage outfits. When they were done, they'd change back into their sensible suits and off they'd trot without saying a word to any of us.

On our first day, we set up our gear and went to a Chinese restaurant over the road. When I asked for a plate of plain white rice, with no meat or fish, the waiter said to me, "Ah, a vegetarian." That was the first time I'd heard that term, and it came in very handy all over the world. Luckily, there was also a pommes frites shop next to the Star-Club, so I didn't have to eat just rice for weeks.

They say that travel broadens the mind, and our minds almost exploded on those early European jaunts. Next to the Star-Club was a transvestite bar, visited mainly by sailors on leave. And there were always random girls hanging around. One day, this girl invited Tony back to her house. For some reason, she was known as "the Freeze." Because I could speak a bit of German, I went with them, to give Tony a bit of support. While they were getting to know each other, I decided to have a snoop. In one of the wardrobes, I found a full SS uniform, with a picture of this girl's father wearing it. I didn't go back there, and neither did Tony.

A local gangster who looked like Jerry Lewis would visit us at the club occasionally, supplying us with hash, on which we'd get constantly stoned. One night, he invited us to his club and there were people fixing smack in there. The police raided the place and arrested everyone except us, because we showed them our passports and said we were guests of the club owner. The following day, "Jerry" stormed into our dressing room, pulled out a revolver and put a bullet in the wall. I've no idea why he was so angry with us—we hadn't snitched on him.

We did so many sets, often to so few people, that boredom became an issue. Especially for Ozzy. One night, he painted his nose purple and commandeered a ladder from somewhere. The stage curtain would be closed before we'd start, so when Ozzy climbed the ladder and poked his face through it, he looked like a fifteen-foot giant. That same show, Tony was meant to play the flute on a number called "A Song for Jim," which was destined to be an unreleased demo. He was so stoned that the flute was nowhere near his lips; all anyone could hear was him blowing into the microphone.

Eventually, we were playing seven forty-five-minutes sets every day. That's when Ozzy really started to blossom as a front man. Before Hamburg, he'd usually stand over to one side of the stage, with Tony in the middle, because he was petrified. He didn't know

how to move or interact with the audience, and Tony kept going on at him to do more than just stand there. He'd say, "Imagine you're organizing a raffle," and Ozzy would mumble something like, "Well, I hope you appreciate us . . ." It took him ages before he developed a rapport with the audience. It was really only when the songs started getting more of a response that Ozzy threw off his inhibitions and dived headfirst into it.

In fact, we all blossomed in Hamburg. Because we only had about an hour's worth of songs, that meant a lot of jamming. It was in Hamburg that the seeds of many future songs were planted. One of those songs was "N.I.B.," which ended up on Sabbath's first album. We'd play around with that one song for a whole forty-five minutes, constantly refining it, depending on the audience's reaction. And experimenting is easier when the audience consists of only three or four people.

THE DEVIL IN MUSIC

Upon returning to England, we got down to rehearsing at Aston Community Centre (the council let us use it for free in the mornings) and immediately started looking for record company interest. Jim Simpson thought we sounded too dark and heavy (of course we sounded dark and heavy, that was our lives), so suggested we demo a couple of songs written by Norman Haines, the keyboardist and songwriter for Locomotive (who were virtually a reggae band). We recorded Haines's "The Rebel" and "When I Came Down," as well as "A Song for Jim" (with Tony actually blowing into the flute this time), but we hated doing those songs, because they were quite poppy and didn't represent what we were about.

A breakthrough came in May 1969, when I saw King Crimson at Mothers club. As part of their set, they played a version of "Mars," from Gustav Holst's Planets suite. I was dumbfounded,

couldn't believe what I was hearing. The following day, I went out and bought *The Planets* on LP, and I couldn't get enough of "Mars," the Bringer of War. I'd never had much of an interest in classical music, but this was angrier and more menacing than most rock music I'd ever heard.

At our next rehearsal, I was playing the main part, the so-called tritone, on bass, when Tony started playing a tritone riff (in medieval times, the tritone, because of its sinister, foreboding sound, was known as *diabolus in musica*, or "the devil in music"). That song would eventually become "Black Sabbath." (My brother had seen the Mario Bava film of the same name, starring Boris Karloff, at the local cinema. I was too young to see it, because it was a horror film, but he relished telling me all about it, and I loved the title.) I've seen it written that Holst invented heavy metal. That might be stretching things a bit, but you could argue he inspired heavy metal's first riff. And since we wrote that song, the tritone sound has become synonymous with metal.

It took us a couple of hours to write "Black Sabbath" from start to finish. Tony played the riff and we joined in, with Ozzy spontaneously singing the lyrics. We were so proud of ourselves when we were done. That evening, we had a gig at the Pokey Hole in Lichfield. The crowd was expecting the normal twelve-bar blues, plus maybe "Wicked World" and "Warning," the Aynsley Dunbar Retaliation cover. But when we got to the end of the show, someone said, "Let's do that song we wrote this morning, if we can remember it." We launched into "Black Sabbath" and watched as everyone stopped what they were doing and stared. I'd half expected it to go down like a bucket of cold sick and was fearful for two or three seconds. But when the crowd went nuts, their eyes bulging in amazement, we knew we were onto something.

PREMONITION

STRANGE OCCURRENCES

My childhood had been full of premonitions and ghostly sightings, beyond the hovering sphere, so it's probably no surprise I'd develop an interest in the occult. One of those premonitions occurred when my dad took me "up town" to Birmingham, to watch cartoons at the News Theatre. After leaving, a bus was waiting at the bus stop, but when Dad told me to hurry up and get on, I refused. Dad got really angry, but I dug my heels in and the bus left without us. About fifteen minutes later, the next bus arrived, which we boarded. On our way home, the police stopped our bus and told us there was an accident ahead. Sure enough, the bus I'd refused to get on had tipped over crossing a bridge on its way into Aston, causing multiple injuries.

There was also the time I went on a day trip with Mom and Dad and landed my first "date." This girl, who was also with her parents, sat next to me on the coach and we got on great. On the way back, she gave me her address and we decided to meet up in Handsworth Park the following Sunday. I was only twelve or

thirteen and had no idea what to do, so we just sat there for an hour or so holding hands. I don't even think we parted with a kiss. A few days later, I dreamed that she sent me a letter, saying she didn't want to see me again. It was a nice letter, but hard to take. As I awoke, my brother was knocking on my bedroom door, saying, "Letter for Romeo!" When I opened it, the letter was exactly as I'd dreamed it, down to the last word.

There were other strange occurrences in the house. I always felt a cold spot, halfway down the stairs, and felt uneasy passing through it. Then one day, I saw the outline of a man wearing a flat cap through the frosted glass of the door. This door led on to a vestibule and then to the front door, so I thought this man must have been inside. But when I shouted to my dad, who came running out of the living room, we found nobody there.

Then there was the time I was kicking my football up the stairs, so that it bounced back off my bedroom door and rolled back down to me. I'd been doing that for a few minutes when the ball disappeared. I started up the stairs to see where it had gone, when suddenly the ball shot back at me, as if someone had forcibly thrown it. That was the end of indoor football practice.

Granny's house in Dublin was the first place I saw a ghost. One day, my parents went out visiting relatives and left me and my sister in the basement bedroom. When we heard a noise, we thought it was our parents returning, so we both rushed out. But to our horror, floating down the stairs was a diaphanous apparition. We both froze for a few seconds, unable to speak, before turning on our heels, rushing back into the bedroom and slamming the door behind us. My brother Peter was so convinced that house was haunted he slept with a knife under his pillow. A lot of good that would have done him!

A lot of the local news throughout my childhood was strange

and macabre. There were the Cannock Chase murders, which investigators never got to the bottom of. In 1965, a little girl from Aston called Margaret Reynolds who I used to see passing our house on her way from school went missing. The whole community came out to look for her, to no avail. A few months later, her body was found in a ditch in Cannock Chase, Staffordshire, alongside another little girl from nearby Bloxwich. The following year, another girl was found less than a mile away. The manhunt was one of the biggest in British history, and the police eventually arrested a Walsall man called Raymond Morris. He was found guilty of killing one of the girls, but the families of the other two never did get justice.

There was also the story of Cynthia Appleton, who lived on Fentham Road, around the corner from us. She reckoned she'd been visited by an alien from Venus. According to Cynthia, they communicated by telepathy. This alien obviously had a lot of time on his hands, because they discussed space travel, the politics of the future and sea energy. Apparently, he also showed her holograms, which were unheard-of back then and taught her to speak Vesuvian. Oh, and he got Cynthia pregnant. A week later, she gave birth to a baby boy. Cynthia's old man Ron, a welder, said he believed her. I suppose he thought it was less humiliating than the milkman.

Having been brought up a strict Irish Catholic, I wasn't supposed to believe in ghosts, and I certainly wasn't supposed to be interested in the occult. But I'd been hearing about Satan for years—the nuns and priests didn't stop going on about him!—and grew up believing that angels and banshees really existed. Plus, like most teenagers, I just wanted to rebel against my parents and their world.

There was an explosion of interest in Eastern mysticism and the

occult in the late sixties, and I became heavily involved. I found anything different mysterious and intriguing, even the Muslims, Sikhs and Hindus who had moved into the neighborhood. I read about all sorts of paranormal stuff, like astral planes, which some religions and philosophies believe are populated by angels and spirits passing on to another place. I thought that might have something to do with the sphere I'd seen.

The famous English occultist Aleister Crowley was too preachy for my taste—I'd had enough of being preached to—and I much preferred the fiction of Dennis Wheatley. I also read the magazine *Man, Myth and Magic*, as well as *The Hobbit* and *Lord of the Rings*, and certain underground occult papers and magazines that were sold near gigs. The Stones had an album called *Their Satanic Majesties Request* and a song "Sympathy for the Devil." Meanwhile, Arthur Brown was singing "I am the god of hell fire!" That sort of stuff appealed to me, though it goes without saying that none of this tallied with my parents' beliefs.

When the arguments between us became unbearable, I decided to leave home and rent a flat with my girlfriend Georgina (I had to tell Mom I was moving in with Tony, because me "living in sin" would have been *the end of the world*). But just before I left, I dreamed a whole set of lyrics and a bass riff. When I awoke, I scribbled it all down, and this became Earth's third song, "Behind the Wall of Sleep." The title was inspired by H. P. Lovecraft's short story "Beyond the Wall of Sleep," but since it had come to me in a dream, I decided it needed a slight revision.

EARTH TO SABBATH

As 1969 wore on, our following continued to grow, especially in the Midlands, northern England and southern Scotland. We also

returned to the Star-Club and a few other places in Europe. Our original songs were going down a bomb, especially "Black Sabbath." Whenever we played it, the audience was awestruck. But when we turned up to a gig in Derby, we noticed the audience was very different to normal.

The punters were all dressed up in smart clothes, like they were expecting a crooner. And after about three songs, the promoter butted in and asked us to play our "usual" songs. We didn't have a clue what he meant and continued with our set. After another couple of songs, the promoter waved his arms and told us to stop again. "Why aren't you playing stuff like your single?" he said. "What single?" we replied. It turned out there was another band called Earth, who had a very poppy single out at the time. So we were booted off and made a quick exit.

Getting mixed up with a pop outfit wouldn't do, so we needed to change our name pronto. I suggested calling the band Black Sabbath, as that song was really getting through to people and perfectly summed up what the band were about, the fact that we wanted to be heavier than anyone else. Alvin Lee, who was a sort of mentor, thought Black Sabbath was too gloomy and suggested Papa Sun instead. None of us liked that, so Black Sabbath it was. And on August 30, 1969, we played as Black Sabbath for the first time, in Workington, Cumbria.

Those demos we'd recorded hadn't exactly set the world alight, probably because they sounded like almost everybody else. And as Black Sabbath, we wanted to reflect the dark side of life—war, poverty, famine and pollution—the stuff everyone else was avoiding because it wasn't deemed commercial.

I was also still getting bouts of depression, which didn't lend themselves to writing about the fluffier things in life. Back then, people didn't talk about mental health. If you felt down, you just

got on with it. It's certainly not something I could have discussed with my bandmates, or anyone else for that matter. People just thought I was naturally moody, end of story. For a long time, I just thought it was a normal part of growing up, that everyone must have felt the same. People who have never had depression can't possibly understand what it's like. There's this almost total darkness, so that you can't see any light at the end of the tunnel. You also worry that that's how you're always going to feel, which makes you feel even more desolate. More than once, I questioned the point of living.

I stopped self-harming after I cut myself so badly I wouldn't stop bleeding. But when I went to the doctor to ask his opinion, he simply said, "Just go down the pub and have a couple of pints, or maybe take the dog for a walk. You'll be alright after that." That was a common solution back then—not pills or therapy—but I knew a couple of pints weren't going to make me better.

Writing was my godsend, my treatment, my way of digging myself out of a depressive hole. That's not an outlet a lot of working-class kids had. But because I'd been exposed to books from an early age, this method came naturally. I'd write lots of poems to expel negative feelings. Though I didn't show them to anybody—they contained the kind of stuff you'd hesitate to tell even a psychiatrist—they became the seeds for the lyrics that would come to define my career.

Because I'd been to grammar school and college, my bandmates viewed me as the brainy one and let me crack on with writing lyrics. Their attitude was, "If Geezer thinks it sounds right, it must be." I think they were just glad that someone could string a few words together.

By the end of 1969, we started doing auditions for record companies. After one gig in Carlisle, we drove all the way to London through the night (a trip of three hundred miles) before arriving at

about 11 A.M. and setting up in a pub, absolutely exhausted. The plan was to play all the songs that would appear on our debut LP. But halfway through our set, this record company bloke shouted, "Stop! Stop! You're wasting my time! Come back when you can write proper songs and play your instruments!" With that, he turned on his heels and stormed out. Unfortunately, most people we auditioned for had that same reaction.

People kept telling us to hook up with the producer Gus Dudgeon, who'd just worked with Elton John and David Bowie. But he listened to us and said, "I'm not producing that rubbish." One bloke who did get us was John Peel, who already had a reputation for championing underdog and left-field bands. We found out he was deejaying at a gig in Walsall, so we called the promoter and told him we'd play for free, just so John Peel could hear us. After our set, John came into the dressing room and said, "I'll get you on my radio show one of these days." *Yeah, he's just saying that*, we thought. But he was true to his word.

A few weeks later, we appeared on his Radio 1 show *Top Gear*, performing "Black Sabbath," "N.I.B," "Behind the Wall of Sleep" and "Sleeping Village" (or "Devil's Island" as it was called then). I hadn't written all the lyrics to some of the songs, so Ozzy just made them up on the spot. But hearing ourselves on national radio for the first time, and knowing we were being listened to by possibly millions, was the encouragement we needed. It came at just the right time, too.

INVENTING METAL

Not long after our debut radio appearance, a freelance A & R guy called Tony Hall came to Jim Simpson with a proposition: He'd lend him the money for Sabbath to record an album and help us

find a record deal. Tony then persuaded Fontana, a subsidiary of Philips Records, to advance us £1,000 and put out a single. We each took £125 for clothes, food and payments for our instruments, and when another band dropped out, Fontana booked Regent Sound studios in London's Soho, where the Rolling Stones, the Kinks, the Who, Jimi Hendrix and others had recorded.

The producer Rodger Bain, who worked for Fontana, was young and inexperienced. And because we'd never been in a recording studio and didn't know what we were supposed to do, we treated it like a gig. We only had two eight-hour sessions anyway, so it's not like he could have made too many suggestions (backing tracks and most of the vocals were recorded on day one, overdubs and remaining vocals on day two). I remember Ozzy wanting to redo his vocals at the end of "Warning," but we didn't have enough time.

Playing the album live worked out best for us, because it captured our rawness. When bands record nowadays, they sometimes don't achieve their essence because everything is so polished. That's why it's so easy to spot songs from the 1970s and '80s, because production values are of their time. The reason our first few albums haven't dated is because they're naïve (in the best way) and down to earth. Apart from the rainstorm and church bells right at the start, the most experimental thing about that album was the wah pedal I used on my solo at the start of "N.I.B.," not realizing then that I was probably the first bass player to do so.

The funny thing is, Sabbath fans think that's how those songs have to be played, every time we play them. Even now, I'll play the bass part slightly differently and people will say, "Oi! Behave! That's not how you played it on the record!" And I'll be thinking, *It was fifty years ago! And we only had a couple of days to record the bloody thing. How am I supposed to play it exactly the same, especially as I*

barely knew what I was doing back then? But that also speaks to the loyalty and attentiveness of our fans, for better or for worse.

HARD TIMES

Once we'd finished recording, we all piled into the van and set off for a miserable six-week tour of Switzerland and Germany. We didn't have the slightest inkling we'd just invented a whole new genre of rock music and would one day be hailed "the Godfathers of Metal." In fact, we didn't think much about the album while we were over there, because we were just trying to survive.

Just as we crossed the Belgian border, the snow started coming down heavily and the van soon got stuck. The heater had long since packed up, so we were all half frozen. Ozzy volunteered to walk to the nearest settlement for help and promptly disappeared into a ditch. All we could see was his hat, perched on top of the snow. Eventually, we were towed to a village and put up in a bed-and-breakfast. There were five of us squeezed into one room. None of us had ever seen a bidet before, but we decided it must be for washing underpants and socks.

By the time we arrived in Switzerland, our van had a fresh gash from where it had slid across some ice and collided with a truck. First up was a ten-day assignment at a youth club in St. Gallen. We stayed above a café, all five of us in one room again. The café had a jukebox, and every morning we were awoken by the song "Venus" by the Dutch band Shocking Blue, which was a worldwide hit. That song must have been played a hundred times a day and was like aural torture.

We had no money between us, not even enough to call our manager for help. As a result, I almost starved. The venues would only give us a glass of milk and a sausage, the problem being I

didn't drink milk and certainly didn't eat meat. After surviving on water for a week, I finally cracked (the British Army should use a combination of food deprivation and Shocking Blue's "Venus" as an interrogation technique). But having drunk a glass of milk and eaten a sausage, I puked violently. That was my body rejecting foreign substances, combined with the thought of eating rotting flesh. Mercifully, Bill eventually "found" a bunch of bananas. I ate the bananas and Bill baked and smoked the skin, which was one of his little eccentricities.

After one gig in St. Gallen, a girl invited me back to her house for a few refreshments. And when I returned to the café, a couple of minutes after ten o'clock, I discovered it was locked. It was a freezing cold night and I thought I might die of hypothermia if I didn't get inside. I knew Bill was in the room, so I started chucking snowballs and stones at the window. Eventually, Bill was stirred from his slumber, but when he tried the café door, it was locked from the inside, too, probably to prevent us from ransacking the pantry after the café closed.

In desperation, Bill tied some bedclothes together, prison style, so I could climb up the outside of the building and enter through the window. I was about halfway up when two policemen appeared and started yelling at me in Swiss German. When I told them I was locked out and just trying to get in from the cold, they shook their heads and lamented, "Oh, English," before trudging off. I made it all the way up, in case you were wondering. So once again, Bill had saved the day.

From St. Gallen, we drove through the snow and ice to Zurich, where we had a two-week residency at the Hirschen Hotel. Our accommodation consisted of two tiny rooms above the bar, and on the walls were tally marks denoting days, like you'd find in a prison cell. The beds were so small, not much wider than fish fingers, and

my arms would hang over the sides. Even worse, I awoke in the middle of the night to find a huge rat sniffing at my fingers.

The hotel manager carried a leather bag with him at all times and demanded to be addressed as "the Doctor." He was a miserable old bastard. Although the hotel had a big room that could have accommodated about two hundred people, the Doctor insisted we set up on a small stage directly opposite the bar. We were worried we'd deafen people, but we needn't have worried, because hardly anybody came in. The Doctor ordered us to play seven forty-five-minute spots a day, finishing just before 10 P.M. So we decided to make the most of it, playing the songs we already had, then jamming and coming up with new songs to fill the gaps.

The first night, a nutter came into the bar while we were playing, stood in front of us and did a handstand for the entirety of one of our songs. When the song stopped, he stood up, picked up all the coins that had fallen out of his pockets and left. On night two, a second nutter wandered in while clapping, stopping only when we finished the first song. When we started the next song, he started clapping again. When we stopped, so did he. This went on for the whole set. And when we finished, he headed for the exit. Without clapping.

On night three, a third nutter came in playing a flute, which he continued to play all through our set. As soon as we finished, he was off, without buying a single drink. Just like the other two. Our only proper fans for two weeks were a couple of hookers who'd come in to shelter from the cold. Things got so bad that Ozzy had to barter one of his microphones for a big lump of hash, provided by a Scottish dealer who appeared one night as if by magic. At least we could get stoned and try to forget about the nightmare we found ourselves in.

We received a cheque from our manager before we arrived in

Germany, so at least we could eat. On the downside, we had to push the van halfway across Switzerland. After our first German gig, on an American army base, the promoter invited us to his club, which was in the middle of a park. It was quite late and there were only a few people milling around. So we decided to get extremely drunk and all hell broke loose. Tony beat up the DJ and took over his spot, while Ozzy got very friendly with a girl and started taking off his clothes, before puking all over her. After Tony and Ozzy stole a couple of handbags, the owner threatened to call the police and we left.

The following morning, we all had the hangover to end all hangovers, made even worse when two girls turned up at the hotel demanding their handbags back. We escaped to the army base, where we got talking to soldiers on their way back from Vietnam. They told me about some of the terrible things they'd done and seen, tales of being ambushed in the jungle and killing villagers. I'd never heard anything like that because the soldiers' stories weren't being told in the media, at least not in the UK. Many of them had turned to heroin to get through it—they couldn't exactly lug bottles of booze around with them in the jungle—and these bases in Germany were where they tried to get straight before returning to their families. Those chats inspired me to write the lyrics for "War Pigs" and "Hand of Doom," which would both appear on our second album.

FAME AT LAST!

Our one-single deal with Fontana meant having to record a cover of "Evil Woman," by an American band called Crow. We weren't fans of "Evil Woman," and really didn't want to do it, but it turned out to be one of the most sensible things we ever did. Another

Philips subsidiary, an even smaller label than Fontana called Vertigo, heard "Evil Woman," liked it and agreed to release our album. When we got home to Birmingham, we went straight to Henry's Blueshouse and as we walked in, our version of "Evil Woman" was playing on the sound system. We didn't even know it was out and that was the first time we'd heard it.

A week before the album *Black Sabbath* was released, Jim Simpson showed us the artwork for the first time. I loved the cover, which consisted of a witchlike figure standing in front of Mapledurham Watermill, but wasn't too sure about the gatefold sleeve. I asked Simpson, "Why is there an inverted cross on the inside? That's really blasphemous." I may have lost my faith, but I didn't want to deliberately offend anyone, especially my mom and dad. Simpson replied, "Don't worry about that, it's going to help sell the album." The following week, on Friday the thirteenth (naturally!), Black Sabbath hit the record shops.

At a meeting at Simpson's house, he said he'd been contacted by Alex Sanders, the so-called "King of the Witches," warning that the members of Black Sabbath were about to be hexed by a group of Satanists, and that we should protect ourselves by wearing crosses. I had always worn a cross since childhood, but Ozzy had his dad fashion us crosses from aluminum, which we all wore, and never stopped wearing for as long as Sabbath existed.

I listened to the album for the first time in my childhood bedroom, on Peter's windup gramophone. I obviously couldn't play it in the living room, where Dad was watching the TV. As it was, somebody showed him the sleeve and he went absolutely nuts: "Why the hell did you put that on the inside?" I replied, "We didn't do it, the record company did!"

The name Black Sabbath, combined with that album cover, meant we were misunderstood from the start. If we'd been called

Papa Sun and that first album cover had just been the four of us standing there, like most album covers, everything probably would have turned out different. As it was, a lot of people made the mistake of thinking all those early songs were about the occult and Satanism. Some people still do, but that wasn't the case at all.

If they'd bothered listening to the album, they would have known that the song "Black Sabbath" was written as a warning not to dabble in all that kind of stuff. Because "Behind the Wall of Sleep" sounds like "Beyond the Wall of Sleep," and H. P. Lovecraft wrote horror fiction, people thought it was a horror song. But it's actually just about sleep! "The Wizard" is based on Gandalf in *The Lord of the Rings*, because I was into Tolkien at the time.

The funniest misinterpretation is of "N.I.B.," which people soon decided stood for "Nativity in Black." It's actually a love song. But I couldn't just do a normal one, I had to put a twist on it, so I made it about the devil falling in love. The reason it's called "N.I.B." is because Bill's beard looked like a pen nib, which is what we used to call him. But because "Nib" would have been a pretty bad song title, I capitalized it and stuck some punctuation in there, to make it more intriguing.

The whole image and reputation of heavy metal is based on a misunderstanding. And it wasn't just the music press and the public who got it all mixed up, it was also a lot of the heavy metal bands that came after us. They were all banging on about the devil and 666, which is how the world ended up with death metal, black metal, doom metal and all these other dark subgenres. I suppose that sort of stuff appeals to some people, but that wasn't who we were.

"Evil Woman" failed to chart, but John Peel kept playing the album on his Radio 1 show. We were still touring relentlessly, and word of mouth could make a band in those days. I'll never forget

the day we found out that *Black Sabbath* had cracked the charts. We were driving up to a gig in Manchester one Saturday afternoon and the album chart show was on Radio 1. Suddenly, the DJ uttered the magic words: "And in at twenty-eight, *Black Sabbath* by Black Sabbath!" We stared in shock, before breaking into cheers and jumping all over each other, like we'd just won the FA Cup final.

SAVAGED

Most people in the music business were as surprised as we were. Six or seven record labels had turned us down, mainly because we were, shall we say, different. They just didn't know what to make of us. For a start, they didn't think we were playing our instruments properly. To be fair, they weren't wrong.

Tony had to make up his own chords, because he was wearing those great big thimbles. Meanwhile, I, too, was making it up as I went along. I just played the bass like I thought it should be played, and to fit in with Tony's idiosyncrasies, rather than trying to copy anyone else. I usually played the same riff that Tony was doing, as well as filling in between his riffs and his solos, making up for the absence of a rhythm guitar. That gave us a heavy, uninterrupted wall of sound. If Tony hadn't lost the tips of those fingers, and I'd learned to play bass at college, we probably would have sounded much more conventional, and nowhere near as heavy.

The record companies also didn't think we were commercial enough. John Peel was the only DJ in the UK playing non-pop music on national radio, and that was only once a week. But the labels didn't realise the size of the following we'd built in the Midlands and up north, probably because all these record-heads were based in London, which they thought was the only place in Britain worth knowing.

As for the critics, they absolutely savaged that first album, which is why we thought it would sink without a trace and were surprised by its success. *Rolling Stone* called us "unskilled labourers"— and like Cream, "only worse." *The Village Voice* called the album "bullshit necromancy" and "the worst of the counterculture on a plastic platter." *Charming.*

The London music press was no kinder. I think it really pissed them off that we'd built up this big following outside of the capital and made it into the charts without their help. They'd been blindsided, shown up as severely out of touch, which is why they hated us and slagged us off. As is often the case with new trends in music, the fans got what the men in suits didn't. It was the fans who realised we'd taken it one step heavier, which made us unique. When you're trying to stand out in a crowded field, there's no point copying everyone else.

We didn't care what the critics thought anyway. The more they laid into us, the more we believed in ourselves. Rejection can crush a band or it can make it more determined and bring its members closer together. And we were closer than brothers back then. In fact, I couldn't have asked for better bandmates. There were no big egos and we were incredibly supportive of each other. If anyone was in trouble or needed something, we'd do what we could to help. That mentality was no different to the community we came from.

SPOOKED

After our first album charted in the UK, people thought we were suddenly millionaires. But the advance we'd received was only £1,000, and half of that went towards recording the album. That left us with £125 each. We had no royalties and no publishing money, which meant we earned nothing from the album when it

was selling in the millions (it stayed on the album chart for nine months).

Meanwhile, Jim Simpson was still sending us out for twenty-quid gigs. My girlfriend was paying the rent on our place, and I'd give her whatever I could, but if we needed anything for the house, I'd have to steal it from a dressing room. After one gig, I nicked the carpet, Ozzy nicked the lightbulbs and Tony nicked a big brass tea urn and sold it as scrap.

The first time I earned three figures was at the Nottingham Boat Club in March 1970. Our total fee was something like £700 and we paid ourselves £100 each. We also found a big lump of hash in the dressing room, which was the cherry on top of the cake. We felt like proper rock stars that night. And while we weren't suddenly rich, we could at least buy ourselves some decent clothes (it was probably around that time I retired my black-and-green flares).

Meanwhile, there was a bidding war going on in America that we didn't know about, until one day Jim Simpson told us we'd been signed by Warner Bros. Records. Warner Bros. had been involved with the Grateful Dead and Van Morrison, which was obviously encouraging. But predictably, the four of us got stiffed in the deal and barely saw a cent.

It was becoming clear that Simpson was out of his depth. And when Black Sabbath charted in the US, the big sharks began circling. Don Arden had managed Gene Vincent, the Small Faces and the Move, among others. He also had a reputation as a bit of a gangster. The *News of the World* newspaper in the UK had done a story about Don and his methods, which included dangling Bee Gees's manager Robert Stigwood from an office window, because Stigwood had tried to poach the Small Faces from him. But when Don sent one of his heavies, a bloke called Wilf Pine, up to Birmingham to see us, we were all ears.

Don promised us the world and was very convincing. He told us Jim Simpson didn't know what he was doing, that he couldn't break us in America, because he didn't know any promoters or agents over there. I remember him saying, "You need proper management. I'm proper management and I want to sign you." With that, he slid a document across his desk and told us to put pen to paper.

I took a quick look at the document and said, "We'll have to read it first." And Don replied, "No, just sign. It's okay." I gave it a quick scan and noticed it said: "The management will be paid _ _ percentage."

"How much percentage?" I asked.

Don replied, "I'll fill that out later."

"You must have a rough idea?"

"About twenty percent."

"Well, can you write that now?"

"No, I'll do it later. Believe me, you won't be thinking about this contract when I've got you to America and you're selling millions of albums over there."

We held our ground, told Don we couldn't sign if we didn't know how much he was planning to take from us. And when we got back to Birmingham, we decided he seemed far too dodgy. Not long after that, Chrysalis, who handled Jethro Tull and Ten Years After, said they were interested in signing us. But when the Chrysalis guys came to see us at the Marquee, Don turned up with all his heavies. The Chrysalis guys didn't stick around for long.

A few months later, Wilf Pine paid us another visit in Birmingham and told us he'd split from Don. "I'm now with another fella called Patrick Meehan," he said. "He's brilliant at what he does and will make you big in America." Meehan's father, also Patrick, had worked for Don. And later, we found out that Wilf and Arnie,

another of Don's heavies, had been hit men for the Kray twins, the notorious East London villains. That explains why Don couldn't really do anything about Wilf and Patrick poaching us from under his nose.

Wilf would tell us stories about nailing rival villains to the floor, literally. We took it with a pinch of salt until we arrived in America for the first time, and discovered that Wilf was the first Englishman to be sworn into the American Mafia (it's all in a book about Wilf, called *One of the Family: The Englishman and the Mafia*).

Things came to a head with Jim Simpson when a scheduled short tour to America was called off at the last minute. Simpson told us Warner Bros. had got spooked and pulled the plug, after realising our shows would coincide with the start of the Charles Manson trial. Manson had been convicted of the murder of actress Sharon Tate, and several others, the previous year. And at his trial, he would talk about how music had influenced his actions. It was being reported that his followers were a satanic cult.

To make matters worse, Simpson informed us that Anton LaVey, the so-called head of the Church of Satan, had organized a Black Sabbath parade in San Francisco, to coincide with our planned gigs at the Fillmore West. Simpson also informed us that Warner Bros. didn't want to be associated with a band called Black Sabbath, who had witches and inverted crosses on their album sleeves and were apparently *obsessed* with the occult. But we found out later that it was Warner Bros. who had organized the Black Sabbath float to promote the band, and it was an Anton LaVey look-alike on the float, rather than Satan himself.

Patrick Meehan told us that Simpson didn't know how to book an American tour and hadn't been able to get us the right visas. I don't know if Patrick made that up to further undermine our trust in Simpson, but it had the desired effect.

BECOMING PARANOID

Meanwhile, we'd recorded our second album, *Paranoid*. A lot of it was written in Switzerland and Germany, where we spent six weeks jamming after recording our first. I can't remember whose idea it was to rehearse the album on a dairy farm in the middle of nowhere in Wales, but it was the perfect setup, because Rockfield was a residential studio where bands could live, rehearse and record.

Rockfield was owned and run by a couple of Welsh brothers called Charles and Kingsley Ward. They'd set it up in the sixties, but it was still a ramshackle working farm. We'd see Charles, Kingsley and his wife, Ann, getting on with business as usual, feeding the pigs and hens and milking the cows. I'd seen cows up close before, on holidays to Ireland, but I don't think any of the others had. Ann also kept the books and had two young daughters. It shouldn't have worked, but it did. They got on with their business and we got on with ours.

The Wards lived in the main house and we stayed in a converted bungalow just off the main track. It was 90 percent pissing around and 10 percent business—if you can call playing music with your mates "business." We'd get up late and do a bit of writing and rehearsing, showing Rodger Bain what we had (what we had was so loud that half the roof fell in—right on top of us), before heading to the pub. And when we got home, we'd smoke a bit of weed and all crash in the same bedroom, which was easier said than done when Ozzy was around.

Ozzy wasn't a big sleeper and would often wake me up at three in the morning, just for a chat. One time in Sweden, the van broke down and we had to push it from one side of the country to the next. By the time we got on the boat to come home, I hadn't slept for three days. So as soon as I lay down in my bunk, I dozed off. The

next thing I remembered was Ozzy shaking me awake and asking for a match. I didn't smoke cigarettes at that time, which he was well aware of, so I could have killed him. Ozzy could be a pain, no doubt about that, but because he didn't take anything seriously, he constantly had me in stitches.

Because I was vegetarian, I did my own meals at Rockfield. *Thank God, because Ozzy was in charge of cooking.* Ozzy's signature dish was curry. One time, we were eating dinner and Bill suddenly pushed his plate away and started retching. Ozzy had taken one of his filthy, sweaty socks off, put it on Bill's plate, covered it in rice and poured curry over the top. Bill could quite easily have been the first person in history to be killed by sock poisoning because Ozzy didn't change his very often.

Bill was a bit more refined than the rest of us, because despite being born in Aston, he'd grown up down the road in Perry Common, which was a bit more upmarket. Tony and Ozzy constantly took the piss out of Bill and he'd just take it, because he was so easy-going. Ozzy would even shoot fireworks through the bedroom window while Bill was sleeping. Bill would wake up to find a Roman candle spinning on the floor, sending sparks flying everywhere and burning holes in his bedclothes. But he never seemed to be bothered. He was the fall guy, that was his role in the band. And it worked.

It was probably during our first stint at Rockfield that we started getting a reputation for wildness. Hawkwind recorded there straight after us, and felt moved to send us a letter telling us how disgusted they were with our behaviour. To be fair, Hawkwind were more hippies at the time, the total opposite to us. And we'd had a flour bomb fight in the studio and wrecked the Ping-Pong table. Who knew Lemmy was a Ping-Pong enthusiast?

The next time we were at Rockfield, Hawkwind were recording

straight after us again, so Ozzy got a big fish from the river and hid it under one of the mattresses. Next time we were there, months later, we noticed the mattress had been thrown out. It had a huge hole in it where maggots had eaten through.

Years later, when Huey Lewis and the News were recording at Rockfield at the same time as us, we challenged them to a game of football. We crippled half of them. While they were recovering, Ozzy sneaked into their studio and pissed all over their tapes (they should think themselves lucky he didn't shit on them). I don't know if they ever found out. Had they accused us, there were a lot of animals to point the finger at, besides Ozzy.

I can't say I found the countryside particularly inspiring from a writing perspective. I didn't transform into William Wordsworth and start penning lyrics about wandering lonely as a cloud and hosts of golden daffodils. A few days in the country wasn't enough to erase the memory of everyday life.

Initially, Ozzy would put a scratch vocal line on top of the music, which involved him making up any old lyrics on the spot. Then I'd take over. There was nothing satanic about my lyrics on *Paranoid*; most were still grounded in reality. "War Pigs" was an anti-war song and "Hand of Doom" was about drug addiction. "Electric Funeral" was about the threat of nuclear war. "Iron Man" was based on Jesus Christ, the notion that he was a hero one minute and persecuted the next. But instead of forgiving his persecutors, in our song "Iron Man" seeks revenge. I've seen so many different interpretations of that song, few of them accurate.

The one song on the album that was a bit otherworldly was "Planet Caravan," about two lovers floating through the universe in a spaceship—the ultimate romantic weekend! That song was jazz influenced and another product of jamming. Bill was a big fan of Gene Krupa, Max Roach and Buddy Rich, which is why Black

Sabbath were probably the only heavy metal band that *swung*. I never played with another rock drummer who played in that style; it was totally unique to Bill. Meanwhile, Tony was influenced by Joe Pass and Django Reinhardt. Like Tony, Django had lost the use of two fingers and would make up his own chords (when Tony thought he couldn't play anymore, his boss at work gave him a Django album and said, "This guy can't use two of his fingers, but listen to what he can do.").

Tony would come up with a riff (or occasionally I would), which we'd all work from. While Tony, Bill and I were jamming away, Ozzy would start pulling vocal lines from thin air. Ozzy doesn't always get credit for how talented he was at coming up with melodies and kernels of ideas. Sometimes he'd only have to throw out one word and I'd write the rest of the lyrics based on that, and he made my lyrics sound as if they were coming from his soul.

We recorded *Paranoid* at two studios, Regent Sounds in Soho and Island Studios in Notting Hill. We turned up in London black and blue, after having a row with a load of skinheads in Weston-super-Mare. That's another rum story. Simpson had promised we'd be receiving cash on the night, but the promoter told me he'd sent the cheque to him. I was severely pissed off and stormed out to the phone box (no cell phones back then) to call Simpson, where I was surrounded by chanting skinheads, offering to kick my head in. I pretended I was having a conversation, and at an opportune moment I dashed back into the venue before the skinheads could catch me. But when I told Tony what had happened, he went berserk—as he tended to do—and went looking for my tormentors, followed by Ozzy, Bill, our roadie Geoff Lucas and me.

We beat the skins to shreds. Ozzy stuck a claw hammer in someone's shoulder and I stabbed someone with a screwdriver. And while they were rounding up reinforcements, we loaded up our

gear and made our exit. Tony had a big black eye and we had no cash to show for our troubles. However, that's where Ozzy got the inspiration for "Fairies Wear Boots," because the skinheads wore great big Doc Martens that nearly reached their knees.

Paranoid took five days to record. Having done the first album in two, that felt like a luxury. We even had time to overdub and do extra takes. Not that we needed many. Mostly, we treated it as a gig, as we had the first. We'd been playing the songs live for a while and rehearsed so hard that we knew them backwards and exactly how we were going to record them. And because the first album was selling so well, the record company just let us get on with it. They didn't understand our music anyway, so wouldn't have had a clue what to suggest. It's very different nowadays, with producers and A & R people telling the musicians *what* to play and *how* to sound.

People sometimes ask me how I got the bass sound on that album. And I simply reply, "I plugged in." They think that if they use the same Fender Precision Bass I used, they're going to sound the same as me. But it doesn't work like that. Nothing will ever sound like that again, however good someone is at playing a Fender Precision Bass, because it was a moment in time, a few days in 1970, perfectly crystalized.

It's become the myth that Tony wrote the song "Paranoid" in about five minutes on his lunch break. I don't know if that's true or not, but I do know he wrote it bloody fast. He didn't have a choice, because we were three or four minutes short. To be officially called an album in those days, it had to be a certain length; and in America, it had to contain at least ten songs. That's why we gave titles to some intros—for example, the intro to "Fairies Wear Boots" was titled "Jack the Stripper").

They gave us an hour to come up with a song, and once Tony

had played it to us several times, Ozzy came up with the melody, I put down the lyrics (I've still got them, scribbled on bits of a script for a BBC radio play—nothing went to waste!) and we recorded it as if we'd been playing it for months. That's the best way to do it, because if you're given lots of time, you're likely to overthink and get stressed.

"Paranoid" is about depression and not being able to explain how I was feeling to anybody—"Finished with my woman, 'cause she couldn't help me with my mind." It was also about how people would perceive me as miserable whenever I fell into a depression. In fact, people sometimes used to call me a "miserable git" and tell me to cheer up or snap out of it. And while I was still with my woman in real life, she'd metaphorically left me because she didn't understand what was going on with my brain.

Despite the darkness of those lyrics, I thought it was too light as a song. I said to the band, "You can't put that on the album, go straight from 'War Pigs' to a three-minute pop song." It sounded too much like commercial rock and I thought it would spoil the whole thing. But we didn't have time to come up with anything else, so I just had to live with it. As for the title, my bandmates didn't even know what it meant. Ozzy asked me one day, "What the fuck does 'Paranoid' mean?" But he still thought it sounded cool.

I wasn't thinking in terms of singles. In fact, I thought singles were slightly dangerous, because they appealed to a certain type of fickle person, who would soon move on to the next new thing. But when Warner Bros. heard "Paranoid," they wanted to release it and made it the name of the album, opting for that over *War Pigs* (they were worried record shops would refuse to stock it, because of its allusions to Vietnam). I wasn't sure about that decision, but what did I know? "Paranoid" was the biggest thing we ever did, the only Sabbath single that was a Top 20 hit.

Music writers have suggested "Paranoid" sounds like an early punk rock song. I'm not suggesting Black Sabbath invented punk as well, but I understand the thinking. The Dickies, one of the first major American punk bands, did a cover of it. They came to see us at the Hammersmith Odeon one night and gave us their recorded version, which was faster and more unwieldy. They released it as their first single, and it remains one of the best Sabbath covers I've ever heard.

People haven't stopped covering it since. Megadeth, Metallica, Green Day, Queens of the Stone Age, they've all had a go. Soft Cell's version is probably the worst, although it's nice that Marc Almond gave it a try! There was even a German cover of it called "Der Hund von Baskervilles." And who knows how many times it's been sampled. Thank God no-one listened to me.

ONE HELL OF A PARTY

"Paranoid" got to number four in the UK singles chart in September 1970, which led to an invite from *Top of the Pops*. And appearing on *Top of the Pops*, prime time on a Thursday evening, was a huge deal in those days, the pop music equivalent of being handed a golden ticket.

We had to walk to the TV studio from our bed and breakfast because we didn't have a car. Just as we arrived, this massive purple Rolls-Royce pulled up beside us and out jumped Engelbert Humperdinck. The very devout Cliff Richard, my sister's childhood hero, was also on the show, and because I was wearing a cross around my neck, he said to me, "Oh, are you a Christian as well?" I didn't have the heart to tell him which band I was in!

When the presenter Jimmy Savile saw us, he said, "I see your single is pissing up the charts!" We were all shocked that a BBC

DJ had sworn. Like most people back then, we all thought Savile was a weird bloke, but we weren't to know he had far worse vices than swearing. After he died, it came out that he was one of Britain's most prolific paedophiles, having abused hundreds of young victims.

That appearance was the first time my family had seen me play, because none of them had ever been to a gig. I even held up a little sign that said HELLO MOM. We'd already had a hit album, but they didn't really recognise that as a success, because hardly anyone was playing our songs. But now we'd had a hit single and appeared on *Top of the Pops*, alongside such superstars as Engelbert and Cliff, they could see that we'd made it. Before that night, my dad was pissed off that I'd given up accountancy. But now he could see that I was doing something I loved, and being successful at it, he was pleased for me.

Even after the success of "Paranoid" the single, Jim Simpson was continuing to book us in small clubs. So a couple of weeks before our second album was released, we decided to give him the elbow and hook up with Patrick Meehan and Wilf Pine. Simpson didn't take that very well. Neither did Don Arden, who loaned Simpson some money and persuaded him to sue us. That particular legal wrangle went on for over a decade.

I know Ozzy felt Simpson got a raw deal, but I was just happy to have a manager who looked like he knew what he was doing. Meehan was young like us and very charming, with the gift of the gab. He told us everything we wanted to hear, promised us he'd free us of Simpson without any hassle and got on great with all the record company people. With Meehan behind us, the record company people thought we were a serious outfit who meant business. And while Meehan would end up ripping us off, we'd probably never have made it to America without him.

The album *Paranoid* was released in September 1970, with not much fanfare. The less said about the cover the better. It was bad enough when the album was going to be called *War Pigs* (hence the bloke waving a sword about). But when it became *Paranoid*, it didn't even make sense. Fortunately, no-one seemed too bothered about the artwork, and it went straight in at number one in the UK. We were about to do a live show in Belgium when we heard we'd done the unthinkable. We had one hell of a party that night.

But now when we went on tour, we were suddenly getting all these screaming girls at the gigs. It made a nice change having a few ladies present—before our second album, we mainly attracted hard-core blues fans, who were almost all blokes—but all they wanted to hear was "Paranoid," which really pissed our proper fans off. It came to a head in Newcastle. We were playing away when this girl climbed onstage and grabbed my legs. As the security guys were dragging her off, she screamed, "Geezer! Tell them I'm your wife!" Screaming women were good for the ego, but they'd soon forget about you and start screaming at someone else. After that, we decided we weren't going to release any more obvious singles.

The critics weren't as effusive, especially those in America. While we think of music critics as being at the cutting edge, back then, they were very set in their ways and out of touch. That's why Led Zeppelin's first album, which I loved, got a terrible slagging, while they adored West Coast singer-songwriters and anything folky.

It was probably 1970 or 1971 that American music writers started using the term "heavy metal" to describe our style of music (Deep Purple had released the album *Deep Purple in Rock* a few months before *Paranoid*, while Zeppelin's *Led Zeppelin IV* came out the following year). I didn't take it as a compliment. One review said it wasn't music, but "more like a lot of heavy metal being banged together." That's why Ozzy still refuses to call it heavy

metal and prefers to think of Sabbath as hard rock. It was only later that it became a compliment, with British bands like Judas Priest proud to perform under the banner of heavy metal, and not afraid to go even heavier.

In the early seventies, music writers who specialized in genre didn't exist the way they do now. Instead, writers covered all kinds of music for whatever publication they worked for, from jazz to soul to folk to rock. And when this heavier sound came along, they just weren't ready for it. But them trashing our music became our badge of honour. The more they slagged us, the more our fans hated them for it and wanted to buy our records. That's why Sabbath must be the most successful bunch of outsiders in music history—for years the bete noire of music critics, but wildly popular with people who really counted.

5

AMERICA CALLING

SABBATH HAVE ARRIVED!

Towards the end of 1970, we found ourselves on a plane bound for America for the very first time. There were the four of us, Wilf Pine and our roadies Geoff Lucas and Richard "Spock" Wall—and it was one of the most thrilling moments of my life, as if we'd been blasted into space. And just like Neil Armstrong and the rest of the NASA lads, who'd landed on the moon a year earlier, we had almost no idea what we'd find when we got there.

Also on the plane were the band Traffic, including Steve Winwood, a fellow Brummie. Steve completely ignored us, as did the rest of them. But nothing was going to extinguish our excitement, and we particularly enjoyed it when their bassist Ric Grech was arrested for trying to access first class.

Unfortunately, they didn't exactly roll out the red carpet when we landed in New York. Our first hotel, the Lowes Midtown, was a dump. Me and Bill had to share a room and the beds were covered in cockroaches. Then there were the inevitable misunderstandings,

and not just because of our Brummie accents. The record company had sent an A & R man to help us settle in, and one of the first things I said to him was, "Do you know where I can get some fags?" This bloke looked at me like I was some sort of deviant, before replying, "Some *what*?"

"Some fags. Can I get them in the gift shop?"

"Get some *fags* from the *gift shop*?"

He obviously thought "gift shop" was some sort of British street slang.

"When you say 'fags,' plural, does that mean you want more than one?" he asked.

"Yeah, I want at least ten. And English fags, preferably."

"Ten fags! You've only just landed, and you want ten fags already?! I wish someone had let me know. I didn't know you guys were that way inclined."

"What do you mean? I just want some cigarettes."

"Ohhhhh, I see. Well, 'fag' means something very different over here, and rustling up ten of them, all English, at the drop of a hat might have been a mission too far . . ."

Then there was the time a girl pointed at Ozzy's tattoos and said, "My friend has a tattoo of a butterfly on her fanny." That boggled my mind, because "fanny" is slang for "vagina" in the UK, not the bottom, as it is in America. "That must have hurt," I innocently blurted out. "Not really, her fanny is quite big," came the reply.

The gift shop was full of girls, who all started screaming when they clocked me and Ozzy—"It's them! It's them! Sabbath have arrived!" That was our introduction to groupies. A few minutes later, a couple of them were in me and Ozzy's room. I'll leave the rest to your imagination. All you need to know is that the cockroaches didn't dampen their enthusiasm.

Wilf Pine soon disappeared, and we later discovered that he'd

gone to pay his respects to the New York relatives of Joey Pagano, a member of the Genovese crime family, who had accepted him into their clan. Then, on the day of our first gig, Wilf called us to his room and we found him in bed with sweat pouring out of every pore, a side effect of the yellow fever jab we'd all been given prior to entering the States. Wilf's bed gave a massage if you put a quarter in a slot, so Ozzy stuck about fifteen in. By the time the bed had stopped vibrating, Wilf had dislocated his arm. He flew back to England the following day, battered and feverish. Ozzy was lucky he didn't end up sleeping with the fishes.

SEA TO SHINING SEA

It was every British band's ambition to crack America, and still is now. If you made it over there, you were set for life. But before that first tour, we didn't realise that each state was like a different country. So just because you'd made a big splash in New York or California, that didn't necessarily mean the rest of the country knew about you, because each state had its own media and the internet didn't exist. Also, the album *Paranoid* wasn't released in America until January 1971. As a result, we'd spend the next couple of years shuttling between Europe and the US, trying to conquer one piece of territory at a time. Back then, if a band wanted to be a global phenomenon, that was the only way of going about it.

But we were hardly the second coming of the Beatles. Our first gig was at a university in New Jersey. There was a decent crowd, excited to see this brand-new band from England, but when we plugged in our instruments and started playing, all the amps blew up. Our roadies didn't realise that the UK and American electrical systems were different.

A couple of days later, we travelled to Staten Island and got

dropped off at this tiny little basement club called Ungano's. We couldn't understand why we were playing in places like that, when we'd been playing big theatres in England. Then someone told us the gig was a showcase, for promoters and agents from all over America. Later, we found out that we didn't even have a tour booked when we arrived in America, despite what Patrick had told us.

The Ungano's gig was another technical nightmare, but thankfully enough promoters and agents realised our potential and bookings started flooding in. A couple of weeks later, we opened for Rod Stewart and the Faces at New York's Fillmore East. During our set, the place went crazy. When the Faces came on, everyone started chucking things at them. I can only assume they'd seen the Faces before, and many other acts like them, while Sabbath were something novel and fresh. Rod didn't like that one bit. But while it was nice to blow other acts off the stage (especially Rod and the Faces, because they didn't let us do a sound check), it's not like it was our stated mission. We just wanted to go out and perform to our best.

We followed with five sold-out nights at the legendary Whisky a Go Go in LA, before four nights at Fillmore West in San Francisco, which had hosted everyone from Led Zeppelin to Miles Davis during its brief existence. While in LA, Warner Bros. treated us to Elvis's show at The Forum, and invited us onto the set of *Bonanza*, where we met Michael Landon and Lorne Green, who played Little Joe Cartwright and Ben Cartwright respectively. *Bonanza* was my dad's favourite TV show at the time, so I was decidedly chuffed.

Just after arriving in San Francisco, I had a gun pulled on me by some scruffy beggar outside a 7-Eleven. Thankfully, he didn't pull the trigger—he probably had more money than me anyway. Then, before the first gig, someone passed me a dodgy joint in our dressing room (it was either a member of the James Gang, who were

on before Love, or Love, who were on last). After our set, while I was watching the James Gang, I started feeling weird, before someone kindly informed me the joint had contained angel dust. The James Gang had a backdrop of stars falling from the sky, so while I was watching them, I was dodging all over the place because I thought one of them was going to land on me and squash me like a pancake.

Our final show of the tour was at the Sunshine Inn in Asbury Park, New Jersey, supported by Cactus and Steel Mill, who had Bruce Springsteen in their lineup. When Cactus came offstage, one of their members marched into our dressing room and accused us of stealing his drugs, while pointing his finger at Tony. Big mistake. The more irate this bloke got, the more Tony seethed. I was thinking, *Oh dear, poor little Cactus man* . . . And in the end, Tony hit this bloke so hard that he crashed through the dressing room wall. It was like something out of a Laurel and Hardy film.

Right on cue, the rest of Cactus stormed in and started going on about rounding up their "gang" to sort us out. They even claimed they knew guys in the mafia, which I assume was supposed to scare us, but was probably just bluster. Halfway through our gig, someone poured a bottle of Coke into one of our amps. It was a very good job that Wilf Pine had gone home.

Towards the end of that tour, I started getting terrible pains in my abdomen and groin. And when I went to see a doctor in New York, he told me I had an incurable Vietnamese syphilis. *What do you say to that?* I spent the flight back to England doubled up in the plane's toilet. And when I got home, Georgina phoned my parents and told them I was extremely ill, possibly dying.

All the walls in our flat were painted black and covered in inverted crucifixes made from aluminum foil (the ceiling was painted orange, so there was a bit of color). Oh, I almost forgot, there was

also a big poster of Satan. When my dad turned up, he ripped the poster and all the crosses down, while muttering, "Mother of God." Only then did he call for an ambulance.

When I turned up to Dudley Road Hospital, in a pair of shredded pajamas, the doctor said it looked like I had a kidney stone, gave me some painkillers and told me to drink loads of water. Sure enough, I passed the kidney stone after two days, which meant they didn't have to operate. Thank God for the NHS. As for American doctors, it took me a long time to trust any of them.

Unfortunately, the story doesn't end there. When I got back to my flat, I discovered that someone had stolen my stereo equipment, my pride and joy. So now all I had to show for breaking America was a brown leather jacket, some satanic objects I'd acquired in San Francisco (including Charles Manson's LP) and a few records that Warner Bros. had given me as a courtesy. So much for rock star glamour . . .

BACK FOR MORE

After a couple of months gigging in the UK and Europe, we were back in the States. *Paranoid* had reached number twelve on the American album chart, and the interest in us was ramped up to a whole different level.

This time we headlined the Fillmore East, before doing two nights at The Forum in LA, which held almost twenty thousand people. And when we weren't headlining, we were supporting bands like Mountain, a favourite of ours who were massive at the time. We hit it off with the Mountain guys, and their vocalist and guitarist Leslie West remained a good friend of ours until his death in 2020.

It was around this time that things started getting full-on rock

and roll, which was always part of the plan. Bill had always been pretty laid-back, but now he was getting heavily into the drink, which meant he was always fighting with Ozzy (as for me, the fact I couldn't find Guinness in America back then drastically curtailed my intake). After a gig in New Jersey, I was making my way down to the motel reception to check out. But as I passed Bill's room, I saw him pick up a TV and throw it at the wall. I continued down the corridor and saw Bill's TV on Ozzy's floor, covered in rubble. Things had got so out of hand between them, even walls couldn't put a stop to their fighting.

Both Bill and Ozzy's rooms were war zones. But when we were checking out, the motel manager said to us, "It was a privilege having you all here, you're so well-behaved compared to other bands." God knows who'd stayed there before us. Meanwhile, Patrick was mumbling, "Quick, let's get in the car and get out of here . . ."

When Ozzy wasn't fighting with Bill, he was fighting with fans. At a gig in Sweden, we were blasting away when this kid at the front started getting really into it. We, in turn, were feeding off his antics, really ramping things up. But suddenly, this bloke appeared from nowhere, whacked the kid on the head and knocked him out. Having seen this, Ozzy jumped off the stage and beat the hell out of this bloke, before climbing back up and carrying on singing, as if nothing had happened. The following day, the bloke turned up at the venue with a plaster cast on his arm. He apologized for his behaviour, said he'd been off his head on acid, and Ozzy was magnanimous enough to sign his cast.

As for groupies, they were stuck to us like barnacles. We'd meet them at the gig or they'd be waiting for us at the hotel bar. But it was more likely to be a Miss Hell lineup than a Miss World one. If there were any good-looking ones, Tony would be in there like a shot. He was a ladies' man, very charming when he wasn't

punching people, could talk a dog off a meat lorry. As for me, I soon got myself lumbered with the nickname "Two-Bagger."

WHERE ART THOU, SATAN?

It was also on our second American tour that the occult stuff started to become a problem. We'd get all these bloody preachers outside our gigs, flashing their crosses and screaming, "You'll all be damned in hell if you go and see these Satanists!" When we played Salt Lake City, there were people on the balcony reading Bibles. These were balanced out by visits from witches and the chief of the Hells Angels. He marched into our dressing room with about fifty mates, threw all the security guards out and told us we wouldn't have any problems. The subtext being, we wouldn't have any problems from *him* and the rest of the Hells Angels.

When an American nurse took her own life and *Paranoid* was found on her turntable, it was suggested at the inquest that the album might be responsible. More likely she wanted to understand that she wasn't alone in depression. Then Don Arden went on a big US talk show and claimed that the final line of "Paranoid" was "I tell you to end your life, before it's too late." The host was aghast—*How wicked! How could anyone tell people to end their lives?* However, the actual words are: "I tell you to enjoy life, before it's too late." That was one of the biggest problems: People who hadn't even listened to our music really wanted to believe all this pseudo-satanic bollocks.

That tour ended on a sour note when someone stole my wallet in Philadelphia, which was our penultimate gig. We did our sound check, I went back to the dressing room to get money for drinks and the wallet had gone. It contained a fully paid-up National Insurance card, photos of my recent holiday in Ireland and £350, my

entire life savings. Even my movie camera, on which I'd recorded our tours, had been stolen. After hundreds of gigs, two tours of America, a hit single and two hit albums, I had precisely nothing to my name.

MASTERS OF REALITY

I've absolutely no idea how we found the time to write any new music, because we were constantly on the road for three years. I can only assume we did it at sound checks. And we had to rehearse and record our third album during the short breaks between tours.

Because *Paranoid* was such a big success, we were under pressure to repeat the trick. But we didn't have any songs left from jamming sessions or previous studio sessions, so we had to write new ones from scratch in the rehearsal room. Luckily, all that touring hadn't blunted our creative edge. And we were brimming with confidence, because our records were selling in the millions and our shows were selling out everywhere. We knew our musical instincts were correct.

Our third LP, *Master of Reality*, was so-called because the final version of an album is called the "master" and the songs, particularly those of a darker nature, were about real-life experiences. At the same time, *Master of Reality* was experimental. We were on an adventure to see where our writing might take us. That's always a risk, because if you try to do something different, there will always be fans who'll say, "They've turned into a different band," or, "They're trying to copy so-and-so," or, "They've disappeared up their own arses."

We were in Island Studios, Notting Hill, for about ten days, which gave us the chance to come up with different sounds. Because Tony's fingers were killing him after years of constant touring, he

started using even lighter gauge strings, which were looser and easier to bend. He also tuned down his guitar three semitones, which gave him a heavy, darker sound. I did the same with my bass, and suddenly Sabbath were heavier than ever.

There were no synthesisers in those days (well, there were, but I think a Kurzweil synth cost something like $120,000), so we had to improvise in other ways. Rodger Bain stood back and let us do whatever we wanted, although the engineer Tom Allom, who'd worked on Genesis's debut album, came up with a lot of suggestions. As well as tuning down for "Children of the Grave," "Lord of This World," and "Into the Void"—which produced a menacing vibe—we messed around with the intro for "After Forever," using a backwards recording of a gong and bass guitar feedback, all fed through a phaser effect.

But for all the darkness, there was also plenty of light on *Master of Reality*. We wanted our albums to be like the Beatles's, with sonic variety and little pools of calmness, rather than constant pounding. Those mellow tracks, like "Orchid," "Embryo" and "Solitude" (probably the first proper love song we wrote), served an important purpose, in that they made the heavy tracks sound even heavier. You need those little intervals, before being hit by another onslaught, especially if you're stoned. And we were smoking a hell of a lot of hash at the time.

Just before the recording of *Master of Reality*, I went over to Ireland to visit my grandma and family, but while I was waiting to board the plane, two detectives appeared from nowhere and said, "Terence Butler? Come with us . . ." I thought, *Oh God, how did they know I've got a big lump of hash in my pocket?* A drug conviction was impending, for sure.

However, once in the interrogation room, one of the detectives asked, "Have you got any connections to the IRA?" I said no, but

he began rattling off names and asking if I was in such and such a place on such and such a date. This grilling went on for about twenty minutes, until they were satisfied I wasn't a Provo and let me go. I returned from Ireland with the title for "Sweet Leaf," but that had nothing to do with weed. The inspiration was actually a brand of fags they had in Ireland, called Sweet Afton (after a Robert Burns poem). I liked the thought that tobacco could be sweet, and thought "Sweet Leaf" was a good song title. Somehow, I'd had the impression that "sweet leaf" was printed on the cigarette box, but alas it wasn't.

"Sweet Leaf" was essentially a stoner anthem, a love song to dope. I didn't really drink much at the time. In fact, hardly any of my friends outside the band drank; we were all smoking dope or popping quaaludes like Pac-Man (quaaludes, or "ludes," gave you a lovely feeling, like when you have an operation, the doctor injects you and says, "Count to ten . . ."). I found dope very relaxing, and I suppose it was inspirational, because it helped me come up with lots of weird and wonderful ideas. And in case anyone is wondering, that really is Tony coughing his lungs out at the start of the song, having taken a big toke on a giant spliff, freshly rolled by Ozzy.

But the most controversial song on that album was "After Forever." I got into a lot of trouble with the line "would you like to see the Pope on the end of a rope." As you can imagine, my dad wasn't happy with that lyric. And interviewers have never stopped asking me, "Why did you say you'd like to see the Pope on the end of a rope?" I must have explained it a thousand times. They're unable to separate the artist from the art, and they haven't listened properly.

That song was about the Troubles in Northern Ireland, which were reaching their murderous peak. I hadn't spent any time in

Northern Ireland, because my family were Catholics from the Republic. And the first time I visited, I was shocked by the nationalistic fervor and religious hatred, which ran both ways. Protestants in Northern Ireland would often hang effigies of the Pope, and I was wondering if they'd regret doing that when it was their turn to die.

Master of Reality reached number five in the UK and number eight in the States, no thanks to the critics, who gave it yet another panning. That's when we thought, *Bollocks to it, we're not speaking to them anymore.* Critics have every right to say they don't like an album or a gig, but a lot of the slagging was just malicious. One bloke wrote a scathing review of a show that was cancelled. After a gig at the Birmingham Odeon, another reviewer wrote in less than glowing terms about songs we hadn't played. One of our friends had spoken to him in the bar and established he hadn't even bothered watching us.

GETTING FLASH

Less than three months after our second US tour, we were out there again. This time, it was fifty-seven shows in less than four months, plus a few festivals back in Europe. We had some big bands supporting us on that tour, including Yes, Alice Cooper, Humble Pie and Black Oak Arkansas (the only band we supported were Led Zeppelin, in Syracuse and Rochester).

Yes were very standoffish. The singer, Jon Anderson, wasn't too bad, in that he deigned to talk to us, but the rest of them were miserable gits. Actually, the keyboardist talked to us as well, but only after he found out he was going to be fired and replaced by Rick Wakeman (not that we had an opening).

A lot of those prog bands were really snooty. They were of-

ten from middle-class backgrounds, had been to university or art school and were usually virtuoso musicians to boot. As a result, they looked down on us working-class "oafs" from the provinces, who couldn't play our instruments properly or read music.

Even worse than Yes were Emerson, Lake & Palmer, who treated us horribly when we gigged with them at the Royal Festival Hall in London in 1970. In later years we became friends with Carl Palmer and Keith Emerson, but back in 1970 we were supposed to be sharing the PA to save time. However, after going on first, they insisted our road crew take their part of it down, which meant we ended up going on an hour late, with half a sound system.

By the time that third US tour was over, we were all exhausted. We'd been on the road for almost three years solid, and when we weren't travelling we were rehearsing and recording. Patrick Meehan kept saying to us, "There's no money in the bank, so you've got to keep touring." I'd be thinking, *How is there no money if we've just played fifty-odd dates in America?* And Patrick would tell us it was all going towards travel, accommodation and tax.

But we didn't worry so much about our health or money, because we were still having fun. We were four kids from Aston who had made it in America, something we'd always dreamed of. And while I found it hard to slip back into a normal lifestyle in England, I was at least able to feather my nest.

I was planning to marry my childhood sweetheart Georgina, so decided we needed to upgrade from our apartment in Erdington. I saw what looked like the ideal place in the local newspaper and soon I was the proud owner (or so I thought) of a lovely house called Two Pines, out in the Worcestershire countryside and just down the road from Robert Plant. One night, I walked into my local pub, asked for my usual pint of bitter, and the landlord said, "We had that Ted Zeppelin bloke in here last night . . ." Another

night, Ozzy pissed on the fire in the lounge and got me banned. You can take the boy out of Aston . . .

When me and Georgina got married, we hired the cheapest Rolls-Royce they had to take us to the registry office (my dad didn't attend, because we weren't getting hitched in a Catholic church), and the doors kept flying open when we went around corners. That's when I thought I needed to learn to drive myself—and maybe buy a Rolls-Royce that actually worked.

My first driving test, I turned up in green flares, a purple jacket and silver boots, with six-inch heels and a big red cross on the side (not dissimilar to the boots the man was wearing in the premonition I had as a kid). I'd had the boots made by a bloke in Kensington Market and honestly believed I'd invented a whole new fashion for men. But not everyone was impressed. On our second US tour, an FBI agent at Chicago's O'Hare Airport had pulled me into an office and had my boots X-rayed, because he suspected the heels and platform soles were stuffed with drugs. I explained that platforms were the new fashion in England and he shook his head in dismay. My driving examiner was similarly appalled. He took one look at me and asked, "Are you serious? You're going to drive in those things?" He'd essentially failed me before I'd even got in the car.

Having passed my driving test at the third attempt, I went out and bought myself a Rolls-Royce the following day (Patrick let me have the money for that, and this one had doors that stayed closed when it went around corners). It used to belong to Aston Villa chairman Doug Ellis, which made me feel like a king. Unfortunately, going about like a king doesn't go down well in Aston.

One day, Georgina's dad invited me to his working men's club, which was full of socialists (not many people voted for the Tories in Aston). While I was having a beer, this irate bloke came running in

and said, "Some cheeky bastard has parked a Rolls-Royce outside the club!" I wanted the ground to swallow me up. Then when I turned up at my dad's factory, to give him a lift home, he pretended he didn't know me. The next time I saw him, he said, "Don't ever come to the factory in that car again!" He was ashamed because his son was driving a Rolls-Royce, which I couldn't understand at the time. Now I think, *God, what on earth was I thinking?* Dad was a proud working-class man, with proud working-class mates. If they'd seen him getting into a Rolls-Royce, he'd have never lived it down.

Almost every time I drove that Rolls-Royce, it was as if somebody up there was willing me to get rid of it. On holiday in Cornwall, I parked on a steep hill outside a pasty shop, forgetting to put the handbrake on. I was probably stoned at the time. As I was ordering my pasty, a bloke came in and said, "Mate, is that your Roller outside? Well, it's rolling down the hill." I replied, "Ha. A Roller, rolling down the hill. Very funny." But I soon realised he wasn't joking. I rushed out of the shop, saw my car rolling down the hill and ran after it in my six-inch platforms. To no avail. It eventually crashed into a fence and I had to have it towed to a local garage. The mechanic took one look at me and said, "I bet your dad is going to kill you when you get home . . ."

I'd started seeing a bit more money by then, and I suppose you could say I started getting a bit flash around that time. When I took the Rolls-Royce in for a service and the bloke asked if I wanted a taxi home, I replied, "No thanks, I'll buy that Mercedes instead." I also bought myself a Jensen Interceptor, a British car that was powerful as anything and almost killed me. I'd been down the pub with a mate and drunk about eight pints, on top of some anxiety pills. On the way home, I was going around a bend at about eighty miles per hour when the car took off, flew through the air and

landed upside down in a ploughed field. If I'd been wearing a seat-belt, I would have been dead, because the roof cut the driver's seat in half. As it was, me and my mate were thrown onto the back seats and the only bad injury I had was to my leg.

CHARLIE IS ME DARLIN'

That crash was just after our third US trip, and we were supposed to be starting a tour of the UK and Europe a few days later. Our management put out a statement saying we were all ill, which was actually true. Going on tour was still exciting, because playing gigs was in our blood and what we lived for. But that much touring and partying just isn't good for anybody. It was like we'd been on a three-year bachelor party. And because no one was going to let us have a break if we said we were feeling under the weather, we started doing cocaine, just to keep us going. And the more money we got, the more cocaine we did.

Drugs were also a way of breaking the monotony, because we were traipsing from one hotel to the next and the only people we saw were each other and assorted groupies. Getting up onstage became a relief, because we were so happy to be doing what we thought we should be doing instead of sitting on a plane or a bus or stuck in yet another identical hotel room, with only three channels on the television to keep us amused.

You've also got to bear in mind that I grew up in a household where alcohol wasn't even allowed, except at Christmas. When I was about eleven, I brought home a can of shandy, which is basically lemonade with the slight flavor of beer, and my dad went mad, started telling me I was going to turn into an alcoholic. So naturally, I was going to experiment given the chance. But more than anything, boozing and taking drugs was just what young

blokes in rock bands were supposed to do back then. And we enjoyed it, at least in the early days.

But after yet another US tour at the start of 1972, we were all close to cracking up. Bill was already becoming an alcoholic. He'd wake up every morning, drink a bottle of vodka for breakfast and carry on boozing all day long. Remarkably, it didn't affect his playing. He'd puke on his kit while drumming away, before necking another bottle of vodka. Eventually, Bill got hepatitis, which almost killed him—but at least it meant he got a couple of months off work and booze. Meanwhile, Ozzy was hoovering up so much cocaine that he tore his epiglottis.

When we played Atlanta (in either 1972 or 1973, it's difficult to nail some of this stuff down) we stayed at the brand-new Hyatt Regency, which was the ultimate in luxury at that time. After the gig, Patrick handed out acid. And when Tony, who has a fear of heights, got in the elevator, which was glass and looked like a rocket ship, he started freaking out. He kept asking us, "Am I going to the moon? Am I going to Mars?" I said to him, "No, Tony, you're in an elevator and you're going back to your room." And he replied, "No, we're not, you're taking me into space . . ." I had to stay with him all night, because he was a gibbering wreck.

The satanic stuff had also got absolutely ludicrous by then. When we arrived to play a gig in Knoxville, there was a big red cross daubed in blood on our dressing room door. I said to the promoter, "How the hell did they allow someone to do that?" During the gig, we were playing away when Tony's amp started crackling. Tony was giving this amp a good kicking when this guy jumped onstage and lunged at Tony with a great big knife. If Tony's amp hadn't malfunctioned, he might have been stabbed. As it was, security managed to get to this bloke in time and bundle him off the stage. At least we'd found out who drew the cross on our door.

That night, we got back to our hotel to find the corridor full of nutters wearing black cloaks, sitting on the floor with black candles and chanting all this satanic crap. We edged past them, locked ourselves in our rooms and called security, but they didn't seem too fussed. So our roadie decided to mess with the Satanists' heads instead. He went out and said, "Gather round, I've got a message from Black Sabbath . . ." While they were gathered around, he told them to bring their lit black candles closer to him, before blowing them out and singing, "Happy birthday to you! Happy birthday to you—now fuck off!" That got rid of them.

Tony finally unravelled after a gig at the Hollywood Bowl. That show was a disaster from start to finish. We did the song "Changes" for the first and only time, and Tony's piano was miles out of tune. Not only that, but somebody had dropped the Mellotron, a fragile keyboard that creates string sounds via tapes, and broken it. I had to keep pressing the keys to keep the string part going. Ozzy was looking at the both of us as if we'd gone nuts. And about halfway through the song, I looked at Tony and said, "Should we just stop now?" He quickly agreed, and we abandoned the song, much to the confusion of the twelve thousand or so fans.

After the show, Tony collapsed in the dressing room. He could hardly breathe and when the medics arrived they put a mask over his face. Tony had been doing a ton of cocaine and not eating enough grub (he claimed he was trying to lose weight, but that was just an excuse, because there was nothing of him in the first place). It was after this incident that we all agreed we needed a break.

I decided to take my missus to Greece for a holiday, the first we'd ever had outside of Britain and Ireland. Just the idea of being away from the rest of the band for a couple of weeks was bliss. But when we arrived at our hotel and wandered down to the beach, who were the first people we saw? Bloody Bill and Ozzy. We'd all

left it to the same travel agent to organize our trips and they'd sent us to the same place. Some break . . .

SNOW-BLIND IN SUMMER

As well as two tours of America in 1972, we somehow found time to record our fourth album that same year. Tony was struggling for inspiration in England, we didn't have any songs written and we were paying 90 percent tax on some of our earnings, so Patrick suggested a change of scenery. We really liked LA and Patrick was mates with John du Pont, as in the chemicals company, so we set up camp in du Pont's Bel Air mansion.

It was an incredible place, with God knows how many bedrooms, a cinema, a vast ballroom overlooking the swimming pool and groupies as far as the eyes could see (Patrick also made sure the two French au pairs were part of the package). The girls would flock from the Whisky a Go Go and the Rainbow Bar and Grill, which had just opened on the Sunset Strip and become the number one spot for groupies to get off with bands.

That was a brilliant time for us. We'd already had three multiplatinum-selling albums, were doing sold-out arena tours, living in big houses and driving flashy cars. And now there we were, living it up in a billionaire's mansion in LA. We'd write and rehearse in a room next to the pool, with Tony making sure we kept to a schedule. And because we were all living together, any time anyone had an idea, we could all get together and try it out.

After we'd settled in, a bloke appeared carrying a big box of Persil washing powder. Except it wasn't washing powder, it was marching powder. While we all gathered around the dining table, he poured out a small hill of cocaine and said, "Welcome to Uncle Charlie!" It was like a scene from *Scarface*. We'd also have cocaine

flown in by "friends" of the management, 100 percent pure and packed in small bottles with wax seals. But having such good stuff flown in by mobsters on a private jet doesn't come cheap: that record cost $70,000 to make—and the cocaine bill was $75,000.

There were also great big bowls of grass and even some heroin doing the rounds. On one occasion, I ran out of cocaine and decided to snort some heroin instead. I was up all night, talking to myself in the mirror. I thought I was God and my reflection was the devil. I wish I could have recorded that conversation, because I'm sure it would have made for some killer lyrics.

One night, Ozzy noticed a button on the wall and remarked, "I wonder what this button does?" When he pressed it, nothing happened. He pressed it again. Still nothing. We'd all gone back to snorting coke and smoking joints when we were suddenly blinded by flashing blue lights. When I looked through the window, I saw three or four police cars parked outside. It turned out the mysterious button Ozzy had pressed was a panic alarm, which immediately alerted the local police.

The mansion came with a maid, and I told her to stall the police while we ran all over the house, flushing the coke, weed and pills down the toilet. Not that the cops even entered the place. All they did was ask the maid if we were okay, before leaving. Afterwards, Ozzy said he thought the button was for the air-conditioning. That mistake must have cost us about ten grand in drugs.

Cocaine had its creative upside because it meant I could stay awake all night, and if I thought of any lyrics, I could scribble them down. Or it might be three o'clock in the morning and someone would say, "I've had an idea," and we'd be able to see it through, because we were all so wired. But cocaine made you talk an awful lot of crap. The following day, I'd remember all the rubbish I'd been saying and not be able to face anyone, because I'd be so embarrassed. It also made people do ridiculous things.

One night, Deep Purple's roadies paid us a visit and Tony decided to get dressed up as a ghost. There we all were, the rest of the band and Deep Purple's roadies, passing round a joint and shooting the breeze, when we started hearing ghostly "woos." The roadies didn't have a clue what was going on, until they looked up and saw Tony stumbling down the stairs with a white sheet over his head. He thought he was scaring us while we were all convinced he'd lost his mind. Which, let's face it, he had.

Then there was the time Tony and Ozzy sprayed Bill from head to toe in gold and blue paint, before sealing it with lacquer. When Bill came round from his drunken stupor, he started throwing up. Then he started having convulsions, which was terrifying. Tony called an ambulance and when they asked what might be wrong with Bill, he had to tell the person on the other end of the phone that he'd sprayed his friend gold. When the medics arrived at the mansion, they were furious and told Tony he could have killed him, because the paint and lacquer meant Bill's skin couldn't breathe. It wouldn't be the last time Tony almost did Bill in.

Another reason we'd decided to head to LA was because the Record Plant, on West Third Street, near what is now the Beverly Center, was one of the best studios in the world. We felt we needed a sonic change from our previous records, and we were also getting better as musicians and writers, so we naturally wanted to push the boundaries. The Record Plant allowed us to do that.

That was also the first album we produced ourselves, without Rodger Bain, but Patrick somehow got his name on the record as a co-producer, despite contributing *nothing* to the process. He'd wander into the studio, sit himself down, listen to what we were doing for half an hour and wander off again, without saying a word. One day, he turned up with a Gucci briefcase. We didn't know what Gucci was, so when Patrick popped out for a minute, Ozzy opened it up and pissed in it. Patrick didn't see the funny side, but

it's not like he could have started anything, because Ozzy would have murdered him.

We'd already recorded a couple of tracks at Marquee Studio in London, "Under the Sun" and "FX," which was recorded while Tony was stoned out of his brains. He took his clothes off, put his guitar on and started dancing around the place. As he was doing so, the cross he had around his neck began bouncing against the strings. The engineer put an effect on it and we all went out and started hitting the strings as well. For some reason, we all thought it would be a good idea to put the "song" on the album.

When we got to LA, we had a lot more time to mess around with ideas, so all sorts of new stuff came tumbling out. I'd bought myself a Fender twelve-string guitar, to help with my writing (it was the only non-Iommi guitar playing to feature on any of our early albums, being the outro on "Wheels of Confusion"), and the mansion was packed with all sorts of instruments, which also helped.

One day, Tony sat down at the grand piano in the ballroom and started idly tinkling away. He didn't really know how to play, but it turned out he was a genius on keys as well as the guitar. While he was playing this tune, Ozzy walked in and started putting a melody to it. We also had a Mellotron (the same one that went wrong at the Hollywood Bowl), so I started playing along on that (how I knew how to play a Mellotron is anyone's guess). That's how the song "Changes" came about, almost out of thin air—almost by magic.

Tony had just broken up with his girlfriend and Bill had recently been through a divorce, so there was an air of sadness in the house. That's why my lyrics were so melancholy. And Ozzy was able to summon such raw emotion, which I have to admit took me aback. "Changes" was quite a departure from the usual Sabbath sound, and I wasn't surprised when the soul singer Charles

Bradley released a cover of it years later, because it really was that soulful.

The acoustic instrumental "Laguna Sunrise" was another light touch on an otherwise pretty heavy record. That song was named after a beach in Orange County, where we'd sometimes hang out. A girl called Carol, who was a pal of Bill's new girlfriend Misty, had a massive house down there, and when she offered me and Ozzy something called psilocybin, we of course accepted. Walking on the beach, I was seeing skeletons and all sorts. Ozzy, meanwhile, thought he was swimming in the sea but was actually flailing away in the sand, like a stranded turtle. Frank Silvagni, another friend of ours, was also hallucinating that the tide was in, so dived off the lifeguard's platform and went splat into the sand.

The original plan was for me and Tony to play violin and cello on "Laguna Sunrise." But having procured the instruments, we soon realised that making a violin or a cello sound anywhere half decent is a lot harder than it looks. Mercifully, the recording featured a proper orchestra instead.

Without "Changes," Tony's guitar riff on "Supernaut" wouldn't have sounded as exhilarating. And without "Laguna Sunrise," "Under the Sun" wouldn't have sounded so dark and dramatic. I think that album showed how far we'd progressed musically, in that we were open to a lot of musical directions. I was listening to a lot of soul at the time and was a fan of Marvin Gaye's *What's Going On*, as well as the various Beatles' solo albums. I was also listening to Carole King, Roxy Music, Mountain and more obscure bands like the Flock, who were a jazz-rock outfit from Chicago, and It's a Beautiful Day, who were a blend of loads of different musical styles. We didn't want to be pigeonholed as a heavy metal or hard rock band, we wanted to be more versatile than that, even a bit quirky.

As for the lyrics, when I listen to them now, I'm amazed at

how cynical and jaded I was at the tender age of twenty-two. Take "Wheels of Confusion," the opening track, as an example: "The world will still be turning when you're gone." That meant that nothing really matters, because we're only here for a brief time and the world will carry on just fine without us. It's quite a bleak thought really.

I can only assume that most of the critics didn't listen to *Vol. 4*, because it got slagged again. I imagine the record landed on their desks and they already had their reviews written: "More heavy metal junk." One bloke who did like it was Rolling Stone's Lester Bangs, who hated our first few albums. Suddenly, he was calling Sabbath "moralists" and "a band with a conscience," while also strangely comparing my lyrics to those of Bob Dylan.

We had planned to call our fourth album *Snowblind*, but the people at Warner Bros. lost their nerve at the last minute. And because we were all back in England or on holiday at the time, we didn't have any say in their final decision. They decided on plain old *Vol. 4*, which wasn't the most inspiring title. That meant the original *Snowblind* artwork was scrapped and replaced by a picture of Ozzy, in yellow silhouette against a black background. It's an iconic cover now, but it didn't go down too well at the time, because we didn't think it represented the entire band.

However, the record company did turn a blind eye to the liner notes, in which we thanked "the great COKE-cola company of Los Angeles." And we meant it, because all that cocaine had fueled the creation of a great album.

Vol. 4 made it to number eight in the UK and number thirteen in America, which was our worst chart performance since the first album. But we didn't panic. Our attitude had always been, "As long as we like the stuff we're doing, we don't give a toss how many records we sell." It was nice to have gold- and platinum-selling al-

bums on our walls, but because we weren't seeing the money we should have been, sales didn't really mean anything to us.

We were just grateful to still be going, because a lot of bands that started around the same time as us had done two or three albums and promptly disappeared. We always assumed it was going to come to an end, sooner rather than later. Even the Beatles didn't last forever.

THE STRAIN

IS THIS HOW IT ENDS?

All four members of Sabbath were so fried that we cancelled a US tour in 1973. That meant we wouldn't play a gig in the States for a year and a half, a lifetime in the seventies, when music trends were so fluid and changed so quickly. In fact, we only played one gig in nine months, at London's Alexandra Palace. In theory, that meant we had a lot of time to write and record a new album. In practice, it meant a lot of aimless jamming and waiting for Tony to come up with some new riffs.

In the summer of 1973, we headed back to the du Pont mansion in Bel Air, thinking we'd be inspired like last time. But the entire atmosphere had changed. The cocaine, which used to be fun, was starting to smother our creativity, and we were trying to force things, instead of letting it flow. To make things worse, the Record Plant had been revamped by Stevie Wonder. He'd just entered his full-on experimental phase and had filled the studio with a load of giant synthesisers and computers, so we couldn't achieve the same sound as before.

One of the most embarrassing things happened to me in that studio. I was playing the pinball machine while singing along to Stevie's latest single, "You Are the Sunshine of My Life," when everyone suddenly went silent. When I turned around, Stevie was standing right behind me, surrounded by his road crew, who looked like they'd just witnessed a murder. Let's face it, they had. After an agonizing couple of seconds, Stevie said contemptuously, "Who's that? Who's that singing my song?" I was so mortified that I slinked out of the studio without saying a word.

Whenever we wrote and rehearsed, I used my bass to show Tony what I'd written, which was very limiting. So eventually I bought myself a ReVox reel-to-reel tape recorder and started recording riffs with a couple of guitars I'd bought in the States. But even then, I felt intimidated presenting my riffs to Tony—after all, he is "the Riffmeister."

To be fair, Tony never suggested any bass parts. If I doubted my playing, he'd praise me and tell me I'd work it out eventually. But it began to irritate me that I was coming up with riffs that nobody would listen to. Ozzy and Bill just assumed that my riffs would pale next to Tony's. During that period, I kept thinking, *If Tony's not coming up with anything, and they're not accepting any of my offerings, it's pointless carrying on. Maybe we've gone as far as we can go. Maybe this is how it all ends.*

After a month or so in LA, we decided to head back to the UK. We'd got to the point where it really was all or nothing. Rockfield was already booked, but the Kingsley brothers suggested we use a place called Clearwell, an eighteenth-century castle in Gloucestershire that was offering the same sort of package. What no-one told us was that Clearwell Castle was haunted.

Just after arriving, Tony saw some bloke walk past our rehearsal room and disappear into what was called "the dungeon," because it

looked and felt like the sort of place medieval traitors would have been banged up and tortured, all cold brick and cobwebs. Tony followed him in, only to discover there was no-one there and no other way out.

Another night, I was on my way upstairs to bed when I saw an old bloke standing outside my bedroom door. He was ancient, wafer thin, almost translucent, and looked like he was on his last legs. I thought he must have been a ghost, but I later discovered he was the grandpa of the people who owned the castle, and was prone to wander around during the night. You'd have thought they might have told us. As it was, the shock I got from seeing him was too much for me, and I drove home every night from then on.

Bill got so scared, he started sleeping with a knife under his pillow. As for Ozzy, he nearly burned to death after falling asleep in front of the fireplace. A log inexplicably came loose and set the carpet alight. Luckily, one of us happened to pop our head in, saw Ozzy smouldering and put out the flames.

But all that spookiness triggered something profound in Tony, because he soon came up with the riff that revitalized him and the band, and turned the mood from trepidation to all-out joy.

THE RIFFMEISTER DELIVERS

I remember Tony walking into the studio and saying, "Well, I have got one thing," before launching into the riff for "Sabbath Bloody Sabbath." It was a glorious moment. Relief washed over me because that riff—one of the best I'd ever heard—meant we had a present and a future. We weren't done yet—Sabbath would live!

While I'm on the subject of Tony's uncanny ability to conjure a monster riff, I don't think he gets the credit he deserves as a guitarist. I recently saw one of those "best rock guitarists of all time"

lists and Tony was down in the thirties. Meanwhile, Eddie Van Halen wasn't in the top ten and Keith Richards was at number two. Whoever wrote that list needs their head testing. And anyway, there's no such thing as the "best" guitarist, or the "best drummer" or the "best" anything—it all depends on the genre and is totally subjective.

I know how great Tony is, because I had a ringside seat for almost fifty years. We'd be jamming away and he'd be coming up with riffs left, right and centre. And I defy anyone to name three better rock riffs than "Iron Man," "Supernaut" and "Sabbath Bloody Sabbath."

Clearwell Castle got everyone's creative juices flowing, and I even plucked up the courage to play Tony one of my guitar riffs, which he liked. After a few Tony tweaks, it became "A National Acrobat," which is one of my favourite Sabbath songs (and not because I wrote it!). Ozzy's on record as saying "A National Acrobat" is about wanking, and he's on the right track. I was thinking about the billions of sperm that don't result in someone being born, and that song is specifically about a sperm that thinks it's going to become a person but never does, and who (or what) decides which sperm make it or don't.

I was reading a lot of science fiction and horror around that time, as well as watching some shocking films, like *The Exorcist* and *A Clockwork Orange*. Those influences, combined with the doomy atmosphere of the castle and the weed I was smoking, made for some deep lyrics, some of the best I wrote.

For example, "Spiral Architect" is about DNA. For whatever reason the concept was in the news a lot, and I didn't understand what the hell the experts and scientists were talking about. But when I saw a diagram of the double helix, or spiral, I thought, *Well, if that's what people are made of, I'll write a song about that.* I remember driving home from Clearwell Castle one night and stop-

ping in a layby to do some coke. When I arrived home, the sun was rising, and I sat down between the two big pine trees on the front lawn. That's when the lyrics came to me, including the line, "Of all the things I value most of all/I look inside myself/And see my world/And know that it is good."

The next day, I called Ozzy from a public phone box (we didn't have one in the house) and he said to me, "You done them lyrics yet?" When I'd finished reading them, Ozzy exclaimed, "That's the best thing I've ever heard."

Tony wanted to play the bagpipes on the recording of "Spinal Architect," but after buying some, he realised he couldn't even inflate them. He even tried using a vacuum cleaner. We ended up hiring an orchestra instead (not for the first time), which meant Ozzy had to hum all the different parts and Richard "Spock" Wall, our sound guy who could read and write music, had to write it all down in legible form.

The song "Killing Yourself to Live" was about how we were working ourselves into the ground with not enough to show for it. Don't get me wrong: We all had nice cars, big houses and money for drink and drugs, but we were starting to wonder, *If we're making platinum albums, where's the rest of the cash?*

Ozzy wrote "Who Are You?" on a monophonic Moog (we couldn't afford a polyphonic synthesiser, like Stevie Wonder had). He always wanted to contribute musically but couldn't play an instrument, so this Moog was perfect for him, because you only had to use one finger. The instrumental "Fluff" was named after the Radio 1 DJ Alan "Fluff" Freeman, who had played the single "Paranoid" four weeks in a row in the newly released spot, until it entered the chart. He and John Peel played a big part in making it a Top 10 hit. Fluff also came to one of our gigs in London and was such a nice bloke that we thought we'd dedicate that track to him.

Yes were in a studio across the road, which is why Rick Wakeman played keyboard on "Sabbra Cadabra." In fact, Rick spent most of his time in our studio, because we had a bar. We'd play darts with him and Charlie Watts, who'd pop in every now and again. Rick's a nice guy, a working-class bloke like us, and he'd constantly complain to us that his bandmates were driving him nuts. We even talked about Rick joining Sabbath, but he'd have only been playing on two or three songs an album, so it didn't make much sense (funnily enough, his son Adam would play keys for us on our later tours).

Yes were recording *Tales from Topographic Oceans*, which was full-on prog. According to Rick, they had a cow and fake trees in the studio to lend a country atmosphere. And they were all allegedly fake vegetarians, by which I mean they'd sneak out for bacon sandwiches. Ozzy ended up putting loads of stink bombs in the air vents of their studio, which didn't go down too well with them.

The lads from Led Zeppelin also paid us a visit and we had a jam, which has since become almost mythical. Bonham wanted to play on "Sabbra Cadabra," but we weren't having it. He put a few dents in Bill's kit because he played so hard. Bonham was nice and friendly when he was sober, and actually quite shy. But he could be obnoxious when he'd had too much to drink, a classic Mr. Hyde. Much like me.

When we got down to jamming, we told the engineer not to record it, but no-one in their right mind is going to miss that kind of opportunity. There are rumours the engineer disobeyed orders and that the Sabbath-Zeppelin jam is out there somewhere—if that engineer is reading this, I'd dearly love to hear it!

Making *Sabbath Bloody Sabbath* was probably the happiest time of my life up to that point. Since we were already quite successful, we were looking for opportunities to experiment. We knew

it was up there with our best records—probably another step forward in terms of musicality—and that the critics would look a bit stupid if they gave it another mauling (*Rolling Stone* loved it, called it "an extraordinary gripping affair" and Sabbath "true Seventies bluesmen"—although we still couldn't make their cover and never did).

Actually, there was one bloke who gave it a terrible review, *Melody Maker's* Allan Jones. He said we looked like "Mott The Hoople groupies masquerading as gay Cossacks" (whatever gay Cossacks look like). He also took the piss out of our Brummie accents, which was just outright snobbery.

Tony would get his revenge on Jones eventually, but that story needs some context. In 1973, Tony married a woman called Susan Snowdon. It was Patrick Meehan who introduced them. Susan's parents had this massive mansion in the Leicestershire countryside, the size of Buckingham Palace, and were ultraposh. I think they might even have had blue blood. God knows what they made of Tony.

The night before Tony and Susan's wedding, we were all doing coke. So when we rolled up to the church, we were bending the vicar's ear—"Is there a toilet anywhere?" There was a queue outside the toilet all the way through the service. The reception was back at the mansion and they didn't have any booze, because they knew we were a bunch of hooligans and would probably start breaking paintings and antiques. Instead of champagne, they served apple juice. That didn't go down well with Ozzy and John Bonham, who was Tony's best man. Tony's mom had to invite them back to her house otherwise there would have been some very expensive damage done.

Anyway, while Tony was living in the mansion, Allan Jones went to interview him for *Melody Maker*. In Jones's subsequent

article, he slagged Tony for his supposed airs and graces (because Tony was living in a big house and drinking tea from a china cup). Tony couldn't win, it appeared: either he was too uncouth or he'd disappeared up his own arse.

Later, when we were doing a gig in Glasgow, Tony requested *Melody Maker* send Jones up to do a review. And when he turned up, Tony beat the daylights out of him. Tony had a weird smile on his face while punching him, which made him look downright evil. Predictably, Jones ran away crying and later gave us our worst review ever. But it was worth it!

CALIFORNIA JAMMING

After a fourteen-month sabbatical, we went back on the road in May 1974. Our biggest gig that year—and probably our biggest ever, in terms of audience size—was the California Jam. Staged at the Ontario Motor Speedway, it attracted between 300,000 to 400,000 people (although the unofficial figure was probably twice that, because an awful lot of people didn't have a ticket). This was a massive event, a coming together of some of the world's biggest bands. But weirdly, Patrick Meehan didn't bother telling us about it until the last minute.

I was relaxing at home when I got a call from one of our roadies, asking where I was. I told him I was in England, and he replied, "Why? You've got a gig in America next week." I got straight on the phone to Patrick and asked him what the hell was going on. He replied, "I've set it all up, the contracts are signed, so you can't pull out. The promoters will sue you to death." I asked him who else was on the bill and he said Deep Purple, our old mates Emerson, Lake & Palmer, the Eagles, Earth, Wind & Fire and a few others. When I asked who was headlining, he said Deep Purple and ELP were still arguing about it.

We couldn't really turn down such a high-profile gig, however much I was enjoying my break back in England. And we soon got back in the swing of things, flying to the venue in a helicopter stocked with a box of cocaine. When we got there, Deep Purple and ELP were still arguing about who'd go on last (they both wanted to be playing while the sun was setting, which was the second from last or last spot). So the promoter said to us, "Look, you were supposed to be topping the bill, but these two bands are saying they're not going on unless the sun is setting. Do you mind dropping down?"

We didn't care, because we knew we'd blow everyone else to death—we were coked out of our brains by then. Even Keith Emerson playing a grand piano fifty feet in the air wasn't going to upstage us. If you watch the film, I look absolutely nuts jumping all over the stage for the first few songs—a few grams of coke and 400,000 people looking at you will make you act like that. By song four or five, I'm completely knackered.

It was also on that tour that we got to know Frank Zappa. He'd done a couple of interviews in which he'd said how much he loved our song "Supernaut" and that the riff was the best he'd ever heard. I thought he must have been joking, but then I discovered he covered "Supernaut" and "Iron Man" onstage. I was blown away, because Zappa and the Mothers of Invention had been such a huge inspiration, musically and lyrically. That also made a few critics think again, because Zappa was about as hip as you could get. His album *Apostrophe (')* was a big hit in the States and he could do no wrong as far as American music journos were concerned.

We met Zappa while staying in the same hotel as him in Chicago and we got on so well that he invited us to his birthday party, which was the weirdest do I've ever been to. When we walked into the restaurant, Zappa and his band were sitting around this big table. And on the table were all these birthday cakes in the shape

of vaginas. One of the cakes was an entire woman, with a pump squirting champagne from between her legs. If that wasn't odd enough, suddenly a load of naked girls marched in and did handstands against the wall, before Zappa wandered over and gave them champagne enemas. I say it was weird, but it was probably par for the course for a Frank Zappa party.

MONEY TROUBLE

Despite Zappa's kind words and going down a storm at the California Jam, we barely saw any money from that tour. Or any other tour for that matter. Worse, none of us had any idea how much money we should have been making, because Patrick never showed us accounts. He'd just send us the occasional cheque, so we could pay the bills or maybe buy a new car. Meanwhile, he had a new car every time we saw him and flew around in a private jet, while his business practices were becoming shadier and shadier.

He had this dodgy mate called Willy who organized a gig in Sicily. It was one of the strangest gigs we did—we went on before the headline act, the Dutch Swing College Band (a Dixieland outfit from the Netherlands), who got pelted with rocks and bottles.

Ozzy and Tony were going through money fast. But while Tony was buying Ferraris, Lamborghinis and all sorts of other flash stuff, I was thinking, *I'm not going to do that, I'm going to save some of my money for later in life.* However, I knew something was awry when I asked Patrick for some cash to buy my mom and dad a house. He told me "we" didn't have enough because Tony and Ozzy had bought their parents a house already, and that I'd have to wait until after the next tour. As you can imagine, that stung a bit.

I tried to buy my mom and dad a house anyway, because I thought they needed cheering up. In 1974, the IRA bombing cam-

paign came to Birmingham, when two city centre pubs were blown up, the Mulberry Bush and Tavern in the Town, killing twenty-one people and injuring 182. My nephew Jimmy often drank at the Mulberry Bush, and I had to call my sister to make sure he was okay.

Following that terrible night, my dad had to leave his part-time job because of his Irish accent. There are only so many times you can be insulted and sworn at. Then the Sacred Heart church was fire-bombed in retaliation for the IRA bombings. It wasn't a good time to be Irish in Brum, even though most Irish citizens were disgusted by the IRA's terror campaign.

However, when I suggested the idea of buying a new place, Dad went nuts: "What, this house isn't good enough for you anymore?" I was shocked by how offended he was. Pride is one thing, but getting angry because your son is trying to make your life more comfortable is something else completely. But I came to understand where he was coming from. Mom and Dad had always had trouble accepting gifts, even small ones. When I bought them a color TV years earlier, they asked, "Where are we going to put that?" I felt like saying, "Where the black-and-white TV that's always on the blink is now!" They were always worried the band wouldn't last and that I wasn't appropriately saving for the future.

Meanwhile, on a lighter note, John Bonham turned up at my house to take me for a ride in his newly imported, from California, hot rod. He was really excited about the drum track he'd laid down on the new Led Zeppelin album, so off we went to his house, where he played me the new track. He mimed every stroke, as he explained the nuances of the drum track. I was blown away at what he was playing. After the track finished, we had a couple of lines of gack with our cups of tea, and I asked what the track was called. "Kashmir," he informed me.

SABOTAGED

Things came to a head with Patrick when we all received tax bills for money we'd never seen. When we went to his office to confront him, he told us there was hardly any money left and wrote us each a cheque for a thousand quid. We realised that Patrick was giving us just enough money so that we could buy nice houses and nice cars, and assuming we wouldn't ask any awkward questions about where the rest of it—the publishing money, the touring money, the royalties—was going.

He thought we were four thick oiks from Aston who should simply feel lucky we'd made any money at all and who he could take for a ride for as long as he wanted. But at least we got a parting shot in. When Meehan popped out of the office, Ozzy relieved himself in his cognac decanter. While Meehan was telling us lie after lie, he was sipping a piss cocktail of Ozzy's mixing.

The lawyers we called in were worse than Patrick. Like him, they thought, *These four idiots haven't got a clue, we'll just give them bills for any amount.* We ended up spending something like £120,000 in lawyers' fees, which was a lot of money in 1974. Patrick seemed to have charmed our lawyers, put them under his spell, because it felt like they were on *his* side rather than ours. Maybe he'd made them an offer they couldn't refuse—who knows?

Eventually, our lawyers struck a "deal" that meant we had to pay Patrick $1 million to get out of our contract. Because Warner Bros. didn't want to get caught up in any legal wrangles, they loaned us the money as an advance on the next album. But that still left us all skint, because any money we made on the album had to go straight back to them. In fact, we were skint for the rest of the seventies.

It was only when the so-called new wave of British heavy metal bands started coming through in the late seventies and early eight-

ies, and were citing us as "the Godfathers of Metal" and their biggest influence and inspiration, that our back catalogue was revived and we started earning what we should have been. It was devastating, knowing that we'd sold God knows how many million records and had almost nothing to show for it. We even discovered that anything of value we had—houses, cars—was actually *owned by Patrick*. We had to buy our houses back off him, at the original prices. Thanks a lot!

I felt silly that Patrick had managed to rip us off so easily. But I was more bitter at the betrayal. I'll always remember a conversation I had with Patrick when he started managing us. I'd said to him, "The one thing I want from this is for my mom and dad to be okay." And he replied, "Of course they will, you'll make so much money that they'll never have to worry for the rest of their life." Meanwhile, he was ploughing most of our money into other businesses and spending the rest on big houses, flash cars, gambling and racehorses.

With Patrick out of the picture, Joe Smith, Warner Bros.'s head of A & R, flew to England in a panic, wondering who was going to manage us. We decided we'd do it ourselves, with the help of our tour manager Mark Forster. But we had a hell of a lot on our plate. As well as the legal wrangle with Patrick, our old manager Jim Simpson was suing us for breach of contract. There were lawyers coming in and out of the studio every day, serving us writ after writ and telling us we needed to be in court. Our accountant, who we'd only met once, was living in the Bahamas. Managing a band is hard at the best of times, but we'd been thrown into the choppiest of waters.

Making our next album was a nightmare. We were under pressure to come up with something special that was going to sell, in an environment that wasn't conducive to creativity. We were in and

out of the studio for ten months, having recorded *Paranoid* in five days. We were drowning in booze and cocaine. We were drained and frustrated. We called that album *Sabotage* because we thought we were being sabotaged. That's why it sounds so bloody angry.

For all our problems, there are some pretty powerful tracks on *Sabotage*. "Hole in the Sky" has one of Tony's best riffs and some of Ozzy's most violent vocals—he sounds like he wants to kill someone. Meanwhile, my lyrics were dark and full of grievances about pollution, the hole in the ozone layer ("there's no future in cars"), the fall of the West and the rise of China as an economic power. Stuff that's come, or is coming, true.

"Symptom of the Universe" is about as heavy as we ever got, before turning it into an acoustic jam for the last couple of minutes. We did that as a laugh but liked it and decided to tag it on the end. That song is about love, belief and fate. I still believe in fate, that everything that happens in my life is pre-planned. That's why my bitterness towards Patrick waned over the years. To be fair, he'd got us to America, and everything else, even negative, just had to happen that way.

Tony wanted that album to be more rock and less experimental than *Sabbath Bloody Sabbath*, but it still has its quirkier moments. We got the English Chamber Choir in for "Supertzar," which Tony had written with his wife, who played the harp. Tony played it to us and we decided to put a big chorus on it. When Ozzy turned up to the studio and saw the choir there, he thought he was in the wrong place. He was beginning to get very fed up by then.

We all hated going into the studio and dealing with all those lawyers, but it hit Ozzy hardest. That's why the song "The Writ," which Ozzy wrote the lyrics for, is dripping with resentment. He put it better than I could have done: "You bought and sold me with your lying words . . . All of the promises that never came true, you're gonna get what is coming to you . . ." The track "Megalo-

mania" is more of the same, a diatribe against all the power-mad record industry people and lawyers who were making our lives so miserable, and a desperate plea for them to get out of our lives and leave us alone.

The bloke laughing at the start of "The Writ" was a mad Aussie mate of ours; it was mixed in with the sound of a baby crying, and slowed down to make it sound eerie. Our coproducer Mike Butcher found that tape just lying around in the studio and never found out who it belonged to. That baby will be in his mid-forties now.

Despite the pain of delivering *Sabotage*, it was another good record. Not that I listen to it much, because it brings back so many bad memories. And the less said about the album cover the better—even that was sabotaged!

Graham Wright, Bill's roadie, came up with the idea of the four of us standing in front of a mirror in a spooky castle, dressed in black and staring at our inverted reflections. We were told to turn up to the photographer's studio on a certain date, for what we thought was a trial session. But they ended up using those shots instead. It was a complete farce. Bill had borrowed his wife's red tights and didn't realise his underpants were showing through. Ozzy's wearing a kaftan, Tony looks like a Spanish waiter and I'm in a jacket and a smart pair of trousers. But we were all so jaded by then that we didn't really care what we looked like.

That was a terrible time, and the only people I could discuss the problems with were our lawyers and bandmates. I couldn't talk to my parents about it. They were natural worriers, and because I was their youngest child, I was still the baby to them. They wouldn't have been able to understand my situation anyway. If I'd said to my dad, "We're being ripped off," he'd have pointed straight at my car, brought up my lovely house in the countryside and said, "Really? You must be having a laugh . . ."

I couldn't speak to my brothers and sisters either, because I was

operating in a different world to them. They were living normal, working-class lives, doing normal, working-class jobs and living in normal, working-class houses. If I'd started complaining, they would have said, "How on earth can you be miserable, with everything you've got?" It was difficult for them to relate to what was going on. It's all relative, I suppose; we were doing what we loved doing and we were far better off than 99.999 percent of the world's population.

Meanwhile, I'd lost contact with most people outside the band. My best mate from Aston had moved to Bournemouth and another old school friend kept asking me for money, so I went right off him. It was Sabbath against the world, as far as I was concerned. We had to rely on each other, because there was no one else who understood or who we could trust.

7

BLOOD, SWEAT, AND FEARS

GOING SOFT?

We were back on the road before *Sabotage* was even released, be-cause we'd booked the tour three or four months into recording the album, not thinking it would take much longer. It was a relief to be back doing what we loved, after ten months penned up in the studio and wrangling with men in suits. And while *Sabotage* only made it to number twenty-eight on the American album chart (it made it to seven in the UK) and the critics gave it another maul-ing, we were still in great demand as a live act. We did two tours of the States in 1975 and saw the future of rock in Syracuse, where we were supported by Kiss.

I wasn't a big fan of Kiss's music—I thought it was a bit cringeworthy—and they gave our road crew a torrid time. First, they demanded our back line and drums be shifted to accommodate their gear, and wanted to confiscate one of our crew's cameras, because he'd taken a photo of Gene Simmons sans makeup. He hadn't a clue who Gene Simmons was, he was merely taking a

photo of our stage setup and Simmons happened to walk in front of it.

But I will say that Kiss's production was incredible. Once upon a time, rock bands would go on, plug in and play. The fans didn't expect anything more than that. But Kiss were the first band I'd seen, at least who played our kind of music, to put on those kinds of theatrics. Arthur Brown had used fire and makeup in the 1960s, but nowhere near on this level. As well as makeup and flames everywhere, Kiss had explosions and thunderous sound effects, while Gene Simmons would spit fake blood. And we had to follow them. We ended up playing to a stunned crowd with polite applause after every song.

Back in the studio, Tony was spending more and more time experimenting and taking longer and longer to perfect his guitar solos. He even wanted a keyboard player to join full-time, which I was wary of. I thought it would soften our sound. In fact, after *Sabotage*, it didn't feel like the same band anymore and I was losing interest. Ozzy started talking about wanting to leave, because he didn't feel part of things. He even suggested we all knock the substance abuse on the head, which was a pretty drastic suggestion coming from Ozzy.

I never had the same capacity for booze and drugs as the other three anyway, so thought it was a good idea. I couldn't physically drink a bottle of vodka, like Bill or Ozzy. I'd get drunk after two or three pints and want to kill everybody. I'd do a couple of lines of coke and my heart would go into overdrive; I'd be sweating profusely and panicking. But more than that, I just didn't see the point of letting booze and drugs take over your life. We didn't have that kind of money anymore and it was turning our brains to mush. But the other three were already in too deep. The day after his great suggestion, Ozzy turned up at my house with a crate of champagne and an ounce of coke.

We stayed up all night boozing and snorting until around 9 A.M., when the doorbell rang. Ozzy looked out of the window and saw two blokes, dressed in trilby hats and raincoats, as it was pouring with rain. He thought they were detectives and went into full panic mode, but when I opened the door, I discovered that they'd come to pick my car up for servicing. Panic over!

In 1977, we all moved to Miami to record, because we couldn't pay our tax on top of our debts. It made sense anyway, because we were already spending so much time there. My wife and I were already leading separate lives and she stayed behind in England. It can't have been easy for her, being married to a bloke in a rock band. And she certainly got lonely, because I'd come home from a tour and find letters from other people she was seeing. But I couldn't really have a go at her, because I was seeing other people as well.

We set up shop in Criteria Studios, where Fleetwood Mac had recently recorded *Rumors* and the Eagles had just recorded *Hotel California*, two of the best-selling albums of all time. Not that we felt much of a vibe—in our jaded state, a studio was just a studio. When we turned up, the Eagles had just moved out, and one of the faders on the control desk wouldn't move. When the technician had a look under the mixing board, he discovered it was all clogged up with cocaine.

By this stage, punk had got big in the UK. I didn't like the politics of punk, all that swearing, snarling and spitting. It was a lot of posturing, a lot of fake toughness. But I liked some of the bands, particularly the Sex Pistols and the Stranglers. In the UK, people saw punk as a welcome antidote to the pomposity that had seeped into a lot of heavy rock. It was just so much more down to earth, fresh and angry. Just like Sabbath used to be. Meanwhile, Tony was in the studio, saying stuff like, "We'll put ten guitars on this bit, another nine on this next bit, some keyboards over here," and

I'd be thinking, *I have no idea what he's talking about. Why can't he just play the riff like he used to?*

Because Tony didn't have a producer to rein him in, he'd do endless guitar solos. He'd play it the first time and we'd say, "Yeah, that sounded great." Then he'd say, "I'll just do it one more time." Hours later, he'd be playing it for the twenty-fifth time and everyone else would have left, because we'd got so fed up listening to the same solo over and over again. The crazy thing was, his best version was usually his first one.

Talking of punk bands, when the Ramones supported us in 1978, they got booed off every night. One show, the audience lifted up the front row of benches and threw them on the stage, as well as showering the band with bottles. The Ramones played the same song over and over again just to piss everybody off even more. After a handful of shows, Joey Ramone came to us and said, "We love touring with you but it's just not working for us." We really liked them, but we reluctantly had to let them go. Punk never really took off in America, probably because most Americans found it too raw.

The bar around the corner from the studio had nude barmaids, and that's where I wrote the song "Dirty Women." As usual, music journos thought it was misogynistic, but it was actually a pop at all the dirty old men in the pub, ogling the women. That was also where I came up with the album title, *Technical Ecstasy*, and the idea for the cover.

Ozzy thinks that cover is terrible—"Two robots screwing on an escalator" is how he once described it—but I thought the idea of robots in ecstasy was brilliant, something that might come true one day. And when the guys from Hipgnosis drew it up, it looked great. To be honest, I just wanted to get away from the satanic stuff and have something that looked more modern.

Because *Sabotage* had sold something like half of what our al-

bums normally sold, we were trying to figure out what direction to go in. Punk bands were doing what we used to be known for—delivering rawness and heaviness and in-your-face, smack-you-over-the-head lyrics—while soft rock was becoming bigger and bigger, with bands like the Eagles, Boston and Journey all selling records by the shipload. So Tony was thinking, *Do we strip it back and go heavier, to compete with punk? Or do we go lighter and more melodic, to compete with soft rock?* He was in a bit of a quandary. He was the band's chief writer and knew that if he took us in the wrong direction, we could be toast.

Soft rock may have sounded like an odd direction for Sabbath to go in, but I liked some of the music those soft rock bands produced. Boston, whose eponymous debut album and single "More Than a Feeling" had gone stratospheric in 1976, supported us on tour later that year, and we became good friends with them. Tom Scholz wasn't much of a mixer, but I had some amazing, if harrowing, chats with their drummer Sib Hashian, who had served in Vietnam. Sib would often ride on our bus and tell us of the horrors he witnessed.

Tony got his way and added a keyboardist, a guy called Gerald "Jezz" Woodroffe, who would mainly fill in chords while Tony was off on one of his solos. We paid Jezz well, and he was a good musician, but the poor bloke got bullied a bit. When we played live, we'd hide him behind a curtain and the road crew would set up the dry ice so that he wouldn't be able to see his keyboard. And because he looked a bit like a parrot, they'd hover a plastic parrot over his head while he was playing away, completely oblivious.

We ran out of money halfway through recording the new album and had to ask Warner Bros. to wire us some. They sent us a telex back, telling us money was on the way and that we should treat ourselves to a McDonald's. I thought, *We've made you tens of*

millions of dollars and now you're taking the piss out of us. Thank you very much . . . But we just had to take it on the chin.

Technical Ecstasy was a critical and commercial flop, only reaching number fifty-two in the States and not making the Top 10 in the UK. In trying to vary our sound, all the trademark doom and gloom had been lost. We'd ended up sounding like a pale imitation of Black Sabbath, too polished and too soft.

There are some decent moments on that album, though. My favourite song is probably "It's Alright," which Bill wrote. He loved the Beatles, so everything he came up with sounded like them. And when he played "It's Alright" to us, we all thought it was great. Ozzy thought Bill would sound a lot better on the track than him, so Bill sang it as well. "All Moving Parts" was another decent track, although the lyrics make no sense. It was supposed to be about a female politician who dresses as a man to get more respect (it was loosely based on Margaret Thatcher). But Ozzy wrote the lyrics to the second half of the song and they had no connection to what came before.

A couple of the songs on *Technical Ecstasy* are just terrible. I came up with the riff on "Gypsy," which is the worst track on the album. Just the title makes me cringe—and the record company put it out as a single. Suffice to say, it didn't sell as many copies as Boston's "More Than a Feeling."

For all our problems, we still managed to have a few laughs while recording *Technical Ecstasy.* One day, Andy Gibb, the younger brother of the three Bee Gee boys, paid us a visit. When he walked into the studio, Tony was blowing up a sex doll with some helium, so we got Andy to take a puff and sing his latest single. Andy was one of the good guys and left us far too soon.

Another time, Bill got dressed up as Hitler. Tony stuck black gaffer tape on his head, to look like a Hitler haircut, and also made

a Hitler moustache. Bill was standing in the lobby of the studio, shouting and screaming in fake German while doing Nazi salutes, when Julio Iglesias walked in with his Jewish manager. Their jaws almost hit the floor. When Bill had finished goose-stepping across the lobby, he spun around, saw Julio and his manager staring at him in horror, ripped the gaffer tape off his head and pulled most of his hair out. God knows what he'd been drinking.

One night, Ozzy wanted to head into Miami's city center. But instead of getting a taxi, like most normal people, he stole a motorbike. The bloke whose bike it was called the police and Ozzy was arrested and slung in jail. When the police called and asked us to collect him, we told them to keep him in for the night. Luckily, the owner of the bike was a big Sabbath fan and didn't press charges.

But despite all the fun shenanigans, when I hear *Technical Ecstasy* now, I just feel a bit sad, because it's the sound of the original lineup nearing the end. We'd lost our spark and it sounded like we were fading into irrelevance.

THE HELLEVATOR

The live shows were still going great, and we did two tours of the States at the end of 1976 and start of 1977. People might not have been as interested in our new offerings, but they were still willing to pay money to see us play our classics.

My main memory of those tours is a cop pulling a gun on me in Norfolk, Virginia. Norfolk is home to the biggest naval base in the world and quite rough-and-tumble. One day, we were having lunch in the hotel restaurant when the manager came over with a tray of glasses in the shape of boots, with little whistles attached to them, to blow when we wanted another one. We spent the next few hours necking boot after boot, and getting absolutely smashed,

until the manager abruptly told us we'd had enough and that he was closing the bar. But instead of leaving, we stood our ground and became even more obnoxious. Someone suggested we try to stick the table to the ceiling, using ketchup, mayonnaise and all this sticky liquor we'd been drinking as glue. As we were doing that, all the other hotel guests were running towards the exit in fear. It was like a scene from a disaster movie.

Meanwhile, Ozzy had somehow pulled a girl and taken her up to his room. This hadn't gone unnoticed by Tony and Albert Chapman, our new tour manager, and they followed Ozzy upstairs and smashed his door in. By the time I got up there, the door was hanging off its hinges, Ozzy had been dumped in a bath of ice-cold water and the girl was nowhere to be seen.

I crept back down to the bar, heavily disguised (so I thought). And when the barman refused to serve me, I decided to help myself. But as I was pouring myself a beer, a cop stormed in, pointed his gun at me and told me to move out from behind the bar. I was wearing my Aston Villa jacket, so I said to this cop, "Go on, shoot me—I'll die for the Villa!" And he replied, "What the hell's the Villa?! I'm gonna shoot you if you don't move away from the bar!" At this point, Albert came running in, threw me over his shoulder and got me the hell out of there. Good job he did, because America being America, that cop probably would have shot me if I'd carried on giving him lip.

In those days, behaving badly was just what rock stars were supposed to do. We were basically a load of working-class hooligans on tour and our record label would even encourage us to behave badly, like the time our publicist suggested we have a fake fight with Slade. Both bands politely declined, thinking it a pathetic idea, especially as we were all friends.

We wouldn't last five minutes nowadays, doing the stuff we did. On tour in Germany one year, we arrived at our hotel in Mu-

nich and decided to get stuck into a few lunchtime bevvies. German beer isn't exactly known for its weakness, so by the time our food was served, we were well on the way to sozzledom—and Ozzy had already pissed under the table. Very appetising.

Ozzy then decided he needed to do a number two. On his way to the elevator he'd already started undoing his trousers. When he got into the elevator, instead of going up to our floor, the elevator went down to the basement. Meanwhile a coachload of American tourists had just checked in and were now waiting for the elevator. When the doors opened, the tourists were greeted by the sight of Ozzy, crouched down with his trousers around his ankles, a big turd beneath him. Nobody said a word. Not me, not a single American tourist, not Ozzy. As the doors closed on the shellshocked tourists, I was thinking, *Did that just happen?* Then I started laughing as hard as I've ever done. I was literally doubled up, my stomach in pain. Ozzy at his finest.

Another night in Germany, we went to a club for a few drinks. Our support band the Streetwalkers (who were fronted by Roger Chapman, formerly of Family, one of my favourite bands) were already in there and things were really rowdy. Unbeknownst to us, someone from the Streetwalkers had threatened a couple of German blokes. When I made my way upstairs to the toilet, one of those blokes was coming down the stairs, and he kicked me in the face. I was desperate for a piss, so carried on to the toilet. But when I came out, all hell broke loose.

Albert Chapman (not Roger, just to clarify!) had seen the bloke kick me and proceeded to pummel him into oblivion. That triggered an all-out bar brawl, involving Sabbath, the Streetwalkers, a load of random German punters and a handful of bouncers. Someone whacked me across the back with an iron bar and Albert got shot in the mouth. It wasn't a pretty sight.

Having finally fought our way out, the police were waiting for

us. As I was getting in the van, I said, "The Hilton, please . . ." They didn't see the funny side and drove us straight to the police station instead. It took a lot of wrangling before Mark Forster and the local promoter managed to secure our release.

The advent of social media and smartphones means you can't get away with anything anymore, let alone crapping in a German elevator in front of a coachload of American tourists. And because the music business is so much more sanitised, and controversy doesn't sell like it used to, too much bad behaviour would get you cancelled in a heartbeat. That's why today's pop stars are a lot more sensible. And if they do ever behave badly, they're smart enough to do it in the privacy of their own homes.

FLICKS LIKE A KNIFE

AC/DC supported us in Europe in 1977, which is where the infamous story about how I attacked their guitarist Malcolm Young came about. Time to put the record straight. I'd always loved weapons growing up, and when I was in Switzerland, I bought myself a flick knife. But it wasn't an actual flick knife, which were illegal in Britain and the US. Instead, I bought myself a "flick knife comb"—it looked and functioned like a flick knife, but instead of a blade, a comb shot out when you pressed the button.

After both bands had been to see Slade in concert, we all went back to the hotel bar and I started showing people this knife/comb. And a few minutes into my knife/comb demonstration, Malcolm suddenly said to me, "I suppose you think you're a big man?" I shrugged and told him it was just a comb, and he started calling me all sorts of names. I ignored him—like I usually did with drunks, unless I was really drunk myself—and the following morning, Malcolm came to my room and apologised.

That was the end of it for me, but AC/DC suddenly disappeared. Then I started reading stuff about me pulling a knife on Malcolm, him punching me and Sabbath chucking AC/DC off the tour. That never happened—there was nothing physical between us, and I have no idea why AC/DC quit when they did. It's a great example of the media's habit of taking innocuous incidents—in this case, just a couple of drunk blokes having a trivial disagreement—and blowing them out of all proportion.

One thing is true though, namely that AC/DC's Bon Scott was in a terrible state on that tour. I was going up to bed one night and walked by him lying unconscious on the stairs. A few years later, Bon passed out in a friend's car and died of alcohol poisoning. He was only thirty-three. That's what I mean about booze and drugs taking over your life—it's a very dangerous business.

UNRAVELLING

The night before a gig at the Birmingham Odeon, we got a call from Ozzy's wife Thelma, telling us he'd overdosed and was in hospital. Any time we played Birmingham was a big deal, our most important show. They were our people, so we always wanted to be at our best. But now we were thinking, *Oh, great, we're going to have to tell the fans the show's cancelled.*

However, the next morning, Thelma called to say that Ozzy had had his stomach pumped and was going to do the gig after all. Don't get me wrong, we were pleased that Ozzy was still alive. And when he turned up at the venue, he was fresh as a daisy and raring to go, as if nothing had happened (that's one way of getting a good night's sleep, I suppose). Meanwhile, we were all really pissed off, because we'd been up all night sitting by the phone, fearing the worst.

Ozzy was really going downhill by this point. His dad was dying of cancer and his marriage was falling apart. Thelma was a lovely woman, but the booze and the drugs had addled Ozzy's brain and the things she had to put up with would have tried the patience of a saint. He was also unhappy that Tony had brought Albert Chapman in as tour manager. He had been intimidated by him since school days.

I went to their house one night and Ozzy had trashed the place, smashed everything to bits. The scene was spooky: Marionettes Ozzy had procured from some old Victorian fair were impaled with crossbow bolts and hanging from his living room wall. He'd also killed all their chickens with a shotgun, mown them down like a maniac. Ozzy had worked in a slaughterhouse and always had a cruel streak when it came to animals, long before he started biting the heads off bats. One year, after a gig in Ipswich, this bloke invited us over to his restaurant, where he had lobsters in a tank. When he put one of the lobsters on a table, Ozzy flicked its eyes off. That was the closest I ever came to smacking him. But when I saw all these dead chickens, I couldn't help feeling sorry for Ozzy, because he was clearly in a world of pain.

In the summer of 1977, we went back to Rockfield to write and rehearse a new album. But the atmosphere was nothing like it had been when we were there seven years earlier, writing and recording *Paranoid*. Back then, anything seemed possible. We were a band of brothers, having fun, brimming with creativity and ready to take on the world. Now, we were almost clapped out.

After a few frustrating weeks, mainly spent waiting for Tony to come up with the goods, I decided to return home to Worcestershire. A few days later, Bill paid me a visit and told me I was fired (Tony was quite happy to beat up strangers, but he hated confrontation with his bandmates, which is why Bill became the

spokesman by default). Apparently, the other three had had a meeting and decided my heart wasn't in it anymore. I didn't really know how to react. I was pissed off, obviously, but a part of me was relieved. The rest of the band were right—I had lost interest. So I thought, *Thank God they've made the decision for me, so I can get on with the rest of my life.*

I spent the next two or three weeks staying healthy and getting lots of rest, not really thinking about anything, let alone what the future might have in store. Then, out of the blue, Bill phoned to say rehearsals were starting the following day. I'd been "unfired," without any explanation. When I met up with the rest of them and asked why I'd been sacked in the first place, they all denied they'd had any say in it. Tony said he had no idea how it happened, as did Ozzy. Bill, who enjoyed his spokesman status, claimed he was just the messenger and started going on about "moot points" and other law terms he liked to use.

I never did get a proper explanation. But my whole attitude changed towards the band members. I felt I could no longer trust them as I had always done. A little bit of me died back then, knowing my so-called "brother" bandmates were talking about me behind my back, negatively, after all we'd been through together. The dream was over—welcome to reality!

I almost didn't want to be invited back, but I had nothing else going on. It was as simple as that. And when I returned to Rockfield, there was a bad feeling around the place. The atmosphere got decidedly worse when our accountant came down to Monmouth, told us we'd never paid any tax and that if we didn't settle our bills, we could all go to prison. That was a very bitter pill to swallow, because once again, he was talking about tax on money we'd never seen—money that Patrick Meehan had been stealing from us.

Upon hearing of our tax situation, I told Ozzy that I wasn't

going on another tour unless we knew what we were going to get paid beforehand. As Ozzy remembers it, he then called a band meeting, in which he said it was crazy that we were touring for the benefit of our lawyers. Apparently, I just shrugged. I can't remember that, but it could quite easily have happened. A couple of days later, Ozzy upped and left.

Ozzy's sudden departure was hardly surprising in hindsight. He felt he wasn't being listened to and had no say in our recording or touring agendas. And like me, he thought there was too much keyboard on our last album, and that we'd lost our rawness. He'd been talking about doing his own thing for months and had "Blizzard of Ozz" T-shirts printed. He'd even started trialing musicians and suggested we do an album together, just the two of us.

Ozzy knew I shared his disillusionment and had been writing a lot of my own stuff at home. But we were in a fix, because we had an album to record and a tour lined up, while we'd also agreed to do a regional TV show in Birmingham a few weeks later.

In a bit of a panic, Tony hired his old mate Dave Walker, the former Savoy Brown and Fleetwood Mac front man. Dave was the only person we thought could do it at such short notice, but it was a total disaster. I quite liked the stuff Dave had done with Savoy Brown, but we played a couple of songs on this TV programme and Dave just didn't fit. He didn't look the part, didn't sound the part. I honestly thought Dave spelled the end of the band.

While all this was going on, Ozzy was talking to the press about starting his own band. But he eventually came back. He didn't really want to but, like me, he couldn't think what else to do. And he wasn't in any kind of condition to start ploughing his own furrow. That was bad news for Dave, who had been busy writing lyrics for the new album, but the rest of us were massively relieved. At least with Ozzy as our front man people might still want to see us.

Ozzy hadn't been back long when he collapsed in the middle

of a rehearsal at Bill's farm. After peeling himself off the floor, he said, "I don't know what happened, it felt like my whole brain went blank." A couple of minutes later, someone called to say his dad had just died. That was a hammer blow for Ozzy, but I think it made him realise that he had friends in the rest of the band, because we gathered round and did everything we could to help.

NEVER SAY DIE!

In January 1978, we headed to Toronto to record what would become *Never Say Die!*, our eighth studio album in as many years. That was another disastrous decision. The Rolling Stones had recently recorded at Sounds Interchange, and everybody was telling us it was the best studio on the planet—as well as cheap. But when we turned up, we discovered it had thick shag carpets and drapes in the recording rooms, which deadened the sound. So the first thing Tony did was rip the carpets up and pull the drapes down, which didn't go down very well with the owner, who wasn't shy in sending us the bill.

The only reasonably priced rehearsal place we could find in downtown Toronto was a cinema, which let us play from nine in the morning until noon. We'd write and rehearse there before heading over to the studio to record. On the first day, we were playing away when we suddenly heard this strange noise. We stopped playing, peered into the gloom and eventually made out a cleaner vacuuming at the back of the room. The fact that a vacuum was overpowering our music wasn't a good sign. But instead of being upset about the interruption, Tony announced he wanted to put the sound of the vacuum on the album. And he was serious. Then, bang on twelve o'clock, the manager threw open the doors, cinemagoers started streaming in and we were asked to leave.

Toronto in January is absolutely freezing and I got a cold in

my ear, which meant everything sounded like I was underwater. That's not ideal when you're trying to record an album. But I think the lowest point of our time in Toronto was when we went to a restaurant for lunch and we only had enough money between us to pay the waiter a one cent tip. As we were leaving, this waiter started calling us "cheap, dirty bastards." It was so embarrassing.

We decided to finish the album at Morgan Studios in London, where Ozzy spent most of his time passed out in the studio bar. I'd rewritten the lyrics for "Junior's Eyes," so that it was now about Ozzy's dad, but when I presented him with the lyrics for "Breakout," he said, "I'm not singing that." Then when I handed him the new lyrics I'd toiled over, he didn't even bother reading them.

After writing the lyrics for "Air Dance," which is about a dancer reflecting on her younger years and past glories—and therefore about the state of Sabbath—I thought, *I've had enough of this*, and drove down to Cornwall. When I returned, Ozzy was nowhere to be seen. I soon discovered that Ozzy had also refused to sing on "Swinging the Chain," and Bill had had to do the vocals instead. Weirdly, a brass band had been added to "Breakout."

Everything about making that album was like pulling teeth, which is why so much of it brings back bad vibes when I hear it. There are some good tracks on it, particularly "Junior's Eyes" and "Johnny Blade," which was about Bill's brother, who was also into his flick knives. But we'd lost direction and served up a disjointed jumble of hard to soft rock, with no metal to be seen. And because we hadn't used a proper producer, the sound was peculiar, with far too many overdubs. Even the title of that album turned out to be ridiculous. *Never Say Die!* made it sound like we'd come roaring back to form, whereas we were actually on our last legs.

Never Say Die! disappeared almost without trace in the States, but actually did pretty good business in the UK, reaching number

twelve on the album chart. The title track also made it to twenty-one on the singles chart, which led to our second appearance on *Top of the Pops*. Me, Bill and Phil Lynott of Thin Lizzy shared a great big spliff with Bob Marley in his dressing room—it was the size of a bugle and almost took our heads off.

YESTERDAY'S MEN?

After *Never Say Die!* I started to seriously think about quitting, and Ozzy was thinking the same. But we had a big tour with Van Halen coming up, desperately needed the money and couldn't think of anything else to do.

I'd never listened to Van Halen before that tour, but I knew they were being talked about as the next big thing and Warner Bros. had pumped millions of dollars into them. When I heard them for the first time, I thought they were great. I loved "You Really Got Me" by the Kinks, and Van Halen had done a cover version and had a big hit with it in the States. Then when I saw them on-stage for the first time, in Sheffield, I was blown away by Eddie Van Halen's guitar playing. He was doing his "tapping" thing, with both hands on the fretboard, and I was thinking, *What the hell is that? Incredible!*

We got on great with Van Halen, even though we came from very different backgrounds. Eddie and Alex Van Halen had grown up with classical music, while David Lee Roth's dad was an eye surgeon. David didn't hide the fact he was very middle-class, but he was a great character and very funny. I'll never forget one of the first times I spoke to him. He was lying on the ground, wearing dark glasses and staring up at the sun. I said to him, "Alright, Dave?" And he replied, "Yeah, just catching some rays, man . . ." End of conversation.

Van Halen did their fair share of partying, plenty of cocaine and ganja, but they didn't let it affect their playing. They had a really good attitude, were desperate to prove they were the best band in the world. And as that tour went on, they really got inside Ozzy's and Tony's heads.

Eddie started doing these long guitar solos, like Tony, and Tony eventually told him to knock it off, which he did. Meanwhile, Ozzy became convinced that David was copying his act. It drove Ozzy to distraction, became a real issue for him. David was very energetic, would be jumping all over the stage on every song. He put me in mind of Jim "Dandy" Mangrum from Black Oak Arkansas, who we'd spent a lot of time touring with. Ozzy did a bit of that, but he could look quite static compared to David. David also started borrowing some of Ozzy's lines. And because we'd go on after Van Halen, the audience would think that Ozzy was copying David. When we played Madison Square Garden, their bass player, Michael Anthony, suddenly started using a wah pedal, which even I thought was a bit cheeky.

The UK tour went well, but when we got to America, things started getting difficult. We'd turn up to a gig and the Warner Bros. reps wouldn't even say hello to us. It soon became obvious that the record label was using Sabbath to make Van Halen famous—as far as they were concerned, Van Halen were their cash cow now, while Sabbath were yesterday's men.

Van Halen were going down a storm every night and while the first part of our show, with all the classics, would be great, Tony would then launch into his twenty-minute solos. He'd be at the front of the stage, eyes closed and lost in his own world, and fans would be standing there with their hands on their hips. Unusually for a metal band back then, Van Halen attracted a lot of female fans, and I suspect many of them found Tony's solos particularly

boring, especially after they'd been watching Eddie and David strut their stuff. I'd get letters saying, "Why don't you play two or three more songs instead of another guitar solo?" But we were too scared to say anything to Tony. I tried to drop hints, but they never got through. If I'd been franker about it, he might have gone mental. He'd never been great with criticism. By the time of the *Never Say Die!* tour, it was his way or the highway.

To make things worse, our recent recordings, which Ozzy had sung in a higher range than normal, were impossible for him to sing live without blowing his voice. That made our set list very limited. Even to this day, Van Halen fans talk about their boys blowing Sabbath offstage on that tour, while Sabbath fans maintain we held our own. But I will concede that we didn't hear any of our new songs on the radio while we were in America, while Van Halen were being played to death and would become a future staple on MTV. That told us which way the wind was blowing.

There were a couple of riots on that tour. The first one, in Germany, happened when the crowd spilled onto the stage mid-set and we walked off (apparently, about a thousand fans had got in without tickets—being a fan of free music, one of them probably went on to invent Spotify). The second, in Nashville, made a bit more sense, because Ozzy didn't turn up to the gig.

Ozzy had a heavy cold, so a doctor had given him some Night Nurse. But instead of taking a couple of spoonfuls, he necked the whole bottle. When we arrived at the hotel, he was already half asleep. When we got to the venue, we thought Ozzy must have gone there earlier. But there was no sign of him. There must have been about twenty people phoning his room, but there was no answer. The hotel manager said he'd looked but he wasn't in there. The gig came and went without him (Van Halen played, we didn't), the venue got smashed up by angry fans and we ended up having to

report Ozzy missing. We thought he might have been kidnapped. We even thought he might be dead.

The police scoured Nashville but couldn't find Ozzy anywhere. They printed off posters and circulated them in bars: HAVE YOU SEEN THIS MAN? There was even a news flash on local TV. The following day, we were getting on the bus when Ozzy came strolling out of the hotel, looking bright-eyed and bushy-tailed, and said, "What time's the gig?" We looked at him like he was mad. I said, "The gig was last night. You didn't turn up and we had to cancel it."

It turned out Ozzy had got off the bus, staggered into the first hotel room he could find—not the one he was supposed to be in, hence why the manager couldn't find him—fallen on the bed and gone unconscious. He'd only just woken up. A few days later, we were supposed to have our first day off in about six weeks. Instead, we had to go back to Nashville to play the gig we'd cancelled.

GLORIA

Ozzy and Bill's drinking was completely out of control by this stage, and they were constantly arguing and fighting. One day, we were checking out of our hotel; Ozzy was in the bar talking to some random bloke and Bill went up behind him and whacked him on the back of the head. Ozzy and Bill ended up scrapping on the floor and Bill's brother Jim, who was also the bus driver, had to drag them out of the hotel and onto the bus, where they continued to pummel each other. I'd just bought a very realistic-looking air pistol, so I pulled it out and said, "If you don't pack it in, I'm going to shoot the both of you." I must have sounded convincing, because they stopped fighting immediately.

I stopped getting the bus with Bill and Ozzy eventually, taking a plane instead, mainly because of Bill's lack of hygiene. Ozzy's

hygiene wasn't the best, but Bill's dirtiness was off the scale. He'd put a clean shirt on before going to bed, so he wouldn't have to change in the morning. I'd say to him, "Why don't you wear the shirt you've been wearing all day to bed and put the clean shirt on in the morning?" And he'd reply, "Nah, it's easier this way."

Most tour buses will have a toilet rule: You can piss in it, but you can't do a number two in it. But Bill wasn't having any of that, and one day the tank got full up with crap. When Bill tried to empty it, it was all clogged up. So he got on his knees and started sucking on the pipe. You've probably guessed what happened next—the tank suddenly became unclogged and Bill was covered head to toe in excrement. When Bill's brother asked if he was okay, Bill replied, "Jim, it's a positive on the shit . . ."

Because he was drinking so much, he'd puke all over the place and never clean it up. One day, I got on the bus and it stank to high heaven. There was sick all over the seats, cigarettes and joints all over the floor and cockroaches having a grand old time. That was when I said, "Okay, I'm gonna get the plane from now on." That decision would change the course of my life.

Shortly after abandoning the bus, I decided to fly to the next gig. And after landing in St. Louis—on September 16, 1978, to be precise—I noticed a beautiful, well-dressed woman waiting for someone at the gate. I didn't think love at first sight existed before then, but that's what it was. At least it was for me.

A limousine was waiting for me outside and when I saw the beautiful woman pull away in her Porsche, with her mate in the passenger seat, I said to the driver, "Follow that car!," like I was in some drippy rom-com. When we reached downtown St. Louis, I told my driver to pull up beside the Porsche at some traffic lights, wound down the window and asked the beautiful woman if she wanted to go for lunch. Miraculously, she said yes, we got on like a

house on fire and she came to our gig that evening. That beautiful woman was Gloria.

The following day, we were playing Kansas City, which isn't far from St. Louis, so Gloria picked me up from my hotel and drove me there. I hated saying goodbye to her and she's never left my thoughts since. It's sobering to think that if it hadn't been for Bill's appalling hygiene, we'd never have got together.

Back in England, after the *Never Say Die!* tour ended, all I could think about was Gloria and when I might see her again. And just before Christmas 1978, I called her from a public phone box and told her I wanted to be with her forever.

END OF AN ERA

After only a few dates of that tour, we were mentally and physically shot. But there was still the odd pleasant surprise, among all the monotony. At one hotel—I forget which one—the band and crew were having a get-together in one of the rooms, boozing, smoking and snorting, when there was a knock on the door. We expected it to be someone telling us to keep the noise down, but it was a young woman asking if she could have our autographs to give to her boy-friend, who was down in the lobby, having been barred by security.

But once we'd signed our names, the woman promptly stripped off and lay down on the bed, before inviting the gentlemen in the room to get to know her more intimately. Three or four of them obliged her, before some old guy from the tour entourage unzipped his trousers and got his tackle out. But as he was approaching the bed, the woman said, "What kind of a girl do you take me for?," before getting dressed, gathering up the autographs, bidding us adieu and leaving in a hurry.

The last gig of that tour was at the Tingley Coliseum in Albu-

querque, on December 11, 1978. And after we returned from the States, we had almost no time off before heading back and setting up in Bel Air. During this time, Tony went to see Don Arden and asked if he'd manage us. Don didn't take much persuading. He'd been really pissed off when Patrick and his old sidekick Wilf Pine had stolen us from under his nose, so taking charge of us was very personal to him.

We knew Don was basically a gangster—hence his nickname, "the Al Capone of Pop"—but he was very well-connected and on a roll, with two of his bands, Wizzard and Electric Light Orchestra, having a string of hit records throughout the seventies. Best of all, Don seemed really into our band. Everybody else thought we'd peaked and were on the way out, but Don thought there were still big things ahead of us.

When we went to see him at his mansion in Beverly Hills, which used to belong to Howard Hughes, the lads from Air Supply, another one of Don's bands, were also there. Air Supply were selling a lot of records and on a high, and when we asked them what Don was like, they told us he was great. So we thought, *Better the devil you know, let's go with Don.*

We all stayed in a rental house in Bel Air, while a garage was converted into a rehearsal studio. But Ozzy didn't arrive at the same time as the rest of us, so we had to jam without him. We actually came up with "Children of the Sea" during those sessions, plus one or two other songs, but the tapes mysteriously disappeared, which wasn't the greatest omen.

While we were waiting for Ozzy to show, one of my fillings fell out, so I went to this "rock and roll dentist" called Max, who allegedly looked after Elvis's teeth. I'd been terrified of dentists since I was a child, when our school dentist, a big German woman, once gave me three fillings without any anaesthetic, drilling right down

to the nerve on each tooth and cramming them with silver amal-
gam. It was agony, and I didn't go back to the dentist until I was
in my twenties. When I told Max about my fears, he loaded me up
with a pain reliever called Demerol, which had a similar effect to
heroin—a nice, warm feeling, followed by oblivion. When I told
the others about it, they suddenly all had toothaches. We were in
this dentist's surgery every other day, and Tony was soon addicted.
He even flew Max over to England, so he could get his fixes legally.

When Ozzy finally rolled up, about two weeks late, he was out
of his brains. It turned out he'd had a disagreement with another
passenger on the plane over from England and been detained on
arrival in LA. The rest of us were really pissed off, and when we fi-
nally got down to rehearsing, he just didn't seem into it. Tony spent
the next couple of months desperately trying to conjure new mate-
rial, with Warner Bros. nagging away at him, but Ozzy wasn't sing-
ing anything that pleased him. Touring with Van Halen had put a
big dent in his confidence, and I also don't think he'd forgiven us
for recording "Swinging the Chain" and "Breakout" without him.

Tony was very worried. We were coming off our lowest-selling
album, the tour had exhausted us and Ozzy wasn't playing ball.
Tony had always been the most professional in the band—had he
not taken it upon himself to lay down the rules, we'd have gone
down the chute years earlier—so he found Ozzy's attitude mad-
dening. For the first few albums, he loved being the leader of the
band, the main music writer and a big part of the production. But
now he thought that he was carrying too much dead weight.

Ozzy says that he kept coming up with ideas and we kept
shooting them down, but I don't remember him offering anything
great. And Ozzy had been a liability for a while, what with miss-
ing gigs, refusing to sing on certain tracks and turning up late for
rehearsals. All of us were in different stages of drug and booze ad-

diction, but it was ruling Ozzy's life, to the extent that he couldn't function anymore. So eventually, Tony said to me and Bill, "It's not going to work with Ozzy anymore, it's time to try somebody else."

Bill, as usual, was given the task of telling Ozzy he was no longer part of the band. Apparently, Ozzy dissolved into floods of tears. I hated that Ozzy was in that kind of state and it made me cry buckets. We knew we didn't really have a choice but to sack him, because he was just so out of control. But we were all very down about the situation. Bill never really got over it. It was the end of an era, for sure. I thought, *Well, that's it. We're finished.* I just couldn't see how Sabbath could survive without Ozzy up front.

8

BETWEEN HEAVEN AND HELL

NEW LIFE

Ozzy says he felt betrayed, which I can understand. I felt betrayed when they sacked me. Against all odds, us four working-class kids from Aston had changed the course of music and become one of the biggest rock bands in the world. We'd been on the road together for more than ten years and become closer than brothers. So when Ozzy was having a bad time, he expected the rest of us to stick by him. And as far as he was concerned, we were all a complete mess, not just him.

But we were heading in the wrong direction as a band, and with Ozzy on board, we were never going to get back on the right track. Plus, if we hadn't sacked him when we did, he might have ended up overdosing and killing himself. Ozzy needed a shock to the system, as well as a new focus.

After Ozzy left, it was like a mourning period, for all of us. But

the record label was demanding a new album, so we had to concentrate on that. That's how ruthless the music business is. It didn't matter that Ozzy was holed up in a Hollywood hotel, with no-one to turn to. With Sabbath teetering on the brink of extinction, it was every man for himself.

That was a very murky time, with lots of clandestine meetings and backbiting going on. Tony was seriously considering breaking up the band and doing something with Ronnie James Dio, the former Rainbow singer. He'd met Ronnie at a party and they'd hit it off immediately, probably because they were in a similar position. Like Tony, Ronnie was at a crossroads, having just been turfed out of Rainbow by Ritchie Blackmore. Ronnie said he left over disagreements about lyrical content, that Blackmore wanted him to write love songs.

I'd been talking about doing an album with Ozzy since the end of the *Never Say Die!* tour, but now that Ozzy had deteriorated so rapidly, I knew that was probably a bad idea. To be honest, I thought it would be a miracle if Ozzy ever got himself together again. Meanwhile, Bill didn't know whether to go with Ozzy or stay with Tony. Then Tony suggested Ronnie become Sabbath's new front man, which really put the cat among the pigeons.

When Ronnie tried out with the band in Bel Air, he sounded great. Rainbow had had a couple of big albums with Ronnie as their front man, including the classic *Rising*, but I hadn't really taken much notice of them. However, when we had a go at "Children of the Sea," Ronnie came out with this great vocal line, and the hairs on the back of my neck stood up, because his voice was astonishing.

We'd been scratching around for months, to no end, and Ronnie had waltzed in and immediately started making things happen. Unlike Ozzy, Ronnie was brimming with ideas. We'd been sitting on lots of riffs that Ozzy didn't like, but Ronnie gave them new life.

He also wrote his own lyrics, which was a nice surprise, because I'd become so disillusioned by Ozzy refusing to sing mine. Ronnie really cared, wanted Sabbath to be a success, which reenergised Tony and relieved some of the pressure on him. On top of all that, Ronnie was a decent bloke. He ticked every box, at least as far as me and Tony were concerned.

Bill just couldn't get over the fact that the old gang were no longer together. And when Tony told Don Arden that he wanted Ronnie to replace Ozzy, Don went berserk. Like Bill, he wanted Ozzy back on board, thought Sabbath were finished without him. And when it became clear that Tony wasn't for turning, and that Ozzy was in no fit state anyway, Don came out with the famous line, "You can't have a midget fronting Black Sabbath!," a reference to Ronnie's diminutive stature. Despite Ronnie's size—about five feet three inches and 130 pounds soaking wet—he was no shrinking violet and gave as good as he got. Now there was a divide between the band and the management.

A WEIGHT LIFTED

I loved what Ronnie was doing and Tony was on a roll writing new riffs, but Ozzy's exit and the rows over Ronnie were really getting to me. Meanwhile my personal life had got very complicated. Unlike Tony, my cocaine days were behind me—it made me too paranoid and talk too much nonsense. And unlike Bill and Ozzy, I wasn't drinking much either. But constantly touring and recording abroad had brought my marriage to its knees. And when I fell in love with someone else, a split was inevitable.

After a brief holiday in the Bahamas with Gloria, I flew back to England to start divorce proceedings. As much as I loved Gloria, it was a heart-wrenching thing to have to do. Georgina was my

childhood sweetheart, and while we barely saw each other anyway, and she knew our relationship had come to its natural end, she was still upset. That said, the divorce was quite amicable and a fairly straightforward process. We sold the house and split everything we owned fifty-fifty. The fact that I didn't have much money, and we didn't have any kids, made things easier.

After I'd sorted the divorce, Tony and Bill kept calling to ask me how I was and tell me they'd love to have me back whenever I was ready. But Ronnie's former Elf and Rainbow bandmate Craig Gruber had been brought in as my replacement, and I think Ronnie—and Craig—assumed the appointment was permanent. Plus, my return wasn't on the cards as long as Don Arden was still managing the band. I'd had enough of him, and just wanted to make music without any aggravation.

Finally, Don gave up trying to get Ronnie out and offloaded his management contract to Sandy Pearlman, who produced and managed Blue Oyster Cult (in the meantime, Don had signed Ozzy to his own record label, so he didn't walk away empty-handed). When Tony called to tell me that Don was out of the picture, at the start of 1980, I packed my bags and headed to Miami. I felt like I could have flown there under my own power, such was the weight that had been lifted from my shoulders.

BLOWN AWAY

Sandy was a strange bloke, always wore an old hat and wouldn't look you in the eye when he spoke to you. But he was full of ideas and, most important, seemed like an honest enough guy. He immediately realised our publishing and recording royalties were in a mess and set about fixing them, so that we'd finally see some money from our record sales.

When I arrived at Criteria Studios, Tony, Ronnie and Bill seemed to be getting on like a house on fire, and I got on great with Ronnie at first. Despite hailing from Cortland, New York, he was an Anglophile, more English than the rest of us. He loved dungeons, dragons, knights and anything "ye olde." He had a suit of armour in his house, which contained a little pub called the King George. His wife Wendy was English, and he supported the London football club Queens Park Rangers and loved Monty Python and all that surreal British humour. Good job, really, because Tony was soon playing daft pranks on him.

On Ronnie's first day there, me and Tony went for a walk and found a dead snake, about five feet long. Being a lover of animals, alive or dead, I brought this snake back to the house. And when Ronnie saw it, he almost jumped out of his skin. That put a very evil glint in Tony's eye. While Ronnie was working on his lyrics, Tony tied the snake to the inside handle of Ronnie's big brown Cadillac, which he looked slightly ridiculous driving, given his size. And when Ronnie opened the door, this snake jumped out on him and he almost had a heart attack. He took it in good spirits. He didn't really have a choice.

That was tame compared to some of the things Tony continued to do to Bill. Tony had been setting fire to Bill's beard for years, but when we were mixing *Heaven and Hell*, at a studio back in London, he went one step further. One day, Bill was leaving the studio when Tony said to him, "Can I set you on fire?" Bill replied, "Not right now, I'm heading home. Maybe tomorrow . . ." Five minutes later, Bill came back in and said, "Yeah, okay, you can set fire to me now if you want." Tony grabbed a bottle of flammable cleaning fluid, which was used to wipe down the mixing board between songs, sprayed it all over Bill and flicked a match at him. Bill went up like a bonfire. He was rolling around on the floor like

a stuntman, covered in flames, and we were throwing newspaper on him, thinking it would put the fire out. Of course, that just made things worse.

In the end, someone doused Bill in water, before his brother, who was obviously furious, rushed him to hospital. Bill's trousers and socks had melted into his skin, and they told him he might have to have his leg off. That didn't happen, but he's still got the scars. In the middle of the night, I got a call from Bill's mom. She was screaming bloody murder, calling me a dirty bastard for almost killing her son. I protested my innocence but refused to grass Tony up. However, she worked it out herself, marched straight to Tony's mom's house and told her what he'd done. Tony stopped setting Bill on fire after that.

As for the music, I had no idea what to expect when I first turned up. But when they played me "Heaven and Hell" and "Die Young," I was blown away, like a fan listening to new material from their favourite band. That was a huge relief, similar to when Tony played us the "Sabbath Bloody Sabbath" riff for the first time.

The improvement from *Never Say Die!* was enormous, as if it was a completely different outfit. Which I suppose it was, what with Ronnie so heavily involved. Another great thing about Ronnie was that he could play guitar, bass and various other instruments, so if he had an idea, he could explain it to the rest of us. With Ozzy, you'd write the music and he'd sing it, end of story. But Ronnie would say things like "What if we put that here?" or "Why don't we move that bit there?" And because Ronnie was an amazing singer, with a great range, the music had more places to go.

Along with the inclusion of a top-class producer in Martin Birch (Fleetwood Mac, Deep Purple, Iron Maiden) and keyboardist Geoff Nicholls, who Tony knew from way back and could also write a bit, it made us more technical than Ozzy-era Sabbath, but in a heavier way than the last two albums.

I quickly got down to adding my "missing formula" bass parts, before we all headed to Paris to record one last track. That track, "Neon Knights," summed up the band's new vigour, because it was the catchiest we'd written for years.

SABBATH—THE SEQUEL

After trashing *Never Say Die!* and implying we were toast without Ozzy, the critics hailed *Heaven and Hell* as a triumphant return to form—which was funny, given that many of them never thought we had form in the first place. The fans also loved it, making it our first million-seller in the US since *Sabotage*.

A band changing their lead singer and becoming more successful was almost unheard-of, which is testament to Ronnie's talent. I think it's fair to say that he saved Black Sabbath—if Tony hadn't bumped into him when he did, that might have been the end of the story. As it was, it felt wonderful to be relevant again.

Meanwhile, heavy metal was going from strength to strength, all over the world, and veering off into lots of different directions. We didn't think we had much in common with the new wave of British metal—I knew bands like Iron Maiden and Def Leppard were Sabbath fans, but I didn't really pay much attention to them and was more likely to be listening to one of Linda Ronstadt's albums with Nelson Riddle in the early eighties. That said, it was great to be back riding the same wave as the new kids on the block and no longer thought of as yesterday's men.

In April 1980, we embarked on our first tour without Ozzy. And the question remained: Had Don been right about Ronnie? Would the crowds accept a Dio-fronted Sabbath? The first gig was at the Aurich city hall in Germany, and it was quite a fraught affair. It was weird having Ronnie out front instead of Ozzy, and Ronnie didn't know how to approach a Sabbath crowd at first. They didn't

know what to make of him either. When we walked on stage, people were booing and shouting, "Where's Ozzy? Bring him back!," while flashing peace signs, like Ozzy used to do. But after a couple of songs, the crowd began to appreciate what an incredible singer Ronnie was.

After that first gig, it felt like we'd been playing together for years. However, Ronnie was still unsettled by one thing: When the crowd flashed peace signs at him, they expected him to return them. Ronnie wasn't comfortable doing that, because that was Ozzy's thing. So after the second gig, Ronnie said to me, "Do you mind if I do that thing you do, instead of flashing peace signs?" He meant the devil horn sign, that I'd been doing since the sixties and mainly used onstage when we were playing "Black Sabbath." I gave Ronnie my blessing and he started flashing devil horn signs all over the place. It soon became his "thing," which was fine by me.

Ozzy and Ronnie were very different performers. Ozzy was an out-and-out front man, all about getting the crowd off their arses and clapping along to every song. Ronnie was a more serious singer. He didn't run all over the stage like Ozzy—for him, it was all about the quality of the vocals and the drama. That's what he lived and died by, and it worked a treat with Sabbath. By the time we got back to the UK, the consensus was that Ronnie had breathed new life into our live act. With *Heaven and Hell* under our belts, we were a more confident band than during the last days of Ozzy. Sabbath were like a classic car that had become clapped out and needed major work. Ronnie was the major work.

We played four shows at the Hammersmith Odeon and went over great. The only person who didn't seem impressed was John Bonham, who came to the first night with Robert Plant. Bonham was pissed out of his brains. While Bill was trying to play, he started grabbing his legs, in an attempt to put him off. It didn't work, because Bill was great that night.

After the show, Bonham barged into our dressing room and shouted, "Where's Ozzy? You can't have a midget fronting Sabbath!" This was right in front of Ronnie. I was wearing a new suit, with black and yellow stripes, and Bonham tried to rip the jacket off my back. I shoved him up against the wall and a couple of security blokes had to step in and calm things down. Eventually, Tony had to kick him out, with the advice to get sober. Four months later, Bonham was found dead. He'd choked on his vomit, having drunk something like forty shots of vodka. It was so very sad—he was gone way too soon, another victim of alcohol abuse. Not that I was teetotal at the time. In fact, I was suddenly drinking like I had hollow legs.

Sandy Pearlman had us co-headlining with Blue Oyster Cult in America, hence the name of the tour—Black and Blue. BOC thought that was a great idea; we thought it was a disaster. Sandy had helped put BOC together and been producing and managing them for thirteen years, so there was no doubt which band he favoured. To be frank, we thought we were a bigger draw than BOC and shouldn't have been given equal billing.

The two bands would finish the show on alternate nights, and BOC refused to share our lights or backdrops. So if we were going on last, their road crew would spend hours taking down all their gear, including a big plastic Godzilla, before we could set up. Some nights, we wouldn't go on until 1 A.M. and everyone would be falling asleep. As you can imagine, we were fuming. I soon formed the impression that BOC enjoyed winding us up. One night, they went on before us and played "Iron Man." It was a horrible version, a piss-take, and I thought Tony was going to kill them.

As in Europe, Ronnie rode out the boos and won over our American fans. But things went from bad to calamitous when Bill decided to quit the band halfway through the tour.

Bill's industrial drink and drugs intake didn't really affect his

drumming, as it didn't seem to affect any of us. When you've rehearsed and done as many gigs as we had, playing your instrument becomes second nature. I suppose it comes down to muscle memory, like professional athletes.

One time, I dropped some acid before a gig in Leamington Spa. A girl had given me a tab, which was meant to be divided amongst the four of us. But none of the others wanted any of it, so I swallowed it whole. About an hour after I got back to my flat, the bed suddenly became a vast desert, and I was a Roman soldier. It was okay at first, but when the cracks in the ceiling started turning into snakes, I started to freak out. Then a huge eye appeared in the ceiling, looking down at me. It was terrifying.

When the sun came up, I could feel the sunbeams stabbing me. On the way to the gig in Leamington, we had to drive through a park, and I imagined all the flowers trying to get into the car to strangle me. When I walked onstage, I was completely out of it. But rather than fall to pieces, I clicked into automatic mode. I thought I was in the middle of the ocean, the spotlights were the ship's portholes, and I was watching my fingers play the songs. And I didn't fluff a note.

But while Bill could still drum with the best of them, his behaviour away from the stage was particularly extreme. I went to bed one night and left him boozing on the balcony outside his room. When I went down for breakfast the following morning, he was in exactly the same position, surrounded by bottles of beer. Another time, Bill and his girlfriend Misty staged a "nude-in." He phoned my room and said, "Come up and have a drink." And when I walked in, they were both stark naked. I didn't know where to look. John Lennon was Bill's hero and he was obviously copying Lennon and Yoko Ono's *Two Virgins* album sleeve photo. Only he was eleven years late—and him and Misty were a lot drunker than John and Yoko.

Bill was pining for Ozzy. But it was more than that. I knew something was very wrong, and it was sad watching a mate disintegrate before your eyes. But if I'd said anything, it probably would have ended in a scrap. And before a gig in Denver, Bill staggered into my hotel room, even more drunk than normal, and started blabbering on about his missus. To which I replied, "Bill, I don't want to hear about any of that stuff." He staggered out again, and the next time we heard from him he was back home in California. Him, his brother and Misty had got on the bus in the middle of the night and hit the road, without telling the rest of us.

RIOTS, PEANUTS AND SUMO

A few days after Bill left, Jim Ward sent us a letter explaining that his brother missed Ozzy too much, their mom had just died and Bill wouldn't be coming back. You might think news of Mrs. Ward's death would make us more sympathetic, but that wasn't really the case. We were in the middle of a massive American tour, were getting rave reviews and suddenly we didn't have a drummer. We'd had to cancel the sold-out gig at the McNichols Sports Arena in Denver, which held something like seventeen thousand, so we were massively pissed off.

We were forced to cancel the next few gigs as well, and the promoter in Hawaii, where we were scheduled to play the Aloha Stadium, was threatening to sue us to death if we didn't turn up. Luckily, Ronnie knew a great drummer called Vinny Appice, younger brother of former Vanilla Fudge and Rod Stewart drummer Carmine Appice. Vinny had played with the American guitarist Rick Derringer before forming his own band Axis. Most important, he knew all of Sabbath's songs. We hooked up with him in Los Angeles, went straight into a rehearsal studio and he fitted in right away.

Three days later, he was playing with us in front of fifty thousand screaming fans in Honolulu.

That was a nerve-wracking evening, and not just because we had a new drummer and didn't know how he'd perform live. There's a big military base near the Aloha Stadium, and just before we went on, a mortar bomb landed behind the stage and blew a big hole there. We also started getting reports of a sniper outside the stadium, shooting at random. Then, towards the end of our set, people started setting seats on fire.

It was like playing a gig in hell, and a particularly fiery baptism for Vinny. He was a more straightforward drummer than Bill, didn't have his swing, but he was a better timekeeper. And while he was slightly off that first night, he was magnificent in the circumstances (he had to use crib sheets for some of the songs!) and we managed to come through it unscathed.

Later on that tour, there was a full-blown riot in Milwaukee. Just as I was about to launch into my bass intro on "N.I.B.," a bottle hit me on the head and crashed into Vinny's cymbals. When the spotlight hit me, I was suddenly blinded by blood pouring down my face. I then came over all dizzy, started staggering around and was eventually helped to my dressing room, where I promptly collapsed. When the rest of the band followed me offstage, mayhem ensued.

Because the stage was still dark when the bottle hit me, the crowd didn't know what had happened. But instead of just explaining things, the idiot of a stage manager, who was with us on a temporary basis, stormed out and said, "What do you think this is, 1776 all over again? The show's cancelled, you American idiots!" The place went nuts; there were bottles flying everywhere and people were smashing the place to bits. The violence even spilled onto the streets, with cops injured and something like one hundred people arrested.

When the dust had settled, the police searched the car of the guy they suspected of throwing the bottle at me and found three rifles. God knows what he was planning to do with them. And while I was in hospital getting patched up, quite a few fans were brought in, with broken bones and covered in blood. I was thinking, *Please, God, nobody recognise me* . . . Sabbath were banned from playing in Milwaukee after that, even though we were entirely blameless.

In November, we played in Japan for the first time. We'd been banned before then, because of Tony, Bill and Ozzy's drug charges. I was so excited at the prospect, I kept singing "Turning Japanese" by the Vapors on the plane over, much to the annoyance of the cabin crew.

We were one of the first metal bands to play in Japan, and it was a weird experience. We went on in the early evening, and the fans were all dressed in suits and ties and didn't really know how to react to the music. At the first gig, we played the first song and there was polite applause. Second song, polite applause. When a kid got out of his seat and started moving to the music, a copper whacked him over the head with a baton. The only time anyone went wild was when we finished the set. It was only afterwards that the promoter told us Japanese crowds only enthusiastically clap at the end of a show.

As for the local cuisine, it was a major issue. We had to abandon one show because Tony had food poisoning. He staggered offstage halfway through the set and wasn't well enough to play the following night. At least he could find something to eat. I couldn't even find potatoes, which I lived on.

Mercifully, I found somewhere that sold peanuts and crisps. Not exactly the diet of champions, but it sufficed. After about a week in Japan, the promoter presented each band member with a bottle of sake. But it wasn't just a bog-standard bottle, it was a

special bottle, full of gold flakes. I necked the whole lot—a bad idea at any time, but especially when you've been living off peanuts and crisps for a week—put the TV on and started watching sumo wrestling. I'm not sure what pissed me off so much, but I ended up punching the screen. Not very clever when you're the bassist in a band.

My finger swelled up so badly I had to go to the fire station to have my wedding ring cut off. Gloria was somewhat annoyed about that. Then when I went to hospital, a doctor put a splint on the wrong way. My finger was broken in six places. I played the final Japanese gig but was in agony. And after a few gigs in Australia, I went to hospital again and they had to pin all the bones together. I was in the operating theatre for hours and I haven't been able to bend that finger since, which isn't great for a bass player.

BIFF

Apart from the disappearing drummer, the riots, Blue Oyster Cult being a pain in the arse, living off peanuts and crisps and shattering my finger, that was a happy time for me. We were packing them in every night, people were writing lots of nice things about us, I'd fallen madly in love with Gloria—and then we got the news that she was pregnant.

While we were recording *Heaven and Hell* in Florida, Ronnie and Wendy rushed Gloria and me to the hospital, as Gloria was losing blood. After an examination, the doctors told her she was losing the baby, but Gloria was having none of it—and she was proved right. In June 1980, she gave birth to our first child, a perfectly healthy boy. Sabbath were on tour in Germany at the time, and I was drunk out of my brains when Gloria called me to say the baby was on its way. I asked the tour manager to drive me to the airport

and he replied, "What about the gigs?" I said to him, "Forget about the gigs, I'm having a baby!"

He drove me to the airport, I got on the plane to St. Louis and I was halfway across the Atlantic, and halfway sober, when it suddenly hit me: *Oh God, I haven't even told the rest of the band. This might be a problem . . .* We had to cancel six shows and the promoter sued us for $100,000. I honestly thought the rest of the band would fire me. But when I returned to the tour, it was champagne all round. Babies don't come along often, and they knew how much it meant to me. I'll always be grateful to them for their understanding.

I'd wanted a kid for so long and had started to think I'd never have one, so I was desperate to experience the whole thing. The birth was as incredible as I'd imagined it would be. Although someone tried to spoil it. When Gloria went into the delivery room, the surgeon told her she had to take her engagement rings off and I put them in the pocket of the hospital gown I was wearing. After the baby was born, I took my gown off, got dressed and left, forgetting about the rings. When I went back to get them, they were gone, never to be seen again.

Our first son's real name is Terence Damien, but we called him Biff from the beginning, because he appeared not to have a neck and looked like a little boxer. I'd always wanted a normal, steady life, with a loving wife and a couple of kids. So after Biff was born, I quit hard drugs for good. Gloria would never have put up with that, because she didn't even drink—never had, and never understood the point of it.

Gloria was exactly what I needed—a good, honest person who loved me and had my best interests at heart. It also helped my career that she was a good business partner because before then I'd been quite indecisive and just gone with the flow. Before the Black

and Blue tour was over, we bought a house in Chesterfield, Missouri, where Gloria's family lived. And on September 16, 1980, we got married. The only people in the registry office were me, Gloria and her sister Grace. I played a gig in Fayetteville, North Carolina, that night.

People sometimes ask what Gloria saw in me. She wasn't really a fan of heavy metal or Sabbath, was more into soul. It wasn't the drink and the drugs, and it certainly wasn't the money, because I still didn't have much. I can only think that it was my dashing good looks, fun-loving personality, intelligence and irresistible charm. Nah, not really. I'm not one to overanalyse these things, I think we just hit it off. In those early days, I was more in love with Gloria than she was with me. And I was scared stiff that she'd soon get sick of me and piss off. As it's turned out, we've had many wonderful years together.

THE STATE WE'RE IN

Also on that Black and Blue tour, Tony met a woman called Melinda. His marriage had fallen apart, Melinda was very good-looking, so Tony asked her to marry him in LA, while off his head on quaaludes and cocaine. The witness at their wedding was a teddy bear. Melinda travelled all over the world with us and they had a baby a couple of years later. Unfortunately, as Tony tells it, Melinda turned out to be a kleptomaniac, who racked up huge bills on his credit cards without telling him. The moral of that story? Don't ask someone to marry you while on quaaludes and cocaine, however good-looking they are.

Meanwhile, Bill was a complete wreck. I went to see him after the Black and Blue tour and he was living in someone's garage. He had an income from royalties, but he always chose strange friends

who took advantage of him. He'd let them take care of his money and they'd run off with it. It was pointless talking to him about his predicament, telling him to pull himself together, because he just couldn't see it. It was a case of "This is just the way I am." But I couldn't believe the state he was in. He looked like a skeleton, had been horribly diminished by drink and drugs. John Bonham had only just died and me and Tony thought Bill would be right behind him. We were really upset about it, but we just had to let Bill live his own life, however it turned out.

As for Ozzy, he'd become a star in his own right. I couldn't believe how fast he'd got himself together, and most of the credit had to go to Sharon Arden. Sharon, Don Arden's daughter, first dated Tony around the time that we were recording *Sabotage*. She was alright, but a bit of a nutter. She was basically one of the lads, could drink with the best of us and was often out of control. I'll always remember one night at the Rainbow, when she was so drunk that she started kicking some bloke's Rolls-Royce in. Looking back, it's not a surprise she and Ozzy ended up together.

Sharon was always friendly to me, and she and Gloria hit it off from day one. But Sharon was always feuding with people and you didn't want to get on the wrong side of her, because she was very strong-willed and knew how to handle herself. One time, she spotted an enemy at a gig, took her shoe off and started hitting him with it. The bloke, who I think was trying to sue her, was cowering on the floor, begging for mercy. The music business is horrible and you have to be ruthless to thrive in it—and few people in the music business were more ruthless than Sharon Arden.

Without Sharon, I think Ozzy would have gone the same way as Bill, or John Bonham or any number of other rock stars who died young. As it was, she hooked him up with hotshot guitarist Randy Rhoads, former Rainbow bassist Bob Daisley and former

Uriah Heep drummer Lee Kerslake, and everything clicked into place.

I liked Ozzy's first album, *The Blizzard of Ozz*, and I was really pleased for him. I didn't want him to rot away after being fired by Sabbath, and it didn't bother me that *The Blizzard of Ozz* outsold *Heaven and Hell*. I'd got my problems sorted, he'd got his sorted, perfect. It's been written that Tony was uncomfortable with Ozzy's success, but that definitely wasn't the case. The bad stuff between Tony and Ozzy would happen further down the line.

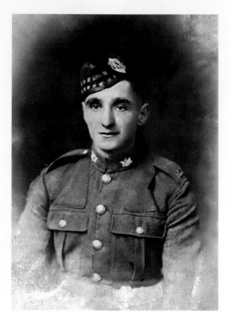

Dad in uniform, Royal Scots
Regiment, 1920s.

Me mammy, sister Eileen, and
me. Dún Laoghaire, ca. 1952.

Me in Victoria Road, ca. 1955.

Holding my homemade guitar with nephew Jimmy, niece Susan, and brother-in-law Albert Croft. Christmas Day, 1959.

Me, Dad, Mom, Granny Butler, and cousins Damien, Bernadette, and Olive in the beautiful Irish summertime, a blazing hot 55 degrees Fahrenheit. Black Rock, Dublin, ca. 1963.

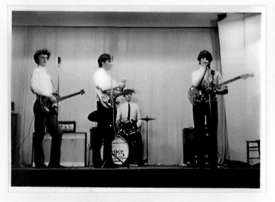

First gig. Erdington, Birmingham, 1966.

**Weekend hippy. Woburn Abbey,
Festival of the Flower Children, 1967.**
(Courtesy of the Daily Mail, *1967)*

Introducing the "Devil Horns," 1968.
(Courtesy of Jim Simpson)

**Tripping in Laguna Beach,
California, 1971.**

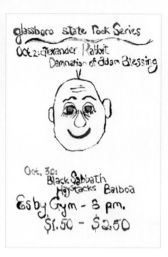

Poster for our first American gig. New Jersey, 1970.

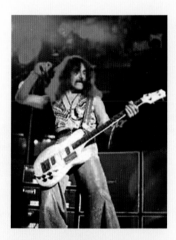

Me in action with my "Enjoy Cocaine" bass, 1973.
(Carl Dunn)

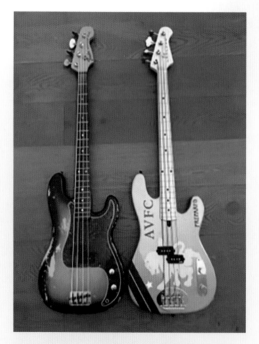

First bass to play "Paranoid," 1970, and final bass to play "Paranoid" (with Black Sabbath), 2017.

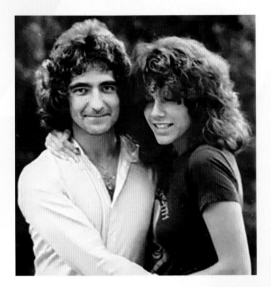

Me, sans 'stache, and Gloria, 1979.

James, Biff, and me (or is it He-Man?). St. Louis, 1986.

Fellow villain Tom Hanks and me, presenting the Portland Timbers vs. Aston Villa match, 2012. *(Courtesy of Craig Mitchelldyer/Portland Timbers)*

Receiving my Walk of Stars award on the hallowed ground of Villa Park, 2017.

Gloria with the latest Birmingham Walk of Stars recipient. Villa Park, 2017.

Upper Leeson St., Dublin, where I spent
childhood summers and saw a ghost!

With "solo" album collaborator, nephew, and
fellow villain, Pedro Howse.

Gloria and moi at one of our animal fundraising events.
(Courtesy of HSUS photographer)

Forty-three years together! 2022.

9

THE MOB RULES

CRACKS

A few days after John Lennon was murdered in New York, on December 8, 1980, we found ourselves in Tittenhurst Park, his old country house. Lennon had sold it to Ringo Starr, but the famous white piano at which he'd written "Imagine" was still in the ballroom and there were notes all over the walls, from John to Yoko and Yoko to John. It was very sad and very poignant, and Lennon's presence was so strong, I half expected him to make an appearance.

We were at Tittenhurst Park, or more correctly the studio on its grounds, to record the track "The Mob Rules" for an animated film called *Heavy Metal*. It came together very easily, probably because it felt like Lennon was hovering over our shoulders. I played my part through an old bass combo they had in the studio, made by an obscure Italian company. It had a great, aggressive sound, and I couldn't replicate it when we rerecorded the song for our next album (it would have been pretty bad form to steal the bass combo from Lennon's old studio).

It was a pretty eclectic bunch on that soundtrack, including the new wave outfit Devo, who didn't have much to do with heavy metal, and Fleetwood Mac's Stevie Nicks. I don't think the film broke any box office records, but "The Mob Rules" stood up well against the competition, and the soundtrack album went platinum.

It was around this time that Sandy Pearlman had the bright idea of the band buying our own studio in LA. It cost about £400,000, which was a lot of bloody money in 1981 (it's a lot of bloody money now!), the idea being we wouldn't have to pay studio bills anymore. Unfortunately, when we went there to rerecord "The Mob Rules," the sound was horrendous and we ended up flogging the studio at a loss (whoever bought it must have done a lot of work on it, because it's now one of the best in LA).

My abiding memory of that studio is the police being called while we were there. Our drum roadie was wearing a weird wallet that looked like a gun shoulder holster, so when he went outside to let the police in, they called a SWAT team. A few minutes later, this roadie had half a dozen rifles pointed at him and we were all standing in the doorway waving our hands and shouting, "Don't shoot! It's a wallet! It's a wallet!"

After that little saga, we decamped to the Record Plant. That's when cracks started to appear in the new lineup. Certain music writers have claimed that I had a problem with Ronnie because he wouldn't let me write any lyrics, but that wasn't the case. Me and Ronnie were good friends; I was quite happy to be concentrating on my bass parts and didn't feel sidelined. The problems were between Tony and Ronnie, who wanted people to know that he'd brought Sabbath back from the brink. There was some truth to that, but he should have known it would touch a nerve with Tony, who was the band's de facto leader.

As time went on, things started getting petty. Ronnie would

constantly complain about Tony behind his back—that his solos were too long, that he wasn't taking on board his suggestions. If Tony's guitar was too loud, Ronnie would tell me to tell him. I'd be thinking, *You bloody tell him!*

Despite the tension, *Mob Rules,* our tenth studio album, had plenty of bright moments. It wasn't as consistently good as *Heaven and Hell,* but some of the individual tracks were every bit as strong. Most of the songs emerged from jam sessions, including "The Sign of the Southern Cross," my favourite song on the album. Just don't ask me what the meaning of the song is—I thought it was about New Zealand but have since discovered it might be about Satanism. "Turn Up the Night," the opening track, has got one of Tony's boldest riffs, and "Falling Off the Edge of the World" is one of the best heavy ballads Sabbath came up with. They even made me do a bass solo on "Slipping Away," despite my protestations. When it comes down to it, I'm an introvert in a world of show-offs, although I did do a few solos live towards the end.

Mob Rules was probably our best-sounding album, along with *Heaven and Hell,* and our producer Martin Birch has to take credit for that. Martin was a great bloke and managed to hold things together even when Tony told him he kept a voodoo doll of him in his briefcase. Whenever Martin had a headache or was feeling under the weather, he'd think Tony had been sticking pins in it.

When *Mob Rules* was in the can, Ronnie suddenly announced that he wanted 50 percent of the royalties, because he'd written the lyrics and vocal melodies. That was understandable, but it wasn't how Sabbath worked—we'd always split the royalties four ways, regardless of who was responsible for writing the songs. That's when the resentment really started to set in. As far as Ronnie was concerned, Sabbath would be struggling or dead without him. As far

as me and Tony were concerned, Ronnie would still be looking for a job without us.

Mob Rules was released in November 1981, and reached number twelve on the UK album chart, twenty-nine in the US, before we hit the road again—which is when things really started falling apart. As an outsider looking in, the reasons for bands splitting up can seem incredibly trivial and childish. But you spend so much time with each other that the least little thing ends up upsetting you. Having started a tour as great friends, three weeks in, you can start to be sick of the sight of each other.

Me and Tony would try not to moan about anything on tour—however much something is getting you down or someone is getting on your nerves, you have to put up a good front and keep grinding away, because you're all in it together and the fans are relying on you to be on form—but Ronnie would be moaning every single day. And Ronnie could be very aggressive without meaning to be. With the original lineup, if there was something to say, you'd say it, but as diplomatically as possible. But Ronnie didn't have the knack of holding back. Whatever was on his mind, he'd blurt it out. Except to Tony, because he knew that might end up getting really nasty.

Anything could set Ronnie off, but his main gripes were the length of Tony's guitar solos and the volume he was playing at. But because he wouldn't complain to Tony, it was me who got an earful every time. That meant I felt stuck between a rock and a hard place and was gradually worn down.

When Ronnie announced he wanted royalties from any Ozzy-era songs he was singing, which was never going to happen, I finally cracked. We were in San Diego when I said to Gloria, "I'm sick of Ronnie moaning, I can't stand being in the same room as him when he's in one of his moods." Like Sharon Arden, Gloria

wasn't shy in saying what she thought. And just before we went onstage, she grabbed Ronnie by the neck, pinned him against a wall and screamed, "Stop upsetting my husband!" I can understand why she did that, because she could see that his behaviour was bringing my depression back, which was the last thing either of us needed. Ronnie didn't take this very well, but there wasn't much he could do about it

The band were going great guns musically and the gigs were sold out, but after three or four months on the road with Ronnie, I'd had enough of his nonsense. After a gig in Florida, I jumped in my car and drove into the night. When Tony tracked me down, I said to him, "If Ronnie is there when I get back, it's over. I can't work with him anymore." Tony was able to coax me back eventually, but that was the beginning of the end for that particular lineup.

THE FINAL NAIL

We hobbled on, until it came to mixing our next album, *Live Evil,* in LA (we didn't know that Miles Davis had released an album with the same name a decade earlier; it just seemed like the perfect title). There had already been a live Sabbath album, *Live at Last,* but that was released by Patrick Meehan without our permission, so we were determined to make *Live Evil* sound as good as possible. Unfortunately, the mixing process turned into a farce.

Me and Tony would arrive at the studio around noon, and Ronnie would arrive after we'd left. We thought that was weird, and we soon found out that Ronnie was spending most of his days rehearsing with a different band—and had negotiated a solo deal with Warner Bros. On top of that, there were strange goings-on with the recordings. Me and Tony would listen to them and think,

I'm sure the guitar and bass were louder yesterday. We kept blaming the engineer, Lee De Carlo, until he cracked and told us that Ronnie was coming in and altering everything Tony had instructed Lee to do. Ronnie denied it, but we trusted what Lee was telling us.

That was the final nail in the coffin. Me and Tony had become convinced that Ronnie was trying to take over the band, and now the cracks had become as wide as a canyon. With Bill out of the picture, I had to give Ronnie the bad news that he was out. That was a sad moment, because away from the business of the band, Ronnie was a decent guy. And with him in the band, we'd recorded a couple of great records and got back on top. But things couldn't go on like they were.

We asked Vinny to stay, but he decided to join Ronnie's new band Dio instead. It didn't work out too bad for them, because their first album together, *Holy Diver*, is regarded as one of the greatest heavy metal albums of all time and sold in the millions. As for Sabbath, we were suddenly without a front man, a drummer and a manager. So much for being back on top again.

BORN YET AGAIN

I'm told *Live Evil* sounds terrible, but I've never even listened to it. That's how much I hated mixing it. On top of that, a month before we released it, Ozzy put out a live album consisting entirely of Sabbath songs. That wasn't a very nice thing to do, and it was obvious that Sharon or Don had engineered the whole thing to piss us off. We outperformed Ozzy in the UK, but he blew us out of the water in the US, where *Live Evil* only just scraped into the Top 100 (in 2022, *Live Evil* was revisited and remixed by Wyn Davis for rerelease).

After Sharon married Ozzy in 1982, becoming Sharon Os-

bourne, she took over his management contract from her dad and signed him up with a new record label, which led to a spectacular fallout with Don. Sharon now saw Ozzy as a weapon of war, and Don was desperate for revenge. Meanwhile, me and Tony were rudderless, so we decided to rejoin forces with Don. It's not as if we suddenly thought Don was a stand-up guy, but he served a purpose. It was the music business at its most cynical.

Luckily, the arrival of my first son had provided me with some perspective. Suddenly, Sabbath weren't the most important thing in my life anymore. I had a responsibility to bring Biff up properly and was just happy being around him and Gloria. That said, me and Tony did wonder what the hell we were going to do next. Without Ozzy, Bill and Ronnie, did Sabbath even exist?

In early 1983, me and Tony were staying in a hotel in LA, and one night someone knocked on my door at eleven o'clock. I thought, *Who the hell is that?* And when I opened the door, there was Ozzy, wearing a yellow jumpsuit/gown ensemble and with his head shaved. He looked like a Hare Krishna follower.

I hadn't seen Ozzy since the split, but we got on great. We spent hours talking about old times and when I explained the Sabbath situation, Ozzy said that Don wanted to manage us again, now that Ronnie was gone, and suggested we give him another go. Then, just as the sun was coming up, Ozzy swished his gown and made his exit. I didn't see him again for almost three years, but I'd hear an awful lot about him.

Top of our to-do list was to find a new front man and drummer. And top-drawer front men and drummers weren't exactly desperate to join Sabbath in 1983. First, me and Tony had approached Whitesnake duo David Coverdale and Cozy Powell, because we'd heard that Whitesnake were on the verge of splitting up. David, who made his name with Deep Purple, would have been ideal—a

big name with a powerful voice and confident stage presence—but him and Cozy decided to soldier on with Whitesnake instead. Tony always tells the press that Michael Bolton auditioned, but that's just him having a joke. And in the end, Don suggested Ian Gillan, another former Deep Purple front man who had just wound up his eponymously named band and apparently needed to make a quick buck.

We met Ian in a pub in Oxfordshire and got completely legless. We were literally under the table by the end of the night. I didn't know him before then—and I'd only really listened to one of his records, *Deep Purple in Rock*—but we got on like a house on fire. Ian always says he couldn't remember anything the following morning—and that he didn't even like Sabbath—but during the course of that piss-up he'd agreed to join us for a new album and tour.

I thought Ian was a decent fit. He had a great voice—and I wasn't in a position to argue anyway. Don had secured us a very good advance from the record company, with the proviso that Gillan be involved. What I wasn't happy about was calling the new lineup Black Sabbath—because it wasn't, it was a mash-up of Sabbath and Deep Purple. And I thought that having Ian on board, and changing the name, would signal a clean break from the past. But Don said the record company would only release the album under the Sabbath name. As a result, me and Tony got a lot of letters, saying stuff like "How can you have a Deep Purple singer? Disgusting!" Deep Purple fans weren't happy about it either.

At least when Bill was persuaded to return, us being Sabbath made more sense. Bill was adamant he'd got himself clean and sober and thought he was up to recording and touring again. It was great to have him back in the fold, and he seemed fine in rehearsals. But that didn't last long.

Gillan was good friends with Richard Branson, so in the spring of 1983, having got enough new material together, we all headed to The Manor, Branson's residential studio in Oxfordshire. It was a massive place in the country, with a go-kart track and boats on the river. Bill turned up with an Alcoholics Anonymous sponsor, and I took one look at him and thought, *This guy is bad news.* The bloke gave off really bad vibes.

Everything seemed fine, until one morning Bill threw his breakfast through one of the old leaded windows. I said to him, "What the hell's the matter?" And he replied, "I just felt like doing it." We had to get a specialist in to fix the window, because of the lead. But the following day, Bill did it again. I was thinking, *Bill's acting weirder off the booze than he did on it. And he was never as angry as this.*

Bill had also brought Misty along with him, but soon announced that he wanted to fly another woman in from America. We were all thinking, *Oh God, here we go again . . .* One day, I went to his room and he was a gibbering wreck, pointing at the ceiling and saying, "Those cottages up there keep attacking me!" I said, "What the hell are you talking about?" And he replied, "Can't you see it? That cottage over there is flying through the air—it's going to land on me and finish me off . . ."

We packed Bill off to hospital, and while he was in there, I found his secret stash of booze in a bin outside the kitchen. Bill had been sneaking downstairs in the middle of the night and necking vodka, before having severe withdrawal symptoms in the daytime, including seeing killer cottages. He'd clearly come out of rehab too soon, and he certainly couldn't handle being in a band environment, with everyone boozing and whatever else.

When Bill was discharged, he said he needed to go back to America and get himself together. We'd recorded most of the album

by then, so that wasn't really a problem as far as the band were concerned. But after we dropped him off at the Holiday Inn, where he was due to stay the night before flying out, his sponsor never turned up—he'd done a runner with Bill's ticket and all his cash. Bill did eventually make it home, but he didn't get himself together for a long time.

Bill wasn't the only one I was struggling to understand. Gillan wouldn't sleep in the house and had a big tent erected in the grounds instead. We'd look out of the window and see him cooking his meals out there, on a big fire. I suppose that was him being a bit quirky and rock and roll, but it suggested he didn't really see himself as part of the band.

One night, our tour manager Paul Clark blew up his tent with a stash of explosives left over from the *Mob Rules* tour. In retaliation, Gillan got drunk out of his brains, stole Bill's car, took it for a spin around the go-kart track and wrecked it. When Bill got up the next day and saw his car, which was now a burnt-out husk, he went mad. Gillan said to Bill, "Someone must have broken in and found the keys." But Paul knew the truth and sank Gillan's boat, which was moored on the river, with another lot of explosives. Gillan wasn't very happy about that, but it's not like he didn't have it coming.

Gillan was responsible for most of the lyrics, and I wasn't a big fan of a couple of them. "Zero the Hero" and "Born Again" were fine, but I thought "Digital Bitch" and "Keep It Warm," which was about Gillan's girlfriend, would have worked in Deep Purple, but Sabbath weren't that kind of band. "Changes" was about as romantic as we got, and even that was a bittersweet love song rather than a raunchy number. I think my only lyrical contribution to that album was the title "Disturbing the Priest," which was about the priest who lived next door and kept complaining about the noise.

I don't know if it was down to the drugs Tony was taking, but his obsessiveness reached new levels during the making of that

album. He'd got hold of this contraption which the BBC used to make sure programmes started and finished exactly when they were supposed to. I can't remember what song it was on, but Tony was saying, "I'm going to play a two-minute solo, but want it to end exactly after ninety seconds." I said to him, "Why don't you just play a ninety-second guitar solo, instead of trying to play a two-minute guitar solo in ninety seconds?" He tried to explain it to me, but I couldn't grasp what he meant, so I left him to it.

Tony was messing about with this contraption for two weeks, and Robin Black, our engineer, got so stressed that he developed a twitch. Meanwhile, I got so fed up that I took the cassette tapes of the songs we'd already recorded and started listening at home. The sound was muffled and unclear. When I told Tony and Robin, they insisted it would be corrected in the mix. It never was, and Tony and Ian blamed me, even though I'd pointed the issues out. That's what happens when you don't hire a bona fide producer, like Martin Birch, to handle things—stuff goes wrong and everyone points fingers. We should have learned that after the *Live Evil* fiasco.

Born Again, as our eleventh studio album would be called, reached number four in the UK, which was an improvement on our two Ronnie-era albums. But at the time, I thought the fact we didn't get the sound right had spoiled it. However, listening to it recently, it was a lot better than I remembered. It's got some good songs on it—the title track, "Trashed," "Disturbing the Priest," "Zero the Hero." I deliver some nice bass effects, Tony has some monster riffs and Ian's singing is great. It just goes to show: If the songs are good enough, you can get away with iffy production.

SABBATH TAP

Things had been getting a bit Spinal Tap for a while before Tony started trying to squeeze two-minute guitar solos into ninety

seconds. When we were rehearsing for the *Mob Rules* tour, the only place we could rehearse was an Irish club in Willesden. It was a well-known hangout for IRA members and sympathisers, so when somebody had the bright idea to test some of our stage explosives, everyone started yelling and running for the exit. They thought the place was being bombed by Loyalist paramilitaries.

Then, at Madison Square Garden, the pyro bloke thought he'd really show them and stuffed the flash guns with three times the usual amount of gunpowder. It practically blew the stage up. Vinny was lucky he didn't die, unlike all those Spinal Tap drummers.

While Spinal Tap had plenty of comedy album covers, including *Intravenus de Milo*, *Shark Sandwich* and *Smell the Glove*, the artwork for *Born Again*, a red devil baby with claws, horns and fangs, was just as cringeworthy. Rumour has it that the designer deliberately came up with a terrible album cover, because he was also designing stuff for Ozzy. I can imagine that, because things were just so ridiculous around that time. I just thought it was a bit sick, but Don loved it, so that was that. It's also divided opinion among Sabbath fans ever since, almost as much as Ian Gillan has.

Then came the infamous Stonehenge episode. Stage sets had become incredible by the early eighties and fans expected something spectacular to go with the music. Ozzy and Dio's stage sets were exactly that, while ELO had a flying saucer descending on the stage. Presumably because we had an instrumental called "Stonehenge" on the album, Don wanted a Stonehenge stage set, with a massive sun rising up behind the stones as the show progressed. I thought it was an utterly ridiculous idea.

Whereas Spinal Tap's Stonehenge set ended up being too small, our Stonehenge set was too big, because the tour manager wrote down the measurements in feet and it was made in metres. When it was delivered, the stones were three times as big as they were meant to be, almost as tall as the real ones.

When we rehearsed at the National Exhibition Centre in Birmingham, the stones were set up on the floor and actually looked really impressive (the sun idea was soon abandoned, because of the exorbitant costs). But when we did our first gig of the tour in Norway and put the stones on the stage, they were almost touching the ceiling. That's when Don had another brainwave: "We'll have a midget crawling on top of them, dressed as the baby devil on the album cover." (Don seemed to have it in for little people—when he was managing Ozzy, he hired one to go on tour with him, as a cruel dig at Ronnie.) So while Spinal Tap hired a little bloke to make the stones look bigger, we used the fact that the stones were so big to make the little bloke look like a baby. Madness.

At our gig in Canada, this little bloke, who was dressed in a red leotard with long yellow fingernails and horns stuck to his head, was crawling across the top of the tallest stone and fell off. That was actually supposed to happen, but someone had removed the mattress and the poor fella injured himself quite badly. That was the end of the devil baby.

When we arrived in the States, we had to leave the stones at the docks somewhere, because the venue's stage wasn't big enough to fit them on. Luckily our amps and speakers were hidden behind smaller stones, which looked quite impressive, so all was not lost. I'm told someone from Don's office called the actual Stonehenge and asked if they wanted a replica. They declined the offer—because the stones were far too big.

Years later, we did a photo shoot with Spinal Tap and asked them if they'd based those scenes on us, but they said it was just coincidence. I find that difficult to believe. Not only did they have that Stonehenge section, but they also had combustible drummers, and we'd been setting fire to Bill for years.

People often ask if I've seen the film *This Is Spinal Tap*. I always reply, "Seen it? I lived it." I know Iron Maiden hated that film,

thought it was an affront, but it's one of the funniest films I've ever seen, because it's so accurate.

It wasn't just the set that was Spinal Tap on that tour. We flew to our Helsinki gig on flight HEL 666, believe it or not. And after we'd finished the show, we got back to the hotel to find they were closing the bar, despite it only being ten o'clock. When we asked why, the barman said it wasn't worth his while, because we were the only people in there. I had a feeling that he just didn't like the look of us, and I sent a few choice words his way as we were leaving.

Gillan had bought a gallon bottle of whisky in duty-free, so I went to his room and tried to drink the night away. But I was still really pissed off with the barman's attitude, couldn't get it out of my head. About halfway down the bottle, Gillan passed out, so I took it to my room and continued solo. And the more I drank, the angrier I got.

When I looked out of my window, I noticed the bar was directly below my room, six floors down. I decided I was going to make a Molotov cocktail and blow up the car that was parked directly outside, having convinced myself it must have belonged to the barman. I stuffed a load of toilet paper into the bottle and went through about twenty matches trying to get a flame from the whisky (unlike brandy, whisky isn't flammable). Eventually I got one, let the bottle drop and it hit the target. It didn't blow the car up, but it did smash the windscreen to smithereens.

I collapsed on my bed, thought, *That was a failure*, before falling unconscious. And the next thing I knew, there was shouting and hollering and someone was violently shaking me awake. When I opened my eyes, I saw six policemen surrounding my bed, pointing machine guns at me. I asked them what had happened and one of them replied, "You're under arrest for terrorism!" I started telling them it had nothing to do with me, and he pointed at the floor,

which was covered in spent matches. "Oh," I said. And with that, they snapped some handcuffs on me, bundled me into the back of a van and off to the police station I went.

At the police station, they asked me who I worked for. When I told them I was in Black Sabbath, they replied, "We don't believe you. You tried to blow a car up." They eventually accepted I wasn't a terrorist and was just some idiot Englishman, but I wasn't out of the woods yet. As I was leaving the interrogation room, I asked a policewoman if she wanted to come back to the hotel with me, as a joke, and one of her colleagues went mental and threatened to punch me. But just in the nick of time, Don and the tour manager appeared, apologised to the cops and bailed me out. Don went nuts and threatened to throw me out of the band, but I lived to be banged up again.

A few weeks later, we had a gig in Barcelona, where the chaos continued. The promoter invited us to his posh club to do a photo shoot. He was so friendly, as were his staff, that we decided to return that evening, by his invitation. We were having a lovely time until Gillan had one too many and started pouring peanuts down the back of the waiter's trousers, every time he leant over the table to pour a drink. At first the waiter pretended to find it amusing— "Ha-ha, very funny"—but he soon started getting really pissed off, understandably. We told Gillan to leave it out, but he wouldn't.

Eventually, another waiter came along and Gillan poured the whole bowl of peanuts down the back of his trousers. That was our cue to say thank you and good night. But as we were walking towards the door, the waiter saw Gillan had a glass in his hand, asked him to leave it behind or drink up and Gillan told him where to go. Out of nowhere, Paul Clark punched one of the bouncers and once again, things descended into bedlam.

While bouncers, waiters and kitchen staff were coming at us

with chains and metal bars, Gillan was nowhere to be seen. We later discovered he'd run away at the first sign of the trouble he'd started. Tony enjoyed a fight, but this was a bit much even for him. The last I saw of him that night, he was jumping into a cab, along with Bev Bevan and Geoff Nicholls. That left just me and Paul to face the music.

There was an old woman outside the club selling flowers, so I grabbed the vase and smashed it against a wall, thinking I was going to stab somebody with it. I'd obviously seen far too many films. Of course, the vase smashed into a thousand pieces and sliced a big lump out of my finger. Me and Paul finally managed to extricate ourselves and hail a taxi, but when we got in, the driver pulled out a gun and ordered us to get out. Meanwhile, the police had arrived, and they bundled me in their car and whisked me to the hospital, because I was covered in blood.

After a nurse picked all the glass splinters out of my wound—without anaesthetic, because I was full of booze—sewed my finger back together and patched me up, the police put me back in the car. I thought they were taking me to the hotel. Instead, they took me to the local jail, where Paul was waiting for me. The first thing the copper did when he walked into the interrogation room was whack Paul across the face with his truncheon, smashing his nose. Paul, whose nose was pouring blood, just smiled back.

The copper made us sign a load of forms written in Spanish and locked us up for the night. And when the promoter bailed us out the following morning, there was a big mob waiting, booing, chanting and spitting at us. Apparently, the guy Paul had punched was in the hospital, in a very bad way. He was also in with some heavy Barcelona gangsters. Two or three cars followed us back to the hotel, so our driver had to do circuits around the city for an hour, until he'd lost them. Then we decided it would be wise to find a different hotel, outside the city.

When Don turned up, he told us he was hiring a load of heavies from Germany to protect us. When we played the gig, there were twelve of these blokes surrounding the stage, and they stayed with us for the rest of the European tour. Until my bandages came off, I had to use my little and right-hand ring finger to play bass, which was rather awkward. Tony, who was wise to these types of incidents, advised me to throw the vase next time, rather than smash the bloody thing. As for Don, he was probably wishing he'd never heard of Black Sabbath.

Our first gig of the UK leg was at the Reading Festival in England, which was another eventful experience. Gillan could never remember the lyrics, but instead of using a monitor, he'd write them down on paper and tape them to the stage floor. When the dry ice wafted on, Gillan was almost on his hands and knees, trying to read the lyrics and failing miserably. To make things worse, he sounded like a robot, because his voice was on the blink.

When we launched into "Born Again," giving it the big buildup as the album's lead track, it immediately became clear that my bass tech (my nephew Michael Howse!) had tuned all the strings to A. There I was, making a terrible racket on this eight-string bass, and I wanted the ground to swallow me up. Then, as I was hastily changing over to my four-string bass, the backdrop went up in flames. It was the ultimate joke gig, and the crowd must have thought we'd lost our marbles.

Gillan was a totally different kind of singer to Ozzy and Ronnie. He sounded really good on the new songs in the studio, but it just didn't work when we were doing the old songs onstage. Also, we had Bev Bevan, formerly of ELO, on drums. Bev was an old friend of Tony's, and obviously knew Don well, and he was a good drummer. But ELO were essentially a pop band, so a lot of Sabbath fans were wondering what on earth was going on. As was I.

The next gig after Reading was Dalymount Park in Dublin.

We'd chartered a plane from Birmingham, so we'd be there early, refreshed from the Reading debacle. However, our equipment didn't make it in time, so Motörhead kindly loaned us theirs.

Our dressing room happened to be in the bar, and as we were waiting to go on, we decided to help ourselves to a few pints of Guinness. After the show, more pints of Guinness were consumed, then off to the airport we went. On the way, our driver recommended a pub, which apparently served the best Guinness in Dublin, so we stopped by and ordered a couple of trays of the black stuff. By the time we arrived at the airport, we were fairly drunk. And by the time we were in the air, we were all dying for a piss—but there was no lavatory on the plane. Out came the sick bags, into which we relieved ourselves. We then put all the bags into one large bag and left it in the aisle. As we were leaving the plane, a flight attendant said, "Hey, aren't you forgetting something?" So I had to take the large bag of piss with me. Most people leave a plane with some duty-free perfume or cigarettes—not me.

Going through customs, the officer asked if I had anything to declare. "Just this bag," I said, and plonked it on his desk. As we were scurrying off, I could hear the officer yelling for us to come back. When a policeman tried to stop Tony, he knocked his helmet off. And when it hit the floor, the badge came off. Luckily, the copper was more interested in retrieving his badge than trying to stop us, so we were able to escape into our waiting limos.

We told the drivers we needed to hide from overenthusiastic fans, so they took us to a private club near the airport. In the club, we carried on boozing until we upset a gang of blokes and ended up in a fight. On the way home, Tony puked all over his driver's back. So endeth our day out in Dublin.

By the time we got to America, I was having doubts about the lineup. Ian was great singing the new stuff, but his inability to learn

the lyrics to the previous Sabbath stuff led me to question his commitment. So when Gillan told us Deep Purple were getting back together and he'd signed up, I was relieved. Tony wasn't happy, because he thought it was a long-term arrangement, not a one-album thing. But the lineup had run its course.

10

TOMORROW NEVER KNOWS

COMING OR GOING?

I decided to limp on with Tony, but I was fast losing interest. It was 1984 and the heavy metal landscape had shifted again, with hair metal now to the fore. I wasn't a fan of hair metal, thought it was tailored for MTV—all about the look rather than the music. At least the glam rock acts of the 1970s—David Bowie, T. Rex, Sweet, Mud—made decent songs, but most hair metal was terrible. It wasn't even metal—it was pop music masquerading as metal.

A few of those bands cited us as an influence, which I just found confusing. For the record, I've never worn spandex, although the whole band went through a leather phase—in 1969, Bill's girlfriend worked at an Austin car factory, stitching the seats, and she'd nick leather and fashion trousers from it. We looked okay, but because the leather was about an inch thick, it was very stiff and bloody sore to wear, like walking around in armour.

During this time, me and the family had rented a house near Mulholland Drive, and Gloria was expecting our second child.

Meanwhile, Tony was sharing a house with Geoff Nicholls, who had become a permanent member of the band. Tony was still doing a lot of coke, and whatever else, and seemed to be losing the plot—he kept saying he could see strangers in his house and garden. We were living very different lives, which rather summed up where we were as a band.

When we started looking for a new singer, we didn't know what we wanted him to be or what direction we wanted to go in. We put out adverts asking for tapes and received loads of them—some good, most terrible. One girl sent in a videotape of her singing Black Sabbath while pretending to hang herself. We passed. Don insisted we audition some bloke who looked like an office worker—and indeed had his own office. We passed again.

Tony thought one bloke sounded perfect, but when we went to see him at a gig in LA, he had big hair, was caked in makeup and didn't sound anything like the person on the tape. The guy was called Ron Keel, who was part of the growing hair metal movement—a nice bloke and good singer but when we got him in the studio, he didn't sound right at all. It turned out that Tony had listened to the wrong side of the tape, and we never found out who the great singer on the other side was.

Don had suggested we hire people to write and arrange more mainstream rock songs for us. One of them was Spencer Proffer, who was trying to sell his brand of commercial rock songs to anyone who'd buy them (Carmine Appice would record some with his band King Kobra, whose first album Proffer also produced). We soon got rid of him, because he wanted to turn us into a softer rock band.

A couple of months later, Don found a guy called Dave Donato. His voice was good in rehearsals, and he looked great—he was still in his twenties, tall and tanned—so Don decided we had

to have him. Before even hearing Dave sing live, Don organised a photo shoot with *Kerrang!* magazine, and suddenly Dave was an official member of the band. Unfortunately, when we went into the studio to try out some new material, Dave couldn't stay in tune.

To make matters worse, Proffer was replaced by Bob Ezrin, who had worked with Alice Cooper, Pink Floyd, Kiss and many others. Bob was obviously good at what he did, but we were a complete mismatch. He tried to get me to play disco bass, like Nile Rodgers in Chic, and I ended up getting really pissed off with him—and thought the whole arrangement was a very bad joke. Bob soon went the same way as Proffer, and Dave lasted about a month before we let him go.

Meanwhile, Bill had come and gone again. He was clean and sober when Tony persuaded him to rejoin us. But his heart just wasn't in it without Ozzy, and he soon decided to jump ship. By that stage, I didn't know whether I was coming or going, or what Sabbath were supposed to be anymore.

A DOSE OF REALITY

In the summer of 1984, I received news from England that my dad was very ill, so jumped on the first flight over. When I arrived in Aston, he was in a terrible state and didn't look like he had long left. I flew back to LA, went straight into rehearsals and came up with a few ideas, before I got the call to return to Aston, where my dad was asking for me. So off I went again, leaving a very pregnant wife and our young son Biff in the safe hands of Gloria's sister.

When I got to the house, I couldn't believe how bad my dad looked. He was wafer thin, couldn't have weighed much more than five stone. He'd fallen over and his hip was at a right angle to his leg. He couldn't get out of bed, so my sister Maura was washing

him and emptying his bucket. My mom and sisters were looking after him because he refused any medical treatment. He'd never seen a doctor in his life apart from his duodenal ulcer episode and always said that if he ever went to hospital, he'd come out in a wooden box.

Eventually, I overruled the rest of the family and called a doctor. When he examined my dad, he discovered that not only did he have a broken hip, but he also probably had lung cancer. On top of that, his Parkinson's disease, which he'd had for years, had become critical. Ignoring Dad's protests, an ambulance was called and off to Birmingham General Hospital he went.

Dad seemed resigned to his fate by then, was even laughing and joking with the nurses on the ward. Bizarrely, Paul Clark, our old tour manager, was in the bed next to him. I visited Dad every day, until they inevitably had to operate, in a bid to keep him alive. But he never recovered and died on October 27, 1984.

A week later, on a dark, stormy day, Dad was laid to rest in Witton Cemetery. It was a heart-wrenching time for me, and I felt guilty and selfish. Dad knew he was dying but wanted to do it on his own terms. However, I couldn't watch as he lay in agony, wasting away in his bed—the same bed in which, all those years earlier, I'd dreamed the lyrics and riff to "Behind the Wall of Sleep." I'd made him go to hospital and he'd left it in a wooden box, just as he said would happen. Understandably, my mom didn't take his death very well either. They'd been married for sixty years, through thick and through thin.

My dad's death was a dose of reality that hit me like a sledgehammer, but I hoped my child's imminent birth would be the perfect antidote to the despair I was feeling. When I arrived back in Chesterfield, Gloria was looking radiant, which cheered me up. And we decided to call the baby James if it was a boy, after my dad.

All went well until James made his appearance. "It's a boy," said the doctor, before the room fell silent. James wasn't crying and was dark blue. When I asked the doctor what was wrong with him, he ignored me and called for more nurses, who quickly went into overdrive. They grabbed the baby and scurried off, while trying to clear his passageway, and Gloria, still completely out of it, was screaming, "What's going on?" It was a harrowing scene.

When the doctor returned, he explained that James had transposition of the great arteries, which meant blood was going round and round his heart and not getting to his lungs. I asked the doctor what that meant, and he replied, "If we leave him as he is, he's going to survive for three or four days, a week at most. Or he can have a procedure whereby a hole is punched through his heart, so that the blood can reach his lungs. But there's only a fifty-fifty chance he'll survive the operation." I felt like I'd been sucker punched.

James was helicoptered to St. Louis Children's Hospital, while I was driven by my brother-in-law Sam. On my arrival, the surgeon said to me, "Are you sure you want me to go ahead with the operation? I need your consent, but I can't promise you he'll survive."

It was a horrible day, reminiscent of my dad's funeral—slate-black skies and rain coming down like stair-rods. And I felt utterly lost. So I went to the window, looked up at the sky and asked God to give me a sign. Just as I did so, a rainbow appeared, cutting a beautiful arc through the gloom. Gloria's brother saw it as well, so it wasn't a figment of my imagination. You might think it was just a coincidence, but it was the sign I'd asked for. I immediately told the surgeon to go ahead with the operation.

Mercifully, the procedure was successful and would hopefully give James enough strength to survive major open-heart surgery when the time came. After ten days in intensive care—during which time I played Paul McCartney's "No More Lonely Nights"

over and over again, to help with the anxiety—James was finally allowed to come home with us.

Gloria spent the next six months interviewing every renowned heart surgeon in the world over the phone. She eventually decided on the heart specialist at Boston Children's Hospital, Aldo Castañeda, who assured her that the procedure he used had a high success rate. In February 1985, we flew to Boston for the operation, with everything crossed. And James, the little battler, came through it with flying colours. Thank God for Aldo Castañeda. And thank God for that rainbow.

The double whammy of Dad's death and James's complications meant I wasn't thinking much about music. And while James was still recuperating, and Gloria was getting over the trauma, I couldn't even contemplate leaving them and returning to the band.

As all that drama was unfolding, Ozzy, of all people, phoned me at least once a week to ask how everyone was doing, which I really appreciated. However, I didn't hear much from the Sabbath guys or my family, apart from Maura. The first I heard from Don was when he called me to ask if I was ever coming back to LA. Don said Tony was anxious to move on with the band and couldn't wait for me forever. I told Don that Tony should soldier on alone, because my family needed me.

LIVE AID

At the start of 1985, I'd have rated the chances of the original Black Sabbath lineup ever performing again as slim to none. Then I saw the horrible pictures of starving children in famine-stricken Africa, got wind that Bob Geldof was putting together a couple of fundraising concerts, got on the phone to Don Arden and suggested me, Tony, Ozzy and Bill get together again for the charity.

The first thing Don said to me was, "You're not doing that. They won't pay you anything." I replied, "It's for charity, Don. To raise awareness and a load of money for starving people in Ethiopia." But charity didn't seem to exist in Don's world. Plus, his relationship with Sharon had reached new levels of toxicity.

Rumour has it that Sharon tried to get Ozzy on one of the bills as a solo artist, but the organisers weren't interested. However, when Geldof realised at the last minute that he had no metal bands involved, he asked us and Judas Priest to play Philadelphia. Tony was reluctant, but Bill and Ozzy were keen, so we told Geldof we'd be there.

We only had one rehearsal, which wasn't really a rehearsal. Tony turned up with a producer he was working with in LA. When Ozzy walked in, he said, "Who's this bloke?," walked up to the producer and poked him in the eye. I think most people thought the same as me: *Oh, good, at least Ozzy hasn't changed* . . . The day before, he'd been served with a writ by Don, in the middle of a live interview. Don was threatening to take legal action if Ozzy appeared under the Sabbath banner, but Ozzy—or more accurately Sharon—just ignored him.

We all got on okay because we knew it was only going to be a one-off gig. In fact, we spent most of our rehearsal time reminiscing. On the day of the concert, we were like the hooligans who'd gate-crashed the party. The only band we really got on with were the Pretenders. Chrissie Hynde made her own way to the stadium, but we shared a van with the rest of them. Ozzy kept saying, "Where's Chrissie? Bill's got a tattoo of her face on his arse." They looked utterly bemused, didn't know whether Ozzy was telling the truth or not (he wasn't!).

Because we were a last-minute addition, they wedged us in at 9:55 A.M.—between Billy Ocean and Run-DMC. I know it was

for charity and all that, but it wasn't a great spot. Chevy Chase introduced us and I think we went over pretty well, all things considered. We hadn't slept and some of us were a bit hungover. In fact, I can't remember much about our performance. We only had time to play three songs—"Children of the Grave," "Iron Man" and "Paranoid"—and I kept whacking my thumb on the spike I had on my custom B.C. Rich bass. We didn't do a Queen and steal the show, but I think we got away with it.

GOING SOLO

The reunion was never going to be permanent, despite the press suggesting we'd done it as a publicity stunt, rather than for charity. Ozzy and Sharon were certainly never going to entertain it. And anyway, my priorities had changed.

After all the worries with James's health, nothing else really mattered. I wasn't in the right place to return to the chaos of Sabbath, and the odds of the original lineup getting back together were about as long as me ditching Villa for Birmingham City. So I decided to sell my portion of the Sabbath name to Tony. I was free of any ties, Tony had got a very good deal, so it was a win-win situation.

Tony was now free to call himself Black Sabbath, whoever else was in his band. But I was still surprised when he released the album *Seventh Star* under the Sabbath banner in 1986, because there was almost nothing Sabbath about it. Tony says *Seventh Star* was meant to be a solo project, incorporating a variety of singers. However, Glenn Hughes, another former Deep Purple front man, ended up singing the entire album. And because Warner Bros. refused to release it as a Tony Iommi solo project, it was billed as "Black Sabbath featuring Tony Iommi"—even though he was the

only original Black Sabbath member in the band. If any Sabbath fans hadn't been confused before, they certainly were now.

Seventh Star was a commercial flop, as was the tour that followed. I thought the Sabbath name was being dragged through the mud. When I was a teenager, I loved the Temptations. So when I saw that a band called the Fabulous Temptations were playing the Handsworth Odeon, I bought myself a ticket. But they had nothing to do with the actual Temptations, and I felt cheated, the same as when I heard about *Seventh Star*. You can call yourself Black Sabbath, but that doesn't mean you actually are Black Sabbath.

When James was well enough, we moved back to England, having bought a house in Warwickshire (we kept the house in Chesterfield, Missouri). We felt the kids would get a better education in England and be a lot safer. America was ultraviolent, even back then, and we didn't want to subject them to that.

I was loving fatherhood. I refused to change nappies and wipe my son's rump—I have a phobia of that end of the body—but Gloria got a nanny in anyway. All in all, I was content just spending time with my wife and kids and enjoying not being in a band.

I didn't even listen to much heavy metal, because most of the modern metal bands had nothing to do with the sound Sabbath had apparently invented. Metallica's *Master of Puppets* was a massive album in 1986, but I was more likely to be listening to soul or jazz. Later, Metallica would release "the Black Album," a masterpiece which would see them become one of the biggest bands of all time. They took true metal into the stratosphere and restored my faith in rock music.

I had a load of songs I'd written over the previous fifteen years, so after a lot of kicking back with the family, I got my own band together, which included my nephew Pedro Howse on guitar. After a bit of trial and error, I roped in a singer from St. Louis, Richie

Callison. Richie had never been to England before and we teased him something rotten. We told him that Ribena (a very strong, syrupy black currant cordial that Brits love) was to be drunk straight from the bottle, sans water, and that real British rockers drank Babycham and cherry b (the former was a cheap sparkling perry that working-class women drank when they were trying to be posh; the latter was a cheap cherry wine, so sweet it made your teeth tremble). The pub regulars didn't know what to make of Richie, sipping from his dainty glass of Babycham, while the rest of us were drinking pints of bitter.

We rehearsed at a place called Cold Comfort Farm in Worcestershire, which had a very spooky atmosphere. I always felt as if someone was staring at me when I was trying to get to sleep, and I eventually discovered that there was a so-called priest hole right behind my bed, where Catholic priests would hide in the sixteenth century, when the Protestant Queen Elizabeth I was on the throne and holding Catholic Mass was punishable by death. The farmer told me a priest had suffocated while hiding in the hole, but I think he was trying to spook me even more.

My new outfit, called the Beez, did a few gigs, including one at the Marquee in London. Ozzy came to see us, and his verdict was that the sound was dreadful. But it was fun while it lasted, and exactly what I needed at the time.

When Richie returned to St. Louis, where he probably had to spend thousands on dental surgery, I carried on writing with Pedro. Pedro was in a band called Crazy Angel, one of the first thrash metal outfits out of the UK. I really liked the heaviness of his riffs. Pedro was great to write with, too, because I was able to express my ideas on the guitar without feeling intimidated.

I put together another band with Pedro, ex-Sabbath and Robert Plant keyboardist Jezz Woodroffe, Persian Risk singer Carl Sen-

tance and Gary Ferguson/John Shearer on drums (later, Jimi Bell, who would join the band House of Lords, replaced Pedro). Iron Maiden's management team, Rod Smallwood and Andy Taylor, were interested in hearing what I was doing, and we recorded an album's worth of songs, one of which, "Master of Insanity" (cowritten with Jimi), would later appear on Sabbath's *Dehumanizer* album.

Listening to those songs now, they have a very 1980s feel about them, completely different to earlier Sabbath stuff. And while Rod and Andy pulled out all the stops in trying to clinch us a recording deal, all anyone wanted to hear from me were Sabbath-sounding songs. I told them I'd already done that, that this wasn't Sabbath, but they weren't interested and nothing came of it.

Meanwhile, Tony was desperately trying to keep his Frankenstein version of Sabbath from falling apart at the seams. Glenn Hughes was sacked in the middle of a US tour and replaced by a virtual unknown called Ray Gillen. Ray lasted just a few months before jumping ship and being replaced by another left-field singer called Tony Martin. Drummers and bassists also came and went, with Tony the only ever-present band member.

Before the release of Tony's next album (nominally another Sabbath record), he asked me to rejoin the band. When I turned up for the meeting, Tony was on his mobile phone, one of those early models that was the size of a house brick. Patrick Meehan was also there, which was a fairly big shock.

Amazingly, Tony had rehired Meehan, Don Arden having been sued to death by ELO and arrested for the kidnapping and torture of one of his accountants (Don, predictably, was acquitted). I refused to shake Meehan's hand, and when I asked Tony why he'd turned to him again, Tony replied, "He knows how to manage a band." I replied, "Yes—and how to rip a band off." I couldn't believe Tony had even considered it.

When Tony asked if I'd do some shows in Sun City, South Africa, I was dumbfounded. South Africa was still an apartheid state, and there was strong opposition to playing there. A year earlier, a group of influential musicians had released the anti-apartheid protest album *Sun City*. Bands who had played there were blacklisted, until they vowed never to play there again.

Tony kept saying to me, "Queen played South Africa, so why can't I?" He was forgetting that Queen had copped a lot of flak, played Sun City before the protest album and only become one of the biggest bands in the world again because of their show-stealing performance at Live Aid. I was in an awkward position, because I didn't want to refuse Tony there and then. But after a few gallons of booze, I told him I'd think it over.

A couple of days later, I phoned Tony to say thanks but no thanks. However, when "Sabbath" arrived in South Africa, Tony, or one of his crew, allegedly included one of the roadies in a photo shoot and told the local press he was me. I was fuming when I found out about that, because playing Sun City seemed like career suicide, as well as being immoral. The simple fact was that Tony was desperate. He needed the money, if only to keep up his image. When he got home from South Africa, he went and bought himself a new Rolls-Royce.

II
BOUNCING AROUND

TERRIBLE TURNS

After another album flopped in 1988, "Sabbath" were dropped by both of its record labels and Tony tried to get me to rejoin yet again. Instead, I decided to hook up with Ozzy for his *No Rest for the Wicked* tour. Me and Ozzy had become really close again, as had Gloria and Sharon. James and Ozzy's boy Jack loved playing *Ghostbusters* together and our families shared many a birthday party, both at our house and the Osbournes'.

Before setting off on the tour, I visited my mom in hospital. When we said goodbye, I shed a few tears, because I had the feeling I'd never see her again. I always had a sixth sense with my mom. We always seemed to get colds or flu at the same time, even when we were in different countries. And I once sprained my ankle at exactly the same time as Mom fell down the stairs, breaking her ankle. So when I became ill after a show in Buffalo, on November 29, 1988, I should have known it had a deeper meaning.

That night, I went to bed and couldn't breathe. I was lying

there thinking, *What the hell is wrong with me?* And as the night went on, things got worse and I went into panic mode. I honestly thought I was dying. I called the tour manager, Bobby Thomson, and he rushed me to hospital, where they did loads of tests on me. The doctor said he couldn't find anything wrong, and one of the medics accused me of taking some kind of drug. I could understand why they might think that—I was in Ozzy Osbourne's band, after all—but I was clean and sober on that tour, as stipulated by the management. When I got back to my hotel room, I had several missed calls from my sister Maura. When I called her back, she broke the sad news that Mom had died.

Mom's passing hit me really hard. When I was a kid, I worried I might never make anything of myself. And I think Mom and Dad thought the same. But they ended up being very proud of my achievements—the gold disc and my picture above their fireplace told me that.

Ozzy and Sharon were great, arranging for me to fly back to England on Concorde and telling me to return only when I felt up to it. Thankfully, Bob Daisley filled in while I was away so I was able to focus on the funeral. But I didn't want to let Ozzy down, and once the funeral was done, I flew straight back to America and carried on with the tour.

I hadn't played anyone else's songs since the early days of Earth, so trying to learn Ozzy's solo stuff was a challenge. I even resorted to using a pick on some of the bass parts, for authenticity. Meanwhile, Ozzy seemed to be in a decent place around that time. But while he was always telling me he'd given up drinking, I soon worked out that he was a secret boozer.

Things took a terrible turn in September 1989, when Ozzy was charged with the attempted murder of Sharon. I knew Ozzy was a loose cannon, but this was a whole different level of madness. They

had this massive house in Buckinghamshire and the guy next door made this horrendously strong plum wine. Ozzy would be out of his mind on this stuff for days on end, so when I went to visit him in prison and he said he couldn't remember anything, I believed him.

He looked really glum, not just because he thought he was going down for a long time, but also because he was genuinely sorry for what he'd done. He said to me, "That's it, I have to go into rehab." Sharon was going to leave him, but when Ozzy promised to change his ways, she stuck by him and refused to press charges.

BACK TO BLACK

By the early nineties, I was a bit lost. I'd tried and failed to get a record deal with my own band and while I loved being a family man, I missed being on the road. But I wasn't the only one who needed a shot in the arm.

Tony's "Sabbath" had been signed by the American indie label I.R.S., who also had R.E.M. on their books, but their next two albums with Tony Martin on vocals failed to make much of an impression (*Tyr*, released in 1990, didn't make the Billboard 200 and the subsequent tour didn't include any US dates). Meanwhile, Ronnie James Dio's star had also faded—after a couple of huge albums in the mid-eighties, his most recent, *Lock Up the Wolves*, had been a commercial flop. Grunge was now the new rock on the block, replacing metal.

I hadn't spoken to Ronnie since the split, but Gloria was still in touch with his missus Wendy. So when Ronnie was playing a gig in Minnesota in the summer of 1990, and me and Gloria happened to be in town, Wendy invited us to come along. I was apprehensive before entering Ronnie's dressing room, but me and Ronnie got on great and he asked me to join him onstage to play "Neon

Nights." Afterwards, we talked about playing together again one day. I wasn't sure that was going to happen, but I was happy we'd buried our differences.

Shortly after that, I went to see Tony at the Hammersmith Odeon, where I told him about my chat with Ronnie and played him some of the songs I'd written. Tony was excited at the prospect of the three of us reuniting and in early 1991, Ronnie arrived in the UK to start rehearsals. If it sounds painless, and very un-Sabbath, it wasn't. Nobody bothered telling Tony Martin and bassist Neil Murray they were out of the band. Plus, Ronnie and Cozy Powell didn't like each other at all (they'd been in Rainbow together), and Cozy didn't seem to take Gloria and Wendy, who managed me and Ronnie respectively, seriously.

Rehearsals in Wales went well at first, and we managed to write and demo some new songs, but things soon went south. Ronnie suddenly decided it wasn't what he wanted and flew back to LA, which meant we had to get Tony Martin back in. And while Ronnie was gone, Cozy went out on his horse and it fell on top of him, breaking his pelvis. You couldn't make this stuff up. I reckon Ronnie put a curse on that horse, because he soon returned and persuaded Tony to rehire Vinny Appice. That was the end of Cozy Powell's time in Black Sabbath, which he wasn't very happy about.

Unfortunately, that wasn't the end of the drama. When we all reconvened in LA, I'd sometimes stay over at Ronnie's house and we'd both get hammered and have drunken rows. I couldn't tell you what the rows were about, but you're always walking on eggshells in a band, because the egos are often so big. One time, we were writing a song, everything was going great and Ronnie suggested we call it "Bad Blood." I said to him, "You can't call it that, 'Bad Blood' was a big hit for Neil Sedaka and Elton John," and Ronnie went mental.

Tony was in a bad way financially and renting a little house in the village of Dorridge, Warwickshire (he'd hidden all his guitars at our house, so the Inland Revenue wouldn't take them). Ronnie and Vinny moved into a house just down the road, which is where we'd all meet up and write the songs, before demoing and recording the songs at Monnow Valley Studio in Wales. In his memoir, Tony describes the making of that album, which would come to be called *Dehumanizer*, as volatile. But I was relieved to be doing what I loved again and have good memories of it.

In 1988, me and the family had moved to a bigger house in Warwickshire, a place in the countryside between Solihull and Stratford-upon-Avon, Shakespeare's old stomping ground. I used one of the rooms as a studio, where I was able to indulge my musical ideas, play around with various instruments and machines and record songs almost in their entirety. And when it came to the *Dehumanizer* writing sessions, I'd play Tony and Ronnie the tapes and they'd have a far better idea of what I was trying to do, whether they liked it or not.

Reinhold Mack, a German who had worked with ELO and Queen, was the producer, and he had a good sense of humour. We'd tease him with references to the Second World War, the sort of stuff that would have the PC crowd choking on their milkshakes nowadays. There was a good atmosphere in the studio, with lots of laughs. We mixed the album at Mack's hometown studio in Munich, which was next door to a bar that served a particularly potent Weiss beer, which me and Ronnie shared a passion for. I think that's where me and Ronnie had a spat about our lyrical direction. I said to him, "I'm glad you're writing most of the lyrics, but please, can you ditch all the dungeons and dragons and rainbows stuff and write about what's going on in the world instead?" Ronnie got really pissed off, but eventually conceded I was right.

Dehumanizer was a collaborative effort and includes the only songs with lyrics by both Ronnie and me—"Computer God" and "Master of Insanity." "Computer God" was actually the title of a song I'd written for my own band a few years earlier. I had this idea that God was the ultimate computer, and we were all its programs. That fits in with my belief in fate, in that everything is mapped out and there's not a lot we can do to alter the course of our lives. "Master of Insanity," which Jimi Bell and I also wrote the music for, drove Tony nuts. That's one of the reasons he didn't like anyone else writing music for him, because the thimbles on his fingers made playing certain stuff difficult.

"I" is one of the best songs Ronnie wrote for Sabbath, a really dark, menacing piece of metal. And that album also tackles some pretty heavy—and relevant—subjects. For example, the single "TV Crimes" is about crooked TV evangelists, who were all over American TV at the time, and still are. We filmed the video for "TV Crimes" two days after the 1992 LA race riots (it was only the second one we did—the first was when Ian Gillan was in the band and looked like it cost about fifty quid). LA was still smoking and the police station just down the road from the studio was covered in sandbags, with machine guns mounted on top. We were worried the riots might start up again at any moment, so it was very intense.

I was proud of *Dehumanizer*—it was a far better album than *Never Say Die!*, that's for sure. It had the same rawness as our early albums, which was partly a happy accident, because we didn't have much of a budget at the time, and partly because Mack was left to get on with things. *Dehumanizer*'s grittiness also made it more relevant to younger rock fans, who were now listening to bands like Nirvana, Pearl Jam and Soundgarden, rather than hair metal, which had mercifully gone out of fashion.

In fact, people like Kurt Cobain and Dave Grohl from Nir-

vana were now saying how much they liked Sabbath; Anthrax had done a cover of "Sabbath Bloody Sabbath," and when Metallica toured with Ozzy, they were always playing Sabbath albums in their dressing room. Ozzy thought they were taking the piss at first, but when he confronted them, they couldn't understand why he thought it was odd that they loved us so much. We were so used to being hated by the critics that when people started saying we'd influenced them, we couldn't get our heads around it. But it was a nice feeling, no doubt about that.

HERE WE GO AGAIN . . .

Dehumanizer was Sabbath's best-selling album for a decade, proof that if we got things right, we still had an incredibly loyal fan base. But things started to go wrong again on the very first day of our subsequent tour. Sabbath were never fussy when it came to riders. At least me and Tony weren't. As long as I got a decent vegetarian meal and Tony got whatever he ate and a bottle of champagne, we were happy. However, Ronnie was a different story.

When we arrived for our first gig in São Paulo, Brazil, he walked into his dressing room, saw a lemon sitting on the table and threw a wobbler. He was screaming, "Who the hell put a lemon in my dressing room? I didn't ask for a lemon! Someone get the promoter!" The promoter apologised profusely, while I was thinking, *Oh God, here we go again. Ronnie hasn't changed one bit . . .*

After another gig in Buenos Aires, me and Ronnie stayed up all night boozing with an Irish journalist. By the end, only me and Ronnie were left and I was dying to fight someone. I couldn't fight Ronnie, because of my height and weight advantage (plus, he was a good friend!), so I decided to seek out someone—or something—else. On the way to my room, I noticed a bronze statue by the lift

and proceeded to head-butt it, splitting my eyebrow open. When I woke up the following morning, my face was caked in dried blood and stuck to the pillow.

As the tour progressed, Ronnie got more and more disgruntled with the dynamics of the band. The beginning of the end was probably when Ronnie fell off the stage in Detroit and Tony laughed his arse off. Ronnie lost it, phoned his wife and told her all about it. Wendy then phoned Gloria and said, "Have you heard that the rest of the band are laughing at Ronnie?" Gloria didn't have a clue what she was on about. We were like a bunch of bickering schoolkids.

Then Sharon asked us to support Ozzy at his "farewell" gigs. Ozzy had been diagnosed with multiple sclerosis and thought he only had a few years to live. I was skeptical, to say the least. Ozzy was the ultimate hypochondriac and had had the shakes for years, but I thought that was just the DTs. He also had a morbid fascination with illness and death, was always convinced he was on his way out. He'd get up onstage, leap all over the place, sing brilliantly, finish the gig and then start complaining that his throat was literally killing him. But because Ozzy was adamant that it was going to be his last tour, we couldn't really say no.

When we told Ronnie that we'd agreed, albeit tentatively, he flatly refused and called Ozzy a clown. We stressed that it was just a bit of fun, to mark the end of Ozzy's time on the road, but he wouldn't even entertain the idea. If we'd agreed to a whole tour with Ozzy, I'd have understood Ronnie's attitude. But we could have quite easily done those two shows and carried on as before.

As it turned out, the doctors had made a mistake and Ozzy didn't have MS. But Sharon still called it the No More Tours tour and we got conned into playing the final two shows in Costa Mesa, California. To be fair, we probably would have done it anyway, be-

cause I always loved playing with the original lineup (we certainly didn't do it for the money, because we didn't get paid).

Before we played, the first order of business was finding a new singer. Rob Halford, who had just left Judas Priest, fitted the bill perfectly. Like us, Rob was from the West Midlands. We'd known him for years (Tony had managed a version of Priest in the early seventies) and found him to be a really funny, down-to-earth guy. He was good mates with Ronnie, and had to run it past him, but once Ronnie had given him his blessing, he was raring to go.

Rob didn't think we knew he was gay, but we did. When he did finally come out in 1998, nobody gave a toss, which showed you how much the world had moved on. Nevertheless, it was a brave decision for Rob to make in the world of heavy metal, with all its pseudo machismo and toughness.

Towards the end of our *Dehumanizer* tour, we flew to Phoenix and did some rehearsing with Rob and Bill, who had also agreed to appear. Bill had been sober since the *Born Again* album and had never stopped loving Ozzy, so as soon as we told him what the plan was, he was on board. But the whole thing almost came crashing down when we walked offstage after the penultimate *Dehumanizer* show in Sacramento and Tony was arrested for nonpayment of child support.

The police led Tony away in handcuffs and shackles and whisked him off to Modesto, where his ex-wife Melinda lived. When he was in the holding cell, some bloke told Tony he'd be lucky to get out alive. Luckily, a Mexican gang leader, who happened to be a big Sabbath fan, recognised him, and promised he'd be protected for however long he was detained.

Not only were we due to play with Ozzy two days later, but we were also meant to play our final *Dehumanizer* gig with Ronnie the following day. They set bail at $75,000, which Tony didn't

have, because he was still in hock to the taxman. Luckily, Sharon got wind of the situation and came to the rescue. Had Tony been missing from the reunion gigs, there would have been a lot of awkward explaining to do.

At the Ozzy "farewell" show, Rob didn't know we had three or four minutes of intro music, so made his grand entrance and had to stand on the stage like a lemon while the crowd was probably thinking, *Why is Rob Halford from Judas Priest up there? Where's Black Sabbath?* But apart from that slipup, the two gigs went over well, particularly the four songs we performed with Ozzy—"Black Sabbath," "Fairies Wear Boots," "Iron Man" and "Paranoid."

The following day, the original lineup was inducted into the RockWalk of Fame on Sunset Boulevard, which consisted of us pressing our handprints into wet cement. The music media were all over the event, as they had been for the reunion shows, and rumours were rife that the original lineup were getting back together for good. I'd have been up for that, and it almost happened. But after something like eight months of negotiations, between all our different managers and lawyers, Ozzy pulled out at the last minute.

I don't know for sure why Ozzy nixed a permanent reunion, because he never gave me an explanation. I've read that Sharon pulled the plug after getting pissed off with Bill's various demands. But I didn't really worry about it not coming off. I've always had the attitude that if something doesn't happen, it wasn't meant to be. If I regretted and fretted about everything that went wrong in my life, but was beyond my control, I'd have probably topped myself years ago.

AT CROSS PURPOSES

We tried to persuade Rob Halford to join on a permanent basis, even had a meeting with his manager, but he decided to form his

own band instead. So after getting together with Tony and playing around with a load of ideas, we decided it would be good to work with Tony Martin again.

Tony Martin wasn't a natural front man. In front of big crowds, he'd stand there and sing and not much else. That doesn't really work in a metal band—you need to be able to get the crowd going. Tony was also a bit odd. He always wore a black fedora, and after one gig I said to him, "You look like Frank Sinatra." He wasn't very happy about that. But he had a good voice, could sing both Ozzy and Ronnie songs convincingly, and I felt bad about how we'd treated him in the past. He worked hard and was easy to get on with, a decent bloke all around.

We also recruited former Rainbow drummer Bobby Rondinelli, before renting a house in Henley-in-Arden, close to where most of us lived. As with *Dehumanizer*, we all pitched in with the writing. And there were some great moments, the highlight being when our old mate Eddie Van Halen popped in during one of our sessions. We spent the afternoon jamming and that's how we came up with the song "Evil Eye."

I wrote quite a lot of music for that album and I thought some of the songs were decent. But I had a big problem with it overall. The record label insisted that *Cross Purposes*, as it would be called, be released under the Sabbath banner, but I thought we'd been working on an Iommi/Butler project. For that reason, I don't consider it to be a Sabbath album.

Cross Purposes didn't make the Top 40 in the UK, and I understood why. Sabbath had become too confusing for people—how many lineup changes can a fan put up with? One minute Ronnie was lead singer, then it was Ian Gillan, then it was Glenn Hughes, then it was Tony Martin, then it was Ronnie again, then Tony Martin was back in. Fans didn't know if they were coming or going. If

a band sticks with the original lineup, maybe with the occasional tweak, fans will stay loyal. But if they don't know who is or isn't in the band, they're far less likely to buy the band's latest record. My loyalty to Sabbath was being tested to its limits, so I knew exactly how they felt.

We were back to playing theatres on the subsequent tour, and we only played four shows in the UK. But because I'm a realist and knew we were no longer big enough to fill arenas, I didn't see any shame in it. I was just happy to be back onstage, however many people came to see us.

Motörhead supported us on the US leg of the tour. One night, their guitarist Phil Campbell looked really down in the dumps. I said to him, "What's the matter with you?" And he replied, "Lemmy got the advance for the new album and spent it all on speed." God knows how Lemmy lasted as long as he did; the amount of speed he was doing on that tour had to be seen to be believed—and he was almost fifty.

We got on well with Motörhead, and they played a particularly fiendish prank on Tony Martin when we were in Miami. He'd gone ahead of us to meet a friend, and when he got to the hotel, it was too early to check in, so he went for a sleep on the beach. And because he didn't use any sunscreen, he got burnt to a crisp. He was in so much pain, he said he wasn't going to do the gig. So we told him to get in a bath of ice, which is apparently one of the worst things you can do for sunburn. He managed to get through the gig, but there was no sympathy for him afterwards. We hid a speaker in the dressing room, rigged it up to a microphone and told Motörhead to slag him off as a joke. When we got to the next hotel, Tony was raging—"You should have heard what those bastards Motörhead were saying about me!"

Bobby Rondinelli left after the European leg of the tour, as

planned, but we added four shows in South America, with Kiss and Slayer. So Tony phoned Bill and asked if he fancied joining us. Bill said, "Yeah, I'll meet you there," to which Tony replied, "What do you mean, you'll meet us there? You haven't played with us for years and don't know what the set list is! You've got to rehearse!"

Bill did come to England for a few days, but the South American gigs were a total disaster. At the first sound check in São Paulo, Bill couldn't get his bass drum to sound right, went nuts and ripped the skin off. Then he stormed into Slayer's dressing room, which was right next to ours, and started yelling at them to stop smoking dope. I said to him, "Bill, it's got nothing to do with you." And he replied, "I can't have people drinking and smoking around me!"

When it came to the show, Bill couldn't hear his monitors properly. In the middle of "War Pigs," he stopped playing and shouted at the monitor guy that he couldn't hear the guitar. Apart from that we managed to bluff our way through the set.

So endeth yet another era of Black Sabbath.

12

SO LOW

ULTRAHEAVY

When we got back to England, I quit Sabbath again and decided to make my first "solo" album. I wrote it at my house in Warwickshire, with my nephew Pedro and Burton Bell, lead singer of American metal band Fear Factory. I loved that process—it was just so refreshing to be part of a proper collaboration, playing with people who'd say, "Oh yeah, that's good, let's do that," instead of butting up against egos all the time. And it was great to get my own ideas out there.

Once we had enough material, off we went to Longview Farm Studios, near Worcester, Massachusetts, having also recruited Ozzy's drummer Deen Castronovo. I didn't want it to be my version of a Sabbath album, so in terms of musical direction, I got my frustrations out by going ultraheavy.

Plastic Planet, by g//z/r, was released in October 1995, and its heaviness surprised a lot of people. Quite a few writers put it in their top ten metal albums of the year, and one of the songs, "The Invisible," about homelessness and drug dealing, was chosen for

the *Mortal Kombat* soundtrack, which went platinum in the US. A short tour was booked and Ozzy came to see us at the Limelight in New York, where I also met Peter Steele from the band Type O Negative. He was another great bloke who left us way too soon.

It was around this time that me and Tony had a big falling-out. On *Plastic Planet* was a song called "Giving Up the Ghost," which was about me leaving the chaos of Sabbath. It wasn't about Tony, but the whole cast of characters from the beginning of Sabbath to the current day—the egos, the rip-offs, the press, the ins and outs of the band. The lyrics were cutting—"You plagiarised and parodied/the magic of our meaning/you can't admit that you're wrong/the spirit is dead and gone/you don't bother me/you are history/a legend in your own mind/left all your friends behind"—but Tony's response was completely out of proportion.

On Sabbath's *Forbidden tour,* they had a backdrop of a cemetery. One headstone said, "Here Lies Geezer Butler," the other, "Here Lies Gloria Butler." I went ballistic when I found out. It was one thing me and Tony falling out, but why did he have to drag my wife into it? That's when I decided to dedicate "Giving Up the Ghost" to Tony and his "fake" Sabbath.

OZZMOSIS

During the making of Ozzy's *Ozzmosis* album, my depression came back with a vengeance. We were supposed to be in LA for six weeks, but it turned into three months. I stayed in my room for days on end, and if someone suggested we go down the pub, I'd decline the offer. Everyone started calling me a recluse. Then we decamped to Studio Guillaume Tell in Paris, where being a vegan was almost a criminal offence. I lived off tomato sandwiches the whole time I was there, which wasn't great for my mental health.

To make matters worse, working with the producer Michael Beinhorn was a nightmare, because he was on a power trip. He wanted to fire Deen Castronovo, an excellent drummer, but was overruled. And recording my bass parts was torture. While I was playing, Beinhorn would loudly and randomly tap drumsticks on the console, completely out of time, presumably to intimidate me. I felt like gouging his eyes out with those bloody sticks. Producers are supposed to encourage you, make you feel comfortable, to bring the best out of you. Luckily, Paul Northfield, a good guy, was engineering, and when Beinhorn was out of the studio, I re-recorded my bass parts with proper amp settings.

We then went to New York, to finish writing and recording, which is where I got to know Ozzy guitarist Zakk Wylde properly. Zakk was a great musician with a ridiculous sense of humour. In fact, he's the only person I've ever met who out-crazied Ozzy. One of his favourite tricks was to piss in the air, catch it in his mouth and swallow it. Not something you'd catch David Copperfield doing. And when the bar next to our hotel refused to serve him, because it was closing (at 5 A.M., to be fair to them), Zakk pissed in his pint glass and drank it. That'll show 'em! He wondered why they banned him from then on.

Zakk also vowed not to wash or shower until the album was finished. On our way to the studio one day, I couldn't figure out what the stink in the cab was. It was like nothing I'd ever smelled before, and I'd spent years on the road with Bill Ward. I thought someone had puked under the seat—or worse. And just as I'd worked out it was the fumes coming off Zakk, he opened the door while the cab was moving and rolled out onto the street, laughing hysterically.

For all his madness, Zakk did save my (vegan) bacon on the subsequent *Ozzmosis* tour. After the show in Albuquerque, Zakk and I went to a bar, where he introduced me to a lethal 120-proof

whisky. A few hours after drinking had commenced, we headed to a club. Despite our almost falling through the door, the promoter was delighted to see us and asked if we wanted to jam. I thought that was a terrible idea, but Zakk was keen. When we got onstage, Zakk said, "Let's do a Hendrix number," before launching into "Purple Haze." Meanwhile, I was attempting to play "Red House," missing the strings because I was so drunk (you might recall I said seasoned musicians click into autopilot while stoned or drunk—not on this occasion . . .).

After being booed off, we were politely asked to leave, where-upon I knocked over several big flowerpots by the entrance. Out-side in the car park, I kicked a car and stood in front of a big truck that was trying to leave. When the driver got out, he was about eight feet tall. If it wasn't for Zakk's charm—he did have some!—the bloke would have pummelled me to a pulp.

I was drinking a lot around that time, and my depression made me an even worse drunk than normal. I thought that because I'd given up drugs, even dope, boozing was okay. But not only did it turn me into a complete maniac—argumentative, shouty, sweary and wanting to fight everyone—it also caused a lot of problems with Gloria. Gloria's never touched alcohol, she doesn't understand its ap-peal. And while I was never physically violent towards her, I was verbally abusive. She also hated me drinking around the kids. Gloria must have given me about ten last chances. I'd not drink for a while but eventually go back to it, usually when she went back to America.

While I was on the road with Ozzy, I was missing Gloria and the kids horribly. But I didn't want to let Ozzy down by pissing off, so stuck with it. But I was sinking deeper and deeper into darkness. I could actually feel myself changing from the old me, someone who was quite sociable, into this other me, someone who didn't want to talk to anybody. It was scary at first, thinking the old me would never come back. I still feel awkward in certain social situations.

A KID AGAIN

I spent most of 1996 at home with the family in England. I loved buying the boys comic books and toys, so much so that collecting the ones I wished I'd had in my childhood became a hobby of mine. I'd take the boys to comic-cons and toy fairs and collect rarities. I filled a room with them, and when Pedro came to visit, we'd get talking about the Gerry Anderson puppet shows we watched when we were kids. I loved the early ones, like *Four Feather Falls, Fireball XL5, Supercar* and *Stingray*, while Pedro loved the later ones, like *Captain Scarlet, Thunderbirds, Joe 90, Space: 1999* and *UFO*. I was also a big fan of *Batman* (the 1960s TV series), *Dr. Who* and *Man in a Suitcase*.

Most of those shows were referenced in my band's second album *Black Science,* which we recorded at Le Studio in Morin-Heights, Quebec, under the name Geezer. People kept telling me g//z/r was confusing, and some fans thought it was too like the Guns N' Roses abbreviation GNR. I even received some of their fan mail!

Having had a miserable time recording *Never Say Die!* in Canada, this was a different experience entirely, better than any doctor's prescription. The studio was very atmospheric (no need to rip up any carpets or tear down any drapes), as was the surrounding area. We spent the first few days tubing down the nearby hills. The snow was at least a foot deep, and the lake on the studio grounds was frozen enough to skate on. It was like being a kid again, at least if I'd grown up in Canada rather than Aston.

After *Plastic Planet,* we'd recorded a song for the *Mortal Kombat* sequel. The singer on that was a guy from New Jersey, Mario Frasca, but for *Black Science,* we decided to audition for a new singer at Long View Farm Studios. At the recommendation of the studio owners, a local guy called Clark Brown auditioned and got

the job. Clark fitted in with the songs perfectly, and his sense of humour was as silly as mine and Pedro's. Deen Castronovo was again on drums, while Paul Northfield was coproducer and handled engineering. But while we were preparing for the release of *Black Science*, and my mind should have been focused on that, Sharon Osbourne asked if I'd be interested in being part of a Black Sabbath reunion, at the Ozzfest rock/metal festival.

TOGETHER AGAIN

Sharon had put on the first Ozzfest the previous year, after Ozzy was rejected by Lollapalooza. Apparently, Lollapalooza's organiser didn't think Ozzy was cool enough, so it was Sharon's revenge. On the face of it, a reunion seemed highly improbable. I'd only recently stated that the original lineup would never get back together. And not only had me and Tony fallen out, but Ozzy had also been saying all sorts of horrible things about Tony. Oh, and Sharon had sent Tony a bag of her daughter's poo in the post. Lovely. But we got together, agreed to put the past behind us and start afresh. The prospect of the four of us reuniting just proved too tempting—and the money wasn't bad either.

The Ozzfest tour consisted of twenty-odd dates in America, with Faith No More's Mike Bordin on drums. Bill said he wasn't invited, while Ozzy's people said he was ill. To be honest, I think Sharon just needed a quick yes-or-no answer, which she thought she was unlikely to get from Bill. However, Bill did rejoin us for two dates back in Birmingham at the end of 1997. We had Vinny Appice on standby, because of concerns about Bill's health, but he was more than up to the task. I was actually a bigger health risk, having fallen ill while touring with my own band—I got gastroenteritis and had a stint in hospital.

It was fantastic to have the four of us back onstage together,

headlining our first UK shows for almost twenty years. It was scary, as it always was playing our hometown, but beautiful nonetheless. The gigs were recorded for a live album, *Reunion*, which went multiplatinum in 1998. Sabbath were hot property again, which made a full-blown reunion an inevitability. Surely?

Me and Tony were getting on so well again that he decided to play the ultimate practical joke on me. I'd got drunk, had a blazing row with Gloria, stormed out of the house and driven straight to Tony's, which was only a few miles away. It was about eleven o'clock at night, but being such a good friend he ushered me in and listened to my drunken ramblings. After a couple of hours, I headed back to my place. I was still way over the limit, and Tony wanted me to sleep it off, but I thought I'd worn out my welcome.

It was all country lanes between our houses, so I thought there was little chance of the police catching me. But about two miles from Tony's, a flashing blue light appeared in my rearview mirror. My blood ran cold—I'd already upset Gloria, now I was about to lose my driving license and get a very heavy fine. I might even get a couple of weeks in the nick. I pulled over, wound the window down and waited for the copper, who had parked up behind me. It was pitch dark, so I couldn't really see whoever it was approaching my car, but suddenly I heard him shout, "Get out of the vehicle now!" I staggered out, in a state of terror, and there was Tony, laughing his head off. I could have killed him at first, but as relief set in, I began to see the funny side.

Having agreed to a European tour, we headed to Monnow Valley to rehearse in early 1998. Me, Tony and Geoff Nicholls would go for long walks together, and one day we were ambling along when an ambulance flew past, heading in the direction of the studio. As a joke, Tony said, "That must be for Bill" (Bill had been sober for a number of years, but he smoked sixty a day and turned up in Wales with a suitcase full of cigarettes). Then, on our way

back, the ambulance flew past in the other direction. When we arrived at the studio, Ozzy emerged from his bedroom and told us that Bill had had a heart attack.

Thanks to the great doctors and nurses of the UK's NHS, Bill survived to drum another day. I even managed to make him laugh with the card I gave him, congratulating him on his newborn baby. But after the shock had subsided, and I knew Bill was going to be okay, I thought, *Oh God. We were back on top, things were going great and we've got a huge tour coming up—and now Bill's gone and had a bloody heart attack. What do we do now?*

With Bill up on bricks, we got Vinny Appice back for the European shows, because he was the only person who knew all of our songs. Bill was able to introduce us in Milton Keynes, which the fans loved. Knowing Bill sometimes didn't wear underpants, Tony sneaked up behind him and pulled his shorts down, which brought the house down.

Bill was back on drums for a performance on David Letterman's *Late Show* (Tony didn't repeat the gag, thank God), which was a great gig for any band. Funnily enough, that appearance almost didn't happen because Ozzy hated singing on TV, but the audience reaction was incredible. Letterman even visited our dressing room and told us he was a big fan, which surprised me. He didn't seem the Sabbath type.

BREAKDOWN

Later in LA, where I'd gone to do the bass parts for two new tracks on the *Reunion* album, I had a nervous breakdown. I hadn't felt too clever before leaving St. Louis, and when I heard the new tracks, I hated them and my depression deepened. I became paranoid, convinced that Tony and Ozzy had lured me there to kill me. The thoughts would repeat on a loop in my head. One day, Ozzy and

Tony sent someone out to pick up a curry, and I became convinced they were planning to poison my meal. I was on the phone to Gloria every night, telling her she had to get me out of there or I'd end up murdered. At first, she thought I was drinking too much. But in the end, I couldn't face anyone or anything in LA and had to fly home.

When I went to the doctor, I discussed what I'd been experiencing—the paranoia, the darkness—and he told me I was having a breakdown. I'd sort of worked that out, but it's almost impossible to make sense of anything when you're in that situation. I'd been depressed on and off for a couple of years before then, but this hit me like a ton of bricks, sent me toppling into this big, black hole that I couldn't get out of. The doctor understood me, but it was difficult to explain to anyone else.

Gloria must have found the whole episode terrifying. And I had to tell my bandmates I had mononucleosis, because I knew that usually puts you in bed for a couple of months. They probably didn't believe me, but I didn't want to tell them the truth, because Sabbath seemed to be back on top again.

That was the first time my mental health had been properly diagnosed and treated. The doctor prescribed me Prozac and after six weeks, the dark fog began to lift. Finally, I could see a way out of the hole. And once I was out of the hole, I felt great. I was thinking, *This is how I used to feel back in the seventies—happy!* I've been on antidepressants ever since. They truly are a lifesaver—although they do make you pile the weight on!

THE ALBUM THAT NEVER WAS

By the late nineties just about every rock and heavy metal band in the world was citing Black Sabbath as a major influence. Ozzfest certainly helped with that, because we were sharing a stage with

bands like Foo Fighters and Slipknot. When Anthrax guitarist Scott Ian was asked to name his top five metal albums, he replied, "The first five by Sabbath."

There were two Sabbath tribute albums released around that time, including covers by Megadeth, Sepultura, Faith No More and the rapper Busta Rhymes. Sabbath had already been sampled by everyone from the Beastie Boys to Cypress Hill, and that trend accelerated now that we were officially cool again. Daft Punk and Kanye West would borrow from "Iron Man," Arctic Monkeys would borrow from "War Pigs," A Tribe Called Quest would borrow from "Behind the Wall of Sleep" and Eminem sampled "Changes." Even Lady Gaga said she was a Sabbath fan. Getting that kind of validation from fellow musicians, whatever their genre, feels fantastic.

When you get new bands namechecking you, you inevitably get some of their fans on board as well. On that US tour in 1999, we had thousands of kids queuing up for our autographs. It was chaos, not least because some of them wanted to have deep conversations about every song we'd written. I found that difficult at times. They were hard-core fans who absolutely adored us, but we'd only have a few seconds to chat to them before security moved them on.

I'd be really humbled by some of the autograph requests. There were people showing up to our shows with only a few weeks to live, telling us that Sabbath had kept them alive. Just recently, a kid turned up to a signing event with a little glass vial containing his dad's ashes around his neck. His dad was a massive Sabbath fan, so I signed the vial for him. I know some musicians aren't big on signing stuff, but how on earth could you refuse a request like that?

After playing Ozzfest again in 2001, we planned to record a new studio album, which would have been the first from the origi-

nal lineup since *Never Say Die!* in 1978. The following year, we all went down to Monnow Valley and came up with about six songs, but they just weren't up to scratch. Clearly, it just wasn't the right time for us. The songs felt too forced: Neither the tunes nor the lyrics flowed naturally. Geoff Nicholls really tried to get things going and threw a few vocal ideas around with Ozzy. But every idea I had was ignored.

The project was abandoned after we played the songs to Rick Rubin at his house in LA. Rick had a reputation as the number one producer on the planet and had worked with everyone from the Beastie Boys to Mick Jagger. He also had a reputation for making veteran artists relevant again, most notably Johnny Cash. But Rick didn't exactly make a good first impression on us. When we arrived at his house, his assistant said, "Rick will see you in half an hour. He's in his meditation room . . ." We all thought, *Oh God, here we go . . .*

Once Rick was done meditating, we played our songs to him. While he was nodding away, not saying anything, I was thinking, *These are crap*. Rick claimed to see something in the songs, but it was too important an album for it to be substandard. So that was that; we decided collectively not to proceed.

The next time I saw Ozzy, he was on my TV, starring in his own reality show. I wasn't that surprised by *The Osbournes*, because Sharon had always wanted to be famous. I actually thought the first season was hilarious. It showed Ozzy exactly how he was—he wasn't putting on an act.

After the show took off, Ozzy became a household name all over the world. I'd go round to his house and there would be paparazzi everywhere. Even old women knew who Ozzy Osbourne was. It didn't bother me that Sharon became more famous than Ozzy, even. Before one gig in New York, there were about forty

paparazzi outside the hotel and they completely ignored the four of us; they were only there to photograph Sharon. I found that hilarious. Plus, Ozzy rejoining the band meant the fans he'd built up as a solo act, and from his TV show, were now seeking out Sabbath's Ozzy-era records and coming to our gigs. It was like our fan base doubled overnight.

While Ozzy was off being a celebrity, I made my third solo album, *Ohmwork*, which was released in 2005. We had a lot of fun making that record, because it all felt very cosy and there were no massive expectations.

Me and Pedro came up with some ideas in England, others we came up with in my basement in Chesterfield, before I moved to LA. We recorded the album at Shock City Studios in St. Louis, which was owned by Doug Firley from Gravity Kills, who had a big hit in America with "Guilty" and were also managed by Gloria. Our drummer was a local guy, Chad E. Smith, and we recorded without a producer. We each did our part, and if everyone approved, that was the final decision. If only I was as decisive over the band's name—now we were called GZR (when all three albums were released by Universal in 2021, and the vinyl versions finally made an appearance, it was under the name Geezer Butler. I got there in the end).

For the final mix on *Ohmwork*, I booked into Skip Saylor's studio in LA, brought in producer Toby Wright (Alice in Chains, Metallica, Slayer and many more) and added a vocal by Lisa Rieffel, from the band Killola. Lisa was, and is, a fine singer, as well as a successful actor, and she definitely added something different to the track "Pseudocide." I wrote "Pardon My Depression" in my basement, and it was a play on the old British sitcom *Pardon the Expression*—having gone all sci-fi on the previous album, the lyrics on *Ohmwork* were a bit earthier. I'm not a fan of hip-hop, but

Clark Brown was such a good rapper that I got him to do a bit on "Prisoner 103."

MAIDEN OVER

I played a couple more Ozzfests with Sabbath, including in 2005, where there was a big bust-up between Sharon and Maiden front man Bruce Dickinson. Ozzy could only sing every third night, to protect his voice, and it got back to Sharon that Bruce was going onstage in our absence and insulting their TV show. Sharon was never going to let that go, but her reaction was extreme, even by her standards.

Before the last show Sabbath and Maiden appeared in together, at the Hyundai Pavilion in San Bernardino, there was no sign of the chaos to come. Steve Harris, Maiden's bassist and leader, even popped by to say thanks for the tour, and we exchanged bass strings. But just before Maiden went onstage, Sharon came to my trailer and told me to watch the TV monitor.

I thought Maiden had something unusual planned—maybe the drummer was going to set fire to his kit, or Bruce was going to give a fencing exhibition. Instead, when they walked out, some people in the crowd started chucking eggs at them, which Sharon had orchestrated. And when they did their song "Trooper," during which Bruce unfurls the Union Jack and shouts, "These colours don't run!," one of Sharon's assistants ran on with an enormous Stars and Stripes, before snatching the Union Jack from Bruce's hands and throwing it to the ground. As he was being dragged away, the power cut out. Some of the crowd then realised that Maiden were being sabotaged and started booing. It was a strange end to what, up until then, had been a very harmonious Sabbath-Maiden combination. The moral of the story? Never cross Sharon Osbourne.

RONNIE'S RETURN

In 2006, Sabbath were finally inducted into the US Rock & Roll Hall of Fame (the UK version had beaten them to it by a year). We'd been eligible for ten years, but never received enough votes (allegedly). I really wasn't bothered, but Ozzy had sent them a letter, telling them to take Sabbath off their list. However, the self-appointed arbiters of musical taste eventually bowed to the inevitable and allowed us in.

The Sex Pistols were inducted the same year but didn't turn up to the ceremony (someone read out a statement written by Johnny Rotten, comparing the Hall of Fame to a "piss stain"). Blondie were also inducted, but Debbie Harry barred some of her former bandmates from performing, which was a bit awkward. Remarkably, all four of Sabbath's original lineup turned up, but we refused to play. Instead, Metallica did a rendition of "Iron Man." It was quite a bittersweet evening for me, because I thought Ronnie should have been involved. Unfortunately, Sharon was never going to allow that to happen.

After being inducted into the Hall of Fame, we thought we'd gone as far as we could with the original lineup. Me and Tony had been talking about how much we missed playing Ronnie-era songs. And with perfect timing, Rhino Records got in touch and said they wanted to release a compilation of songs taken from our albums with Ronnie, including new material. Gloria got in touch with Wendy, Wendy asked Ronnie and he said he was up for getting back together.

At the end of 2006, Ronnie flew over to England, we gathered at Tony's house and got down to writing, before heading into Tony's studio—Tone Hall—and recording three new tracks for *Black Sabbath: The Dio Years*. Originally, Bill was to play drums, but he sent

Tony a multipage fax of suggestions, which Tony didn't agree with, and Vinny was once again drafted in.

It was great seeing Ronnie again, and we all got on like a house on fire. I found myself thinking, *Why on earth did we break up in the first place? Was it really because of that?* The only thing that pissed me off was when the album was released and I discovered that "The Sign of the Southern Cross," one of my all-time favourite Sabbath songs, had inexplicably been left off.

Because we had so much fun writing and recording the new material, and Ronnie's voice was still in such fine fettle, we started talking about playing live together again. We didn't want to risk a full-blown tour, because things had a habit of turning sour. To test the water, we did a one-off concert at Radio City Music Hall in New York, which was recorded for an album and DVD. It went very well, apart from union interference—they only allowed us a fifteen-minute sound and lights check, and imposed a strict curfew, which meant we had to drop a couple of songs from the set.

After the release of the live album and DVD, we decided to go for it and put together a world tour. To avoid confusion, we went back out as Heaven & Hell, after the first Ronnie-era album, although most fans still referred to us as Black Sabbath. We kicked off the tour in Vancouver in March 2007 and finished in Bourne-mouth, England, that November. In between, we did dozens of gigs in the US, Mexico, Europe and Australia, supported by Down, Megadeth and Alice Cooper, among others.

One of the highlights was the show in Singapore, because no version of Sabbath had played there before. The only problem being that Singapore had a strict ban on chewing gum, and chewing gum was one of my big superstitions. For as long as I could remember, I'd been popping a stick of gum in my mouth as I went onstage and chewing it during the opening song.

When we played the Birmingham NEC in 1997, I was so nervous I forgot my gum and had to run back to my dressing room and get it. And to avoid arrest and shame in Singapore, I locked myself in my dressing room toilet, frantically chewed on a stick of gum for a few minutes and flushed it, just before heading for the stage. I felt like someone snorting cocaine in a nightclub, half expecting a bouncer to come crashing through the door.

It was great playing a set of only Ronnie-era songs. I'd always been very fond of them, and it made a nice change from the usual Sabbath set, which was pretty much the same on every tour. Ronnie was in his mid-sixties but was on fire every night.

Ronnie always gave the fans absolutely everything, on and off the stage. When we were touring Europe in 2009, we arrived at our hotel in Oslo and there were loads of fans waiting for us. When we went to check in, the receptionist couldn't find Ronnie to give him his key. Eventually, he found him outside, drinking cans of beer with the fans. Ronnie was brilliant like that.

But while Ronnie would often have a bottle of wine and a six-pack of Boddingtons before a gig, I never went onstage even half inebriated (there was the time I dropped some acid before a gig in Leamington spa, but the only time I performed drunk was when me and Zakk Wylde ended up playing two different songs at the same time in that club in Albuquerque).

People think bands become so familiar with their songs and each other that they just turn up to the venue, sink a bottle of whisky, stroll onto the stage and start playing. But before every gig, Tony would spend two hours warming up. Even Ozzy would do vocal exercises for an hour. Meanwhile, I'd lock myself away, do half an hour of yoga, lie down for an hour, warm up the fingers for about twenty minutes and listen to some silly songs. And it would be the same every time.

BETTER THE DEVIL YOU KNOW

In Japan, a journalist asked if it was just a one-off tour, or if we were planning to record any new material together. We didn't know what to say, because we really hadn't discussed it. But after the tour was over, we decided that because it had gone down so well, and everything felt so right, we'd do a new studio album together.

The writing of that album, *The Devil You Know*, was an idyllic experience, because it wasn't forced. We all gathered at Ronnie's house, played each other what we had, picked out anything that was suitable and went from there. Tony had two CDs of riffs, Ronnie was full of ideas as usual and I had loads of stuff in the locker as well.

It was nerve-wracking playing my ideas—especially if they were met with total silence and a "hmmm, what else have you got?"—but the process was refreshingly democratic. It was weird at times, because some stuff I thought was really good was rejected out of hand while Ronnie would seize on other stuff I thought he wouldn't like. It didn't have to be some mighty riff, it could just be a couple of throwaway chords that Ronnie thought would be good to sing over, or a bass intro (as in "Double the Pain"), or outro, or riff.

We headed to Rockfield once more to record the album, with Mike Exeter, Tony's engineer from Tone Hall, at the controls. It was fun recording it, and Tony got up to his old tricks by loading Vinny's hair dryer, with which he used to dry his hair after laying down drum tracks, with talcum powder. When Vinny turned the dryer on, he looked like a sweaty ghost!

I was happy with how that album came out, especially the heavier songs like "Bible Black" and "Rock and Roll Angel." I was even happier when it went straight in at number eight in the States,

the highest chart placing for a Sabbath album for almost forty years (even if it wasn't officially a Sabbath album). We were in Norway when Gloria called to give me the news. When I told the rest of the guys, we were all jumping up and down and hugging each other, because we didn't even expect it to break the Top 20.

We were back to being kids again, like the time we heard that "Paranoid" had reached number one. You could argue that the performance of *The Devil You Know* was the bigger achievement, because we'd had to put the band back together—for the umpteenth time—gone out on the road and built up a whole new following, which takes some doing at the age we were then.

Before leaving for that tour, as we were checking in at Heathrow Airport, Tony was served a writ. I found out it was from Sharon, suing Tony for the Sabbath name. When I got to the hotel in Norway, Sharon contacted me to see if I would join her and Ozzy in a lawsuit to have the name reverted to the four original band members. Out of loyalty to Tony, and because I didn't feel comfortable suing him while we were on a world tour together, I declined. Sharon went ahead with the lawsuit and eventually forced Tony to share the Sabbath name with Ozzy and her. I thought Tony would repay my loyalty by insisting the name be reverted back to all four original band members. Silly me!

Then, as so often in the Sabbath story, we came crashing down to earth. We were touring the States in 2009 when Ronnie started getting really bad stomachaches. We kept telling him to take a few days off, but he wouldn't listen. He'd be doubled up in the dressing room, go onstage and perform like nothing was wrong with him, before being doubled over again when the show was over. He was convinced it was indigestion, or something else not too serious.

Ronnie's last show was in Atlantic City, on August 29, 2009. I remember us both watching the support band Halestorm that

night. We really liked them and were thinking of having them on a future tour. The next day, on the plane back to LA, Ronnie was still in pain, but he still had time to argue with a bloke who'd taken his overhead bag compartment. When we landed, there was a camera crew there. We asked what was going on and the reporter replied, "There's a man threatening to jump off a building unless Ronnie Dio talks to him." This bloke was calling himself the Man on the Silver Mountain, which is a famous Rainbow song, from when Ronnie was in the band. Ronnie was in agony, but he got in a car and talked the bloke down.

The first doctor Ronnie saw said he had trapped wind. When Ronnie told me, I said to him, "That doesn't sound right. It's got to be more than that." He looked awful, and eventually he got a second opinion. This time, the doctor told Ronnie he had stage four stomach cancer. But Ronnie, fierce fighter that he was, was convinced he could beat it.

FAREWELL, OLD FRIEND

Gloria and I went with Wendy and Ronnie to check him into the MD Anderson Cancer Center in Houston, which is the best stomach cancer hospital in the world. Before we left, Ronnie thanked me for being there for him, and I left the hospital with tears in my eyes. Despite the various spats, he really meant a lot to me.

After a couple of months, the doctors said there was nothing they could do to save Ronnie's life, so he came back to LA. Wendy threw a big party up in Santa Barbara and Ronnie turned up in a wheelchair. He must have weighed about five stone and struggled to walk a few yards even with a stick. The funny thing was, the doctors had told him his diet—mainly meat—had caused his cancer. So Ronnie had suddenly given up meat and started eating only

vegetables, having avoided them all his life. He said to me, "I can't believe what I've been missing all these years, vegetables are great!" But he'd left it far too late.

About a month later, Ronnie was taken into hospital, where they pumped him full of morphine, so that he was completely out of it. We visited every day, as did Vinny and other friends and family, plus Dio band members and crew. We surrounded Ronnie's bed, all praying and talking to him, unsure whether he could hear or not, until the doctor came in and said, "It's time." Me and Gloria left the room and let Wendy say her goodbyes. She was with him when he died, comforting him on his bed.

It all happened so fast. Less than a year earlier, Ronnie had been jumping around onstage like a man half his age. He was a brilliant performer to the end. I used to say that there was only one true Sabbath, namely the original lineup, but I've changed my view on that.

Ronnie-era Sabbath had its own following, and many fans have told me they got into Sabbath after the *Heaven and Hell* album. Lots of bands have told me that as well—only after hearing the Ronnie-era albums did they listen to our earlier stuff. It was a totally different kind of music, with different ways of writing, recording and touring, so that it feels like I was in two different bands—both of them great. Ronnie is largely unsung outside of the world of metal, but he was a musician's musician and probably the greatest metal vocalist of all time. I'm so glad we got back together and managed to climb to the top again before he passed away. But, most important, we were once again the best of friends.

At Ronnie's funeral, in Forest Lawn, LA, hundreds of people from the world of metal and rock turned up to pay their last respects. It was a fine send-off, no doubt about that. Ronnie looked at peace in his open casket, some very emotional speeches were given

by friends, from his childhood days and his time in the music business, and lots more tears were shed.

A couple of months after Ronnie's death, the surviving members of Heaven & Hell, plus Glenn Hughes and Norwegian singer Jorn Lande, who worshipped Ronnie and sounded like him, played a tribute set to Ronnie at the High Voltage Festival in London. In Ronnie's honour, we gave our fee to a cancer charity, and the promoter said he'd match our donation. That was an emotional night. Ronnie might not have been there in person, but we could feel his spirit.

BEGINNING OF THE END

PLOUGHING ON

In November 2011, the four original members of Sabbath held a press conference at the Whisky a Go Go and announced we were getting back together to record our first studio album since 1978, followed by a world tour. We'd been discussing it since Ronnie's death and thought it would be a good way of wrapping the whole Sabbath story up, before walking into the sunset.

As you've probably guessed, the reunion didn't go as planned. It all seemed to be working when we gathered at Ozzy's house to record some demos. But then there was a big row about the Sabbath name, all over again. I was under the impression that since the original members were back together, writing and recording a new album, the name would revert to all four of us, whatever had happened between Tony and Ozzy a couple of years earlier. But when the name was discussed, it became clear that Tony and Ozzy had no intention of sharing the Sabbath name with me or Bill. I felt cheated, so I left the band again. They got someone in to

252 ⚡ GEEZER BUTLER

replace me, but a couple of weeks later I got a call from Tony, begging me to come back. In the end, I got my lawyers on the case and they managed to sort everything out. I was assured that despite not part-owning the Sabbath name, everything would be split equally and the band wouldn't be able to tour as Sabbath without my approval, if needed.

As writing was in process at Ozzy's house, he made the observation that Tony had lost too much weight, and that he should get checked out. When Tony got back to England, he was diagnosed with a form of lymphoma.

If I'd been diagnosed with cancer, I'd have cancelled everything and stayed at home for the rest of my life. But Tony's not like that. When me and Ozzy flew to England to resume writing, Tony would have chemotherapy in the morning and come straight home to his studio, where we'd put some ideas together.

We'd say to him, "Tony, have a couple of weeks off." And I did take time off, including watching Aston Villa play a preseason friendly against the Portland Timbers in Oregon. Me and Tom Hanks, a fellow Villan, introduced the teams before kickoff. But while I was away having fun with Gloria, Tony was at home, getting on with work. He was tired and nauseous, his hair was falling out, but he was determined to plough on, just like he did when he lost the tips of his fingers.

While Tony was just about up to writing and playing his guitar in the studio, he certainly wasn't able to tour. We did a one-off gig headlining the Download Festival in England, prior to a warmup in Birmingham. The reunion tour was put on ice, and instead we went out as Ozzy and Friends, the friends including Zakk Wylde, Adam Wakeman, Tommy Cluefetos and Slash.

When Bill first came back, I thought he was doing great. His timing was off a few times, but that's Bill. However, when me and

Gloria got back from a holiday in Hawaii, we were told he'd been fired. Bill put out a statement saying he'd been given an "unsignable" contract and wouldn't be putting pen to paper until he was shown "dignity and respect."

I don't know the ins and outs, because contracts and the like were always sorted out between our lawyers. However, I suspect Bill was given an "unsignable" contract because Sharon didn't think he was up to a world tour. In fact, I know that Ozzy and Tony didn't think he was physically able, because of a shoulder problem and heart condition. Like the Godfather in reverse, maybe they made Bill an offer he couldn't accept.

We suggested to Bill that he come on tour and do a few songs a show, but Bill, proud bloke that he is, insisted it was all or nothing. I was upset that what should have been a triumphant return for the original lineup had turned into a bit of a soap opera—and ended up making it worse. While Bill was churning out public statements, Sharon was giving me her side of the story, including that Bill had refused to play a charity gig at Birmingham's O2 Academy. Stupidly, I then put out a statement on the internet, including a line about Bill wanting money for said charity gig. I regret doing that, because I'd ended up doing the band's dirty work. Worse, I'd betrayed Bill's friendship by not believing his side of the story, which was that he'd actually agreed to do the charity gig for free.

Tony was back for the Birmingham gig, which was effectively a warmup for the Download Festival in Donington Park a few weeks later. And while there were a few thousand people in the audience, it was really a chance to iron out any wrinkles. That was one of the best gigs we'd ever done. Everyone was on fine form, including Tommy Clufetos, who was a very different drummer to Bill, much more direct, like Vinny Appice.

It's always dark and stormy at Donington, and that year was no

different. The wind and rain were so bad on the opening day that they had to cancel some of the acts. The weather had calmed down by the Sunday, although it was freezing by the time we took to the stage. Thankfully, something like 100,000 fans had stuck around, and we were bang on it from the first note.

There are always nerves on big occasions like that. When you're at a festival, you can hardly sneak in in the afternoon and do a sound check in front of everyone. So when you walk out on the night, you're hoping everyone behind the scenes has done their job properly. Then when you start playing, you're looking at the monitor guy, telling him to turn things up or down. Only when the levels are sorted can you relax and get on with what you're there to do.

Once you're all in the groove, and you're making 100,000 people go mental, there's no greater feeling—apart from Villa winning the cup (or anything!). That was what we were born to do, and the consensus was that we were on vintage form that night. The show kicked off with a video montage of our best riffs, before we tore into our early classics, starting with "Black Sabbath" and finishing with "Paranoid." What the fans wanted, we gave them in spades. After all that drama, it turned out there was plenty of life in the old dogs yet.

13

Tony was responding well to his treatment and was in a much better frame of mind. He had an in-house engineer, so only had to think of the music (in my house, I'd spend days programming the equipment, to get the right sound, before I could even think about writing anything). That allowed him to come up with hundreds of riffs, some of them brilliant. He'd play them to me and Ozzy and we'd pick out which ones we wanted to work on. Or he'd already

have written the entire song and we'd only have to tweak it here and there, and add vocals and lyrics.

Once again, Rick Rubin was hired as the producer—and he didn't do a lot. One of the first things he said to us was, "You're not a heavy metal band." Then he played us our first album, before saying, "When you made that, there was no such thing as heavy metal. Think back to that time." I thought, *How can he expect us to go back forty-odd years and pretend that what happened since didn't actually happen?* I think he liked the rawness and spontaneity of the first three albums, but it was hard to channel that organically.

When we were at Ozzy's house in LA, Rick would walk in, lie on the couch, listen to our new songs—we had fifteen by then—and say, "Nah, too metal,"' or, "Yeah, that's good. Keep writing." Eventually, we said to him, "We're not gonna write any more; that's the album," and Sharon had to have a word with him.

We finally entered the studio in Malibu in August 2012, having recruited Brad Wilk (Rage Against the Machine) on drums, but Rick didn't become any more helpful. We'd ask him why he didn't like something, and he'd reply, "I think you can do better." We'd say, "Yeah, but how can we do better?" And he'd reply, "You'll figure it out . . ." At one point, Rick tried to get Tony to play through some 1968 amps, presumably thinking it would make us sound like we were back in 1968. Tony told him that wasn't going to happen, and rightly so.

Pretty much any producer could have done what Rick did on that album. But the record company knew his involvement would create extra publicity. Their reasoning was, "If people know the great Rick Rubin is on board, they'll be more likely to buy the album." Also, they probably thought that because of Rick's reputation, he'd be able to reel Ozzy in and make him work harder. But even that didn't go to plan. Ozzy gets bored quickly, and whenever

Rick asked him to repeat a vocal part, he got very frustrated. Rick would say, "That was great. Do another one . . ." After nine or ten takes, Ozzy would say, "If every take I do is great, why can't you use any of them?"

On reflection, the best producer I ever worked with was Martin Birch. When he produced *Heaven and Hell* and *Mob Rules,* he had lots of great ideas and was really patient in capturing *our* sound, rather than trying to get us to sound like *he* wanted us to sound. We'd play him our demos and he'd say, "Oh, I get what you're trying to do," and he'd do his best to make it happen.

We wanted that album, which we'd end up calling *13*, to sound like the original Sabbath, rather than the Ronnie James Dio version of Sabbath (or any of Tony's one hundred versions of Sabbath). At least Rick was right about that. That meant going back to how we sounded before we started to experiment and "progress." At that stage in our careers, I think that's what the fans expected as well.

Just like the old days, I wrote most of the lyrics on *13*. But it was more of a challenge than it used to be. Back in the late sixties, I was a working-class kid from the streets of Aston. In 2012, I was trying to conjure up lyrics while sitting in a big house in Beverly Hills. That made it a lot more difficult to tap into the bad things that were happening in the world. I was also having to self-censor, so that I wouldn't offend anyone. It was quite a painful process, and I was relieved that Ozzy mucked in, writing two or three sets of lyrics himself.

Sometimes, Ozzy would come up with a phrase and I'd think, *What can I write about that?* I'd scribble down the lyrics that night and Ozzy would sing them the following day. It was Ozzy who came up with the title of the song "God Is Dead?" (I wanted to call it "American Jihad," but Ozzy thought that was a terrible idea.) There was a lot of religious terrorism going on at the time, and a

few months earlier, a man had burst into a movie theatre in Denver, shot twelve people to death and injured dozens of others. So that song is about a religious maniac who kept reading that God was dead, as in the famous Nietzsche quote, and ended up trying to kill everyone who was writing or preaching it. Think Salman Rushdie!

"Dear Father" is about the Catholic Church and the sexual abuse scandals that were being uncovered at the time, almost weekly. Having been raised a Catholic, I was sickened by it. I thought a priest preying on children in his flock was just about the biggest betrayal imaginable. When I was a kid, I was in awe of priests, as were most kids from Catholic backgrounds. To me, they were God's representatives on earth, so I can't even begin to imagine what it would have been like to have had that trust abused in such a horrible way.

There was a bit of creative tension during the recording of 13, but after forty-five years of Sabbath, I wouldn't have expected anything different. More than half the songs on the album are over seven minutes long, because Tony loved putting extensions on them. I haven't got Tony's patience—he'll sit there for days thinking up extra parts to tag onto a song—and I'd sometimes say to him, "This song's fine the way it is, just leave it." But he wouldn't listen, and I'd often end up agreeing with him, because those little details usually improved things.

We knew 13 had to be a good album, because of all the hoopla surrounding it, and that's how it turned out. Tony wasn't happy with how Rick had made it sound, so took the master tapes back and redid a lot of his parts. But Rick certainly came in handy after it was released in the summer of 2013, because the music writers were wary of criticising anything he was involved in. Saying that, I think the fans would have lapped it up whoever had produced it.

After decades of slagging, we were finally getting our dues as music pioneers.

Before *13* was released, the anticipation was incredible. The record company really gave it the big buildup, the biggest we'd ever had by miles, and we were doing interviews all over the world. All that hype did its job, because *13* topped the charts in something like twelve countries, including the UK and the US, and went platinum in four.

I listened to the chart rundown on the radio in England, and when the DJ reached the top spot, she said, "Number one . . . Black Sabbath?!," as if she thought we'd all died years ago. She was obviously used to hip-hop, pop or dance music being at number one and couldn't get her head around the fact that a load of ancient metallers, who were old enough to be her granddad, had beaten them to it.

I was sixty-three when *13* came out, an age when most blokes do nothing more energetic than pottering around their gardens, planning their retirement. But the first *13* tour took in twenty-odd countries across five continents and consisted of God knows how many shows. Thankfully, travelling is in my blood, and we were no longer chugging around in a clapped-out van and staying in fleapits. Instead, we had our own plane and were staying in some of the best hotels in the world.

I was probably sticking too many sleeping pills down my neck, because of the mad scheduling, but I wasn't on the booze, so was bright-eyed and bushy-tailed most days. I did a lot of walking and yoga and was probably the healthiest I'd ever been on a tour.

For years, the only substantial vegan food most restaurants had in their kitchens were potatoes. So I'd bring my own vegan butter and cheese and just ask for a baked spud. It was a step up from raw turnips, but I'd get home from a tour and never want to see a spud again. Thankfully, by 2013, I could get vegan everything almost everywhere I went, even chocolate. People will be reading this and

turning their noses up, but vegan chocolate beats American chocolate any day of the week. Eating a bar of Hershey's is like eating a candle.

It wasn't like the hell-raising days of yesteryear, but I enjoyed nearly every minute of that tour. I knew it was probably the last one we'd do, and the last time most people would see us play, so I tried to do my best every night and savour every second, although I did feel a bit self-conscious at times. I'd seen other old bands trying to do stuff they were doing in their twenties and thought they looked ridiculous, so I kept thinking, *I feel daft. Why am I doing this at my age?* It really got into my head. That's why there was no headbanging or throwing my bass in the air, because I wanted to retain some dignity.

Sadly, that tour wasn't so easy for Tony. After each gig, he'd be absolutely shattered, virtually on his knees. Then we'd get straight on a plane and arrive at the next city at four or five in the morning, so he wouldn't have enough time to recharge his batteries. Plus, he was flying back to England every few weeks to get more treatment. That tour was a massive drag for him and probably didn't do his health any favours.

We did it all over again in 2014, kicking off with eleven dates in North America, stopping off in Abu Dhabi, before fourteen dates in Europe. The only downside was Bill's absence. Even if he'd done a handful of gigs, that would have been special, but he wasn't for turning. That was a shame, but Bill was a grown man, and we'd long since given up trying to fathom his reasoning.

THE END

After that tour, there was talk of doing a blues album, but that never came to fruition. Because of Tony's cancer, we thought we better put any recording on hold and fit one last tour in, while he

was still able. That farewell tour, dubbed The End, consisted of eighty-one dates and went on for over a year. We sold more than a million tickets and raked in $85 million. Not bad for a bunch of old fogeys who music writers had bashed for the best part of four decades.

We were supposed to finish up in Japan, on our hundredth gig, but we had to cancel the last twenty concerts because Tony was exhausted. It turned out for the best, because it meant our final gig was back in Birmingham, where it all started.

That was a very emotional evening. Me, Tony and Ozzy had old friends and family there and people had flown in from all over the world to see Sabbath play one last time. I don't think anyone left disappointed, because there was fire and explosions and we played just about every song they would have wanted. And after almost two hours onstage, I pulled out my Aston Villa bass and we played "Paranoid" for one last time, Tony played one last solo, Ozzy said one last thank-you, we took one last bow and we made one last exit. I hope we left the crowd wanting more, because that's how you want things to end.

We had to be in the studio two days later, to record some bonus tracks for the live album and video. And once the last song was in the can, it was time to say goodbye. What are you supposed to say to each other after all those years? Well, if you're three working-class blokes from Aston, you don't get too emotional. There were some quick hugs, some mumbled "See ya"s and then we went our separate ways. Ignore the rumours, we'll never do it again. Well, the other three can do what they want, but, for me, the Sabbath story is over.

EPILOGUE

At the time of writing, I'm seventy-two and happy doing pretty much nothing. During the COVID pandemic, I didn't have much choice. A few years ago, former Guns N' Roses drummer Matt Sorum asked me to join a band with him, Billy Idol's guitarist Steve Stevens and Franky Perez, who's a great singer. So we got together, wrote a load of songs and did a mini tour. Then, just as we were about to go into the studio, three things happened: Matt fell out with Franky, the plague hit and all the studios closed down.

Occasionally, a band will send me a demo and ask me to play with them, and usually I'll say, "The bass player you've got is fine, what's the point?" I did play bass on a single by Apocalyptica, the Finnish classical-metal band, and I've done a few guest appearances at shows, but mostly when I play bass now, it's just noodling around in the house.

Apart from the very first bass I owned, which I swapped for a new one, I've got every one I've used from the *Paranoid* album onwards, which amounts to about eighty, quite a few of them Lakland Custom basses. I've got two rooms full of them and the rest take up half the garage.

I don't feel my years, which might surprise you, given that I was in a rock band for half a century. It's probably the vegan diet. I'm trying to grow old gracefully. I gave up wearing leather in about

1980, and while I'm not yet wearing beige cardigans and Velcro shoes, I am dressing more conservatively. I prefer a low profile as I do a lot of solo travelling all over the world, especially where old steam trains are involved, and Gloria and me love going on cruises. I've embraced my grey hair, unlike the old rockers who dye their hair jet black in their seventies. Who are they trying to kid? They look like they're wearing wigs. Some of them probably are.

Me and Gloria now spend most of our time in our house in Utah, up in the mountains, with our three dogs and three cats. On a typical day, I wake up, sink three cups of Yorkshire Gold tea, lounge around on the sofa, take the dogs for walkies and devour a book. Rock and roll! I buy books six or seven at a time and have ended up with tens of thousands. We even had a library in Chesterfield, and if I lived to be five hundred, I wouldn't be able to read them all. The last time we moved, I spent about a week unpacking just books, mainly crime novels—I read anything by the Scottish writer Ian Rankin—and vowed not to buy any more. Then I read a couple of good reviews and ordered more books online. I suppose it's an addiction, but a lot more wholesome than booze, which I don't touch at all nowadays.

If I listen to music, it will usually be old rock, pop, soul or jazz, or newer rock bands like Rival Sons, Mastodon and Royal Blood. I love Billie Holiday—she's up there with the Beatles and I play her all the time.

The music business has changed beyond all recognition. Streaming has almost killed the album, because hardly anyone listens to them all the way through anymore. You can count the artists capable of making an entire album of good songs on the fingers of one hand. But more often than not, I'll hear a single I like, have a listen to the whole album and discover there are only two or three decent songs on it.

Until fairly recently, most bands started from the very bottom, by playing in pubs and clubs, for years if necessary. Only if audiences took to you would a record label sign you. But nowadays, a band will appear from nowhere and suddenly be number one. That's because so much modern pop music is manufactured. It's a case of "Does this group look good enough to make it? Do they sound 'current'? How do we make the perfect single to get them played on the radio? How do we make the perfect video to get them played on YouTube or whatever the current media outlet is? How do we make our first million/billion?"

While bands in the sixties and seventies got robbed by dodgy managers, modern artists and groups get robbed by streaming services like Spotify, who pay a fraction of a cent per play. It's not even worth looking at Sabbath's income from Spotify, it's so small. If you're a massive pop star, you'll make money from streaming. But the only way for most rock and metal bands to make money nowadays is to go on tour, which is why the pandemic was catastrophic for so many musicians and road crews. I spoke to a guy who used to be a roadie for Sabbath and he told me he'd had to get a "normal" job, because the bottom had fallen out of the industry.

When I'm not reading a crime novel or listening to music or an audiobook, I'll take in a crime play on BBC Radio 4, or listen to talkSPORT, which is mainly men chatting about football. Or me and Gloria might binge-watch something on cable, usually a British crime series. But nothing beats watching my beloved Aston Villa, whose every match is shown on TV here in the States.

When the skinheads took over and Sabbath took off, I had to stop going to Villa Park. But wherever I was in the world, I'd always phone home to find out Villa's latest result. If they lost, I'd

be down for the rest of the day. If they won, I'd have a spring in my step. Luckily, I was in the UK when Villa won the league title in 1981, their first since 1910, but I was stranded in Chesterfield, Missouri, when they won the European Cup the following season. I found a phone box, called a mate in England, he put the receiver next to the radio and I listened to the whole game. I was in that phone box for two hours, but it was worth it—what drama!

Five years after winning the biggest prize in club football, Villa were relegated from the old First Division. Since then, we've been up and down and up again, lost a couple of FA Cup finals and won a couple of league cups. We've been a badly run club, until recently, but things are looking up. We've got a couple of billionaire owners now, an Egyptian chap and the bloke who owns the NBA's Milwaukee Bucks. But however things pan out, and however much heartache they put me through, I'll never stop loving that club.

In 2018, I was invited to Villa Park and presented with a Birmingham Walk of Stars award, which they hand out to famous people from the city. I'd always refused it, because I hate things like that, find it difficult being the centre of attention. It's not as if I found a cure for cancer or solved the world's problems, but when they said they wanted to give one to Bill as well (Tony and Ozzy already had a star on Birmingham's Broad Street), I couldn't really say no.

The last time I was on the Villa Park pitch, I was running after my hero Peter McParland. This time, I was scared out of my wits. When they shoved the microphone in my face, all I could muster was a quivering "thank you." Afterwards, I had to do an interview with the local news channel and went to pieces. Less than a year earlier, I'd been performing in front of sixteen thousand people just down the road. Shyness comes in many guises.

The following year, me and Tony unveiled the Black Sabbath Bridge, also on Broad Street (Birmingham is said to have more canals than Venice, but don't expect a Black Sabbath gondola any time soon). There was also a Sabbath bench, which was the idea of an Egyptian superfan, Mohammed Osama, who campaigned for it for years. Broad Street is full of bars, pubs and clubs, so I'm sure it will get plenty of use. Hundreds of people turned out and it was great to be recognised by our hometown. Birmingham is where we were made, for better or worse, and Brummies will never stop being our people.

We've still got the place in Warwickshire, which our house sitter Debi keeps going, and I've got two surviving brothers and one sister back in England. Jimmy lived in the family house, 88 Victoria Road, until he died. It was strange going back there for the last time, to clear everything out. I couldn't believe how small it was, because it seemed huge when I was a kid. And the memories swirled all around me. It was, after all, where I came into the world, grew up and dreamed the lyrics and bass riff for "Behind the Wall of Sleep." And it was where I had a visit from the future—a man on a stage, wearing long hair, silver boots and playing a guitar. That man being me.

Aston has changed beyond all recognition since my childhood; it's an alien place to me now. I still feel English/Irish to the core, and my accent has barely changed since I left all those years ago (God knows how thick it was while I was still there, because people still struggle to understand me), but I think it's time I became a US citizen.

For years, I didn't bother applying, because I was always on the go, with recording and touring. Eventually, I decided I was going to take the plunge after Sabbath's final tour. Then, like an idiot, I got involved in a pub brawl. I can't go into the details, except to

say I got drunk, whacked some clown, got arrested and ended up with a criminal record. I haven't touched alcohol since, which is probably why I'm still here. But it will happen eventually, because America is now my home, where my wife is from and where my two boys and grandkids were born. And it's been very kind to me and the other Sabbath lads.

Living in America as a Brit has some challenges, though. I miss talking about football (proper football!) with people who know what they're on about. I do enjoy the NFL and MLB (Go Cards!) but I can't really take it seriously, what with all the commercial breaks every five minutes and the fact that a team will up sticks and move to a different city if it isn't bringing in enough cash. Who cares about the fans? Capitalism at its worst. Having said that, I fulfilled an ambition by attending the 2022 Super Bowl, where the LA Rams were victorious. It was a great day out, a fantastic atmosphere, with nobody threatening anyone else because they were wearing their team's colours.

One of my biggest peeves about America is all the commercials for prescription drugs on TV. Don't people have doctors to advise them? And no wonder drugs are hugely more expensive in the States—the drug companies have to pay for the commercials! And don't get me started about the word "Christmas"—it's like a dirty word in America. "Holiday" tree, anyone? Office "holiday" party? I'm surprised "Easter" hasn't been banned, but even that's now about the Easter bunny, rather than about Christ.

I also find myself agreeing with things I never thought I would and completely baffled by some of the other stuff that goes on. It's mind-boggling that supposedly the most advanced country in the world doesn't have socialised medicine, like in the UK and most other countries. Trillions of taxpayers' dollars go towards the military and people are going bankrupt when they fall ill. How can

that be right? But I'm conservative about other things, for good reason.

About fifteen years ago, my son Biff got stabbed in LA. He'd been out for a drink with his new workmates in Hollywood, just left the pub and two scumbags attacked him. When Biff put his arm up to defend himself, one of his assailants shattered his elbow, before stealing Biff's Nike trainers and legging it. Biff was rushed to hospital and while his life was never in danger, it cost him $25,000 to have his elbow fixed. Twenty-five grand for the pleasure of being mugged and stabbed! Ridiculous.

My family is close-knit, despite the distances between us. James went to Oxford University and King's College London, so he's a pretty smart bloke. He lives in London with his fiancée Jess, and while he's tried to explain what he does for a living, I've never quite been able to work it out. He's very political, very left-wing and very into trying to save the environment, which is obviously a good thing. He despairs of some of my political views, but we both enjoy a good argument! And, at the time of writing, he and Jess are soon to present us with our fifth grandchild!

Biff was the singer in a band called Apartment 26, who Gloria managed. Apartment 26's debut album, *Hallucinating*, was released by Hollywood Records in 2000, and they recorded their third album with Atlantic. Their second album, *Music for the Massive*, was released in 2004. They appeared at several Ozzfests, including in 1999, when Sabbath headlined, and did several tours on their own. But Biff didn't like being on the road and is now a commercial editor, who has won Emmy and Clio Awards, among others. He does a lot of work for Apple and Nike, including directing a commercial featuring Kobe Bryant, one of his basketball heroes, and has

done ads and intros for the Super Bowl. One of his Emmys was for an emotional documentary he directed called *Long Live Benjamin*, about the artist Allen Hirsch and his friendship with a monkey. Biff speaks like a Brit, because he went to school there, but is very much American, as are his wife and four kids. He's doing great and I'm very proud of what both sons have achieved, through their own hard work.

Gloria and I dote on our grandkids—they mean the world to us. They're very aware of who their granddad is and some are turning into fine musicians themselves. One granddaughter went to her first guitar lesson wearing a Black Sabbath T-shirt and recently had all the kids singing "Iron Man" in a school concert. It's a strict Catholic school, so I was sitting there thinking, *Bloody hell, I wonder what all the parents think about their children singing a Black Sabbath song.* Thankfully, they were all cool about it. At least no-one breathed garlic in my face or tried to take me out with a silver bullet.

My veganism remains important to me. I've never been one of those annoying preachy people who tuts at non-vegans or tries to convert them—my kids ate whatever they wanted, as Gloria still does—but I have campaigned for the animal rights organisations PETA and the Humane Society of the United States.

I don't understand how people can kill animals, but someone killing an animal, taking it home and eating it is more favourable than what humans put factory-farmed animals through. I hate hearing about animal abuse and cruelty. Plus, eating too much meat isn't great for your health anyway (as poor Ronnie could attest to), while intensive animal farming is terrible for the environment. As for so-called trophy hunters, who kill animals just for larks, they should be boiled in acid as far as I'm concerned—filthy cowards.

Me and Gloria are involved in the fight against kitten and

puppy mills and banning fur farms, too. All our cats and dogs were rescued, and most of them sleep on our bed, which comes in handy on Utah's cold winter nights. I'm a hoarder by nature, so I'll go into a pet shop to buy dog food, see a kitten in a cage and think, *I've got to rescue that.* If it wasn't for Gloria putting the brakes on me, we'd have hundreds of them.

The supernatural, so much a part of my life when I was young, is something I'm still interested in, although the otherworldly experiences have become few and far between in my later years.

Probably the most significant incident in my adult life happened when we were on tour in the eighties. I decided to have an afternoon nap in my hotel room, which I didn't usually do. While I was asleep, I dreamed that I got up, got in the lift with Tony and it stopped halfway down. When the doors opened, there was a brick wall in front of us—and then the lift suddenly dropped and crashed into the ground. I woke up with a start, thinking, *Bloody hell, that was realistic . . .* I told Tony about the dream, and when we got in the lift to go to the gig, it stopped halfway down. Then when the doors opened, there was a brick wall in front of us. We looked at each other and said, "Oh no," expecting the lift to plummet. But thankfully the doors closed and the lift carried on as normal.

It amuses me when people question my sanity or veracity when I talk about my supernatural experiences, but they quite happily believe in the stories from the Bible—the virgin birth, the resurrection, Noah's ark, Moses parting the Red Sea, etc. Of course, I would never doubt people's faith, and I'm glad I had those core beliefs growing up. They provided me with a set of guidelines on how to live and helped me through some pretty rough times. And although organised religion probably causes more wars and

violence than anything else, I do pray to a higher power. I don't think there's an old bloke in the sky with a long, white beard, but I do believe there's something out there.

That said, I already have a higher power, and she's called Gloria. Gloria has been behind all the success I've had since I met her—she's the love of my life, an absolute diamond. In fact, had I not met her when I did, I'd probably be six feet under in Witton Cemetery, next to my mom and dad.

Even though Sabbath only called it quits a few years ago, it seems like another lifetime. In the course of writing this book, I dredged up memories I thought were gone forever. Some of them aren't great, but I don't like to dwell on them. Perhaps the most amazing part of the story is the fact that all four original members are still alive. And, for the most part, still doing pretty well.

I haven't spoken to Ozzy since the last tour, because Sharon and Gloria fell out about something trivial. Me and Ozzy are fine, it's just that we're both ruled by our wives. He's got a big heart and he was always there for me in times of trouble. Me and Tony stay in touch via email, while I communicate with Bill via email to his wife, because he's not on the internet. We might not be as close as we were, but we'll always be brothers. How could we not be, given everything we went through together?

People tend to ask me: Could Sabbath happen now? The truth is, probably not. The odds of four working-class lads coming together in a rough place like Aston, writing very heavy songs about their gritty reality and making it in the music industry are slim to none. They wouldn't look "right," they wouldn't sound "current" and they'd be too much of a risk for major record companies. Even if they did make it, their lives would be very different to ours. The first two decades of Sabbath was one long party, and no-one

seemed to care what we got up to, however crazy. But that rock and roll excess, which was par for the course in the sixties, seventies and eighties, is largely a thing of the past.

Any other band would have given up years earlier, if what was thrown at us was thrown at them. That's what a tough upbringing in Aston does for you, makes you tough as old boots. For years, the critics hated us. We were badly managed and got royally ripped off. There were more lineup changes than most people had hot dinners. People assumed we'd be rendered obsolete by glam, prog, punk and hair metal. But we saw them all off and finished on top.

None of it happened by chance; it must have been preordained. Four kids living right around the corner from each other, all into the same music, all determined to make it, all immune to the constant pleas to "stop dreaming your life away and get a proper job." It's impossible to explain it any other way.

While we never saw ourselves as a heavy metal band, people told me we invented metal so often that I eventually just accepted it. And I'm glad to be part of the heavy metal community, because metal fans are the most loyal in music, unswerving in their support. But metal or not, I prefer to think of Sabbath as rock's great survivors. If an asteroid crashed into Earth next week, the only things left standing would be the four of us and cockroaches.

I've got no regrets. How could I? I've spent my life doing what most people can only dream of. I was a kid with a mad ambition and made it happen. I was in a band that sold tens of millions of records, conquered the world and inspired others to do the same. I've stuck to my principles and respected the life of people and animals. I've got a wonderful wife, wonderful kids and wonderful grandchildren. I wish the Villa had won a few more trophies, but we can't have it all. After what seems like forever, I feel like the luckiest man alive.

ACKNOWLEDGEMENTS

The reason for writing a memoir came from the fact that when my parents died, I hardly knew anything about their early lives, and I regret not asking them when they were alive. I now have a ton of questions I wish I'd have asked them. I originally set out to write a book for my grandkids, but my wife, Gloria, encouraged me to write it for general publication, as many Sabbath fans have asked why I haven't written a memoir, especially as I was the chief lyricist for Sabbath. I value my privacy, I hate using the phone, except for texting, so it has been a heart-wrenching decision whether to allow anyone into my life (or not.) With the help of Ben Dirs, who extensively researched the Sabbath/Heaven & Hell archives and converted my original manuscript into a more readable document, there is now a final version suitable for publication. Some of my original manuscript was deemed unsuitable for modern readers—times have changed was the excuse I was given, but I suppose as publishers they know more of what is acceptable these days.

Obviously, this memoir wouldn't be possible without the hundreds of people that have populated my life, some of which I wish to acknowledge here. . . .

My mother and father, Mary and James Butler, who gave me life. My brothers and sisters, Sheila, Maura, Eileen, James, Patrick,

Peter, and their families. The Dublin Butlers and Fennels. Ernie, Michael (Pickle) Howse, Jimmy and John Croft, and their families.

The greatest bandmates ever; maestro Tony Iommi (who actually still keeps in touch), Ozzy, Bill, Ronnie, Geoff, Vinny, Adam, Tommy. Pedro Howse, Burton C Bell, Jed Smith, Clark Brown. Right-hand man and gear developer, Terry (T2) Welty. Gone but not forgotten, Mike Clement.

The Beatles, for the inspiration. Jack Bruce, likewise.

Shout-out to those who try to make the world a better place: PETA, LCA, RSPCA, Kitten Rescue, Hunt Saboteurs.

My present and past companion animals, especially Dizzee, Missy, Busta, Snoop, Baldrick, Scamp.

Thanks to David Luxton for the never-ending patience.

Carrie Thornton and Drew Henry at Dey Street Books/Harper-Collins Publishers. Kelly Ellis at HarperCollins Publishers/UK.

Tal Ronnen at Crossroads Kitchen.

Carlene and Phil Eastbury, Risa Shapiro, Michael Horkachuck and superfan Mohamned Osama.

Mega assistant, nanny, keeper of the keys, pet wrangler, life-long friend, Debi Buchan.

My wonderful sons, Biff and James, Tricia, Jess, and my beautiful grandkids, Carolina, Guy, Pippa, Isadora, and Clara.

Above all, my beautiful wife, Gloria, who makes my life worth living. I love you with all my heart and soul, forever, and I thank you for being you.

ABOUT THE AUTHOR

Terence "Geezer" Butler was born in Birmingham, England, in 1949. He was a founding member, bassist and lyricist of heavy metal pioneers Black Sabbath, who have sold over 75 million albums worldwide. *Paranoid*, their breakthrough second album, sold over 4 million copies in the US alone. Having performed their final show in 2017, almost fifty years after their formation, Sabbath continue to be cited as one of the most influential rock bands in history, while Geezer is widely accepted as the godfather of heavy metal bass. Geezer has also played with Ozzy Osbourne's band and released three albums under his own name. He and his wife, Gloria, have two sons, several grandchildren, lots of cats and dogs and campaign for animal rights. They have houses in Utah and Warwickshire, England—and Geezer never misses his beloved Aston Villa playing football on TV.